HISTORIC PHOTOS OF
SEATTLE

TEXT AND CAPTIONS BY WALT CROWLEY

Turner®
Publishing Company

Nashville, Tennessee • Paducah, Kentucky

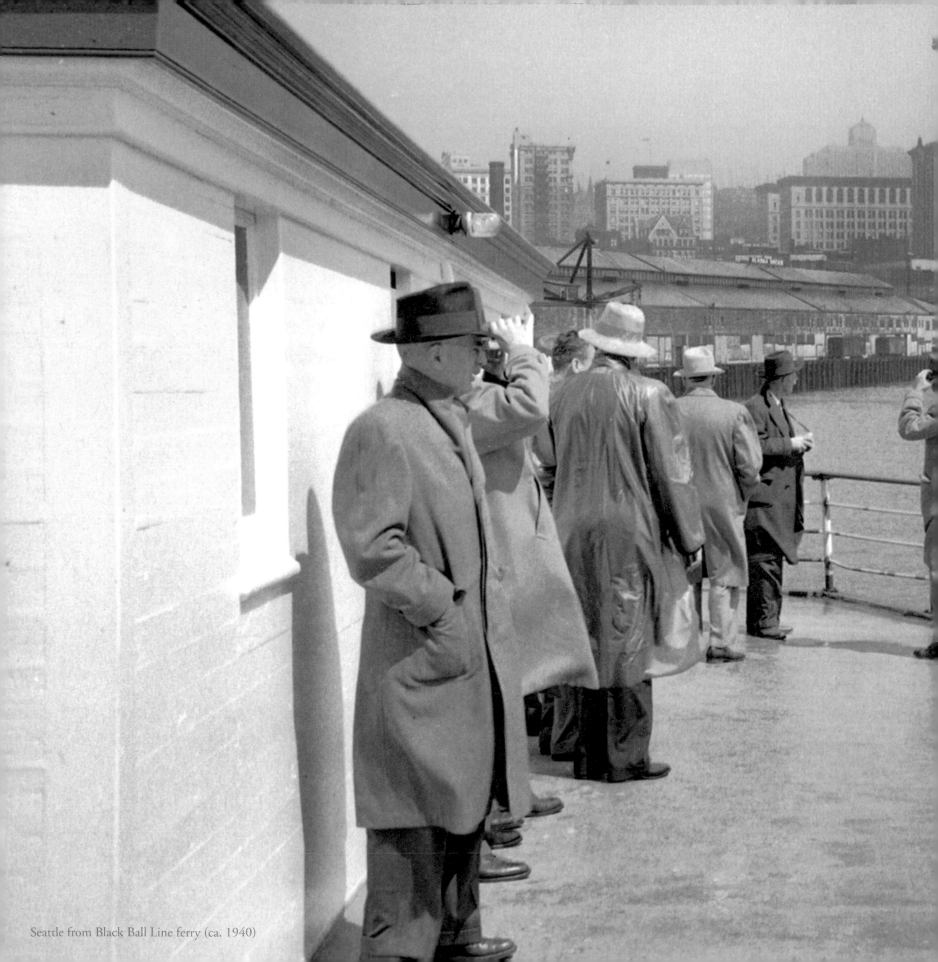

Seattle from Black Ball Line ferry (ca. 1940)

HISTORIC PHOTOS OF
SEATTLE

PIER 48

Turner Publishing Company
200 4th Avenue North • Suite 950 412 Broadway • P.O. Box 3101
Nashville, Tennessee 37219 Paducah, Kentucky 42002-3101
(615) 255-2665 (270) 443-0121

www.turnerpublishing.com

Library of Congress Control Number: 2006933650

ISBN: 1-59652-303-4

Printed in the United States of America

0 9 8 7 6 5 4 3 2 1

CONTENTS

Seattle policeman, probably directing traffic

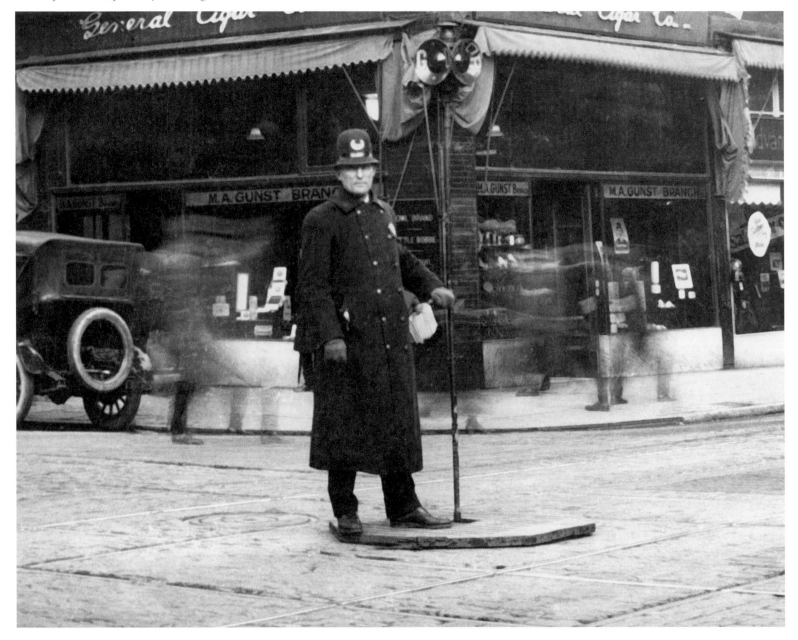

Acknowledgments

This volume, *Historic Photos of Seattle,* is the result of the cooperation and efforts of many individuals, organizations, institutions, and corporations. It is with great thanks that we acknowledge the valuable contribution of the following for their generous support:

Seattle Municipal Archives
University of Washington Libraries Digital Collections
The Edgewater Hotel
The Roosevelt Hotel
We would also like to thank Walt Crowley, author and editor, for his valuable contributions and assistance in making this work possible.

PREFACE

Seattle has thousands of historic photographs that reside in archives, both locally and nationally. This book began with the observation that, while those photographs are of great interest to many, some are not easily accessible. During a time when Seattle is looking ahead and evaluating its future course, many people are asking, "How do we treat the past?" These decisions affect every aspect of the city—architecture, public spaces, commerce, infrastructure—and these, in turn, affect the way that people live their lives. This book seeks to provide easy access to a valuable, objective look into the history of Seattle.

The power of photographs is that they are less subjective than words in their treatment of history. Although the photographer can make decisions regarding subject matter and how to capture and present it, photographs do not provide the breadth of interpretation that text does. For this reason, they offer an original, untainted perspective that allows the viewer to interpret and observe.

This project represents countless hours of review and research. The researchers and author have reviewed thousands of photographs in numerous archives. We greatly appreciate the generous assistance of the archives listed in the acknowledgments of this work, without whom this project could not have been completed.

The goal in publishing this work is to provide broader access to this set of extraordinary photographs that seek to inspire, provide perspective, and evoke insight that might assist people who are responsible for determining Seattle's future. In addition, the book seeks to preserve the past with adequate respect and reverence.

With the exception of touching up imperfections caused by the damage of time, no other changes have been made. The focus and clarity of many images is limited to the technology and the ability of the photographer at the time they were taken.

The work is divided into eras. Beginning with some of the earliest known photographs of Seattle, the first section records photographs from before the Civil War through the end of the nineteenth century. The second section spans the

beginning of the twentieth century through World War I. Section Three moves from World War I to the advent of World War II, and Section Four, from World War II to 1959. The last section depicts subject matter from the latter part of the twentieth century.

In each of these sections we have made an effort to capture various aspects of life through our selection of photographs. People, commerce, transportation, infrastructure, religious institutions, and educational institutions have been included to provide a broad perspective.

We encourage readers to reflect as they go walking in Seattle, strolling through the city, its parks, and its neighborhoods. It is the publisher's hope that in utilizing this work, longtime residents will learn something new and that new residents will gain a perspective on where Seattle has been, so that each can contribute to its future.

Todd Bottorff, Publisher

Seattle regrade showing a house on ungraded land

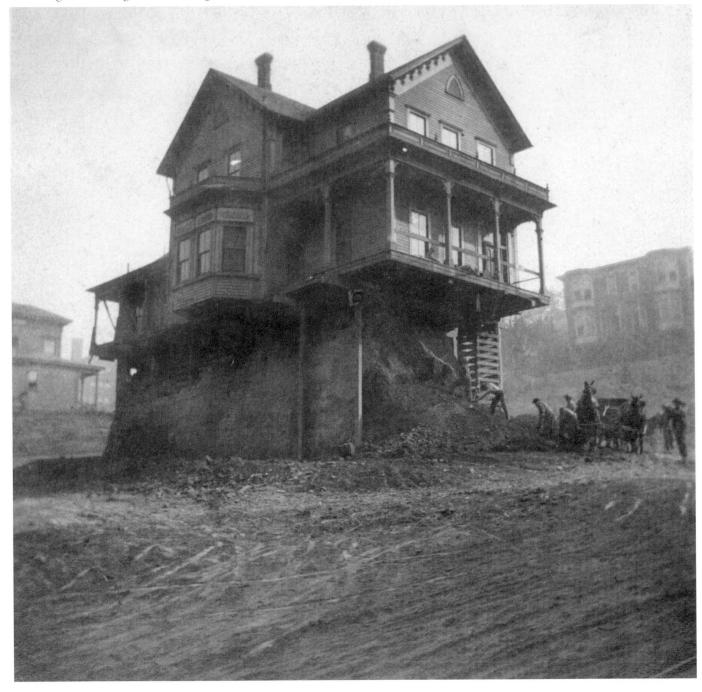

Planting the Seed for a City

1851–1899

Seattle's modern history began on the rain-soaked morning of November 13, 1851, when a bedraggled group of settlers rowed ashore from the schooner *Exact* and set foot on today's Alki Beach. Most of the party of two dozen men, women, and children had been led by Arthur Denny over the Oregon Trail from Illinois to Portland, Oregon. They were later joined by brothers Charles and Leander Terry from New York.

These pioneers had not come west to strike it rich prospecting for gold or to patiently clear wilderness for farms. They planned to build a city in anticipation of the transcontinental railroad they expected would soon connect the Pacific Northwest with the Great Lakes.

The Denny party found Portland, Oregon, already "too crowded" and Arthur dispatched his young brother David and John Low north to explore Puget Sound. They joined up with Lee Terry in Olympia and canoed north into Elliott Bay, where they were welcomed by Chief Seattle, "tyee" of the Duwamish and Suguamish tribes, which had inhabited the region for millennia. They also met a party of farmers who had claimed homesteads in the fertile valley of the meandering Duwamish River just days earlier.

After exploring the area, John Low and Lee Terry staked claims on the western shore of today's West Seattle. David Denny sent a note to his brother with John Low, which read "There is plenty of room for one thousand settlers. Come at once."

The group initially called its new home "New York" after the Terry brothers' home state, but they found the anchorage too exposed. In April 1852, most of the Denny Party relocated to the more sheltered eastern shore of Elliott Bay. They were joined by Olympia physician and merchant David S. "Doc" Maynard, who persuaded his new neighbors that "Seattle" was a better name for their future city than "Duwamps." Meanwhile, Charles Terry rechristened his New York settlement "Alki," meaning "by and by" in the Chinook trading jargon.

Seattle's economic future was launched in the fall of 1852 when Henry Yesler, after being bribed with cash and land, chose Seattle for the site of Puget Sound's first steam-powered sawmill. In December 1852, Seattle was named the seat of a new King County (first named after Vice President William Rufus Devane King and officially rededicated in 2005 to honor Dr. Martin Luther King, Jr.).

Washington Territory separated from Oregon in 1853, and Seattle vied with Olympia to serve as the state capital. It lost, and settled for the Territorial University in 1861. The town grew slowly but steadily to reach a population of 1,100 by 1870.

When the Northern Pacific Railroad chose Tacoma over Seattle for its Puget Sound terminus in 1874, disappointed city founders built their own short railroads to connect the harbor to newly discovered coal deposits. Seattle's population tripled by 1880 while Tacoma languished waiting for the tracks of the stalled N.P. to reach it. Seattle's growth accelerated after a spur line linked it to the N.P. in 1884, and the city swelled to 42,000 during the decade.

By now the Sound buzzed with a "mosquito fleet" of private ferries and steamships, and railroad tracks were spreading across the territory. Frank Osgood introduced the city's first horse-drawn streetcars in 1884 and converted them to electric power in April 1889. Three months later, on June 6, an overheated pot of glue started a fire that consumed the entire downtown. The privately owned water system failed and 64 acres of wood-framed buildings and docks were reduced to ashes.

British writer Rudyard Kipling happened to be touring Puget Sound at the moment and called the aftermath "a horrible black smudge." Undaunted, Seattle quickly rebuilt—with stone and brick. It also raised the sidewalks in today's Pioneer Square to improve drainage, and thereby created the labyrinth of areaways and interconnected basements for today's famous "Underground Seattle" tour.

One month after the fire, voters approved the city government's development of a public water system. City Engineer R. H. Thomson later began laying pipe to tap a vast watershed on the Cedar River 40 miles southeast. He consciously planned it to serve a metropolis of one million.

Seattle gained its own direct transcontinental rail link with completion of James Hill's Great Northern Railway in 1893, and international trade with China and Japan kept the harbor busy. Hops grown in nearby river valleys supported the world's sixth largest output of beer, centered in Georgetown breweries. Seattle was now the largest city in Washington, which had gained statehood on November 11, 1889.

Then the bottom dropped out. A stock market crash and dwindling federal gold reserves triggered the national "Panic of 1893," which dried up East Coast capital for Seattle's development. The regional economy sank into a depression that wiped out many pioneers, including David Denny, who had grown rich with street railways and a sawmill on the south shore of Lake Union.

The city was rescued on July 17, 1897, when the steamship *Portland* arrived with two tons of gold scraped from the banks of the Klondike River in Canada's Yukon Territory, launching an international gold rush. Seattle declared itself the "Gateway to Alaska" (which offered the shortest route to the Klondike) and its merchants fleeced tens of thousands of eager prospectors on their way to and from the gold fields. The city marked its resurrection in 1889 with installation of a totem pole in Pioneer Square, taken from a Tlingit village in Alaska, and ended the decade with 82,000 residents.

Aftermath of Seattle Fire of June 6, 1889, looking West on Yesler Way

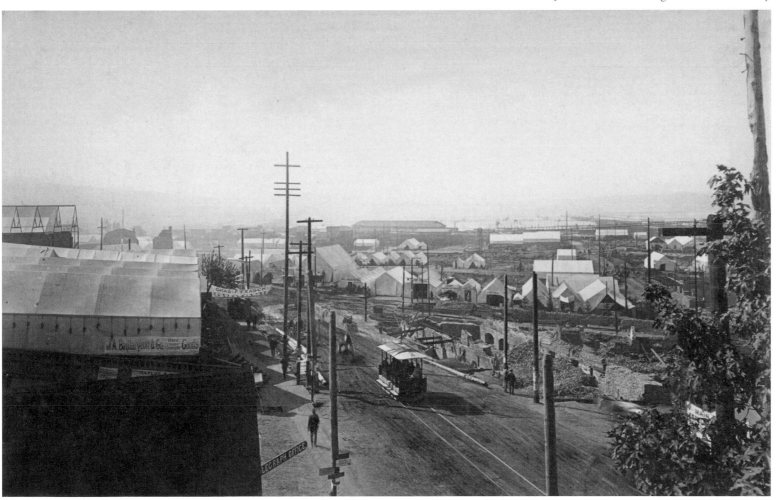

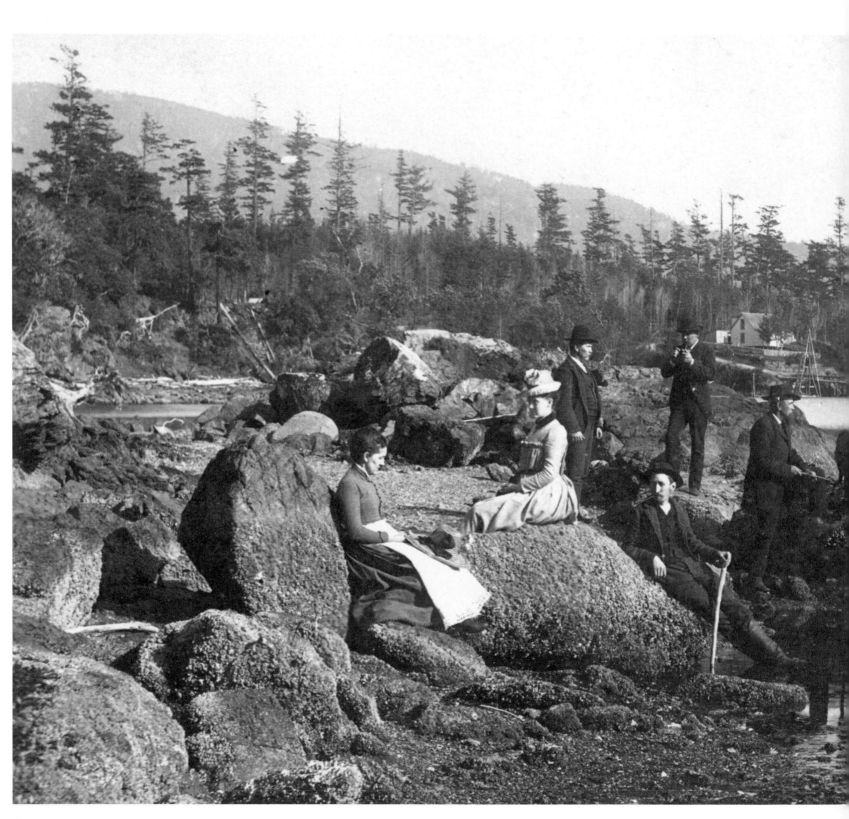

4

Men and women on West Seattle shoreline

Hotel at Woodland Park in 1891

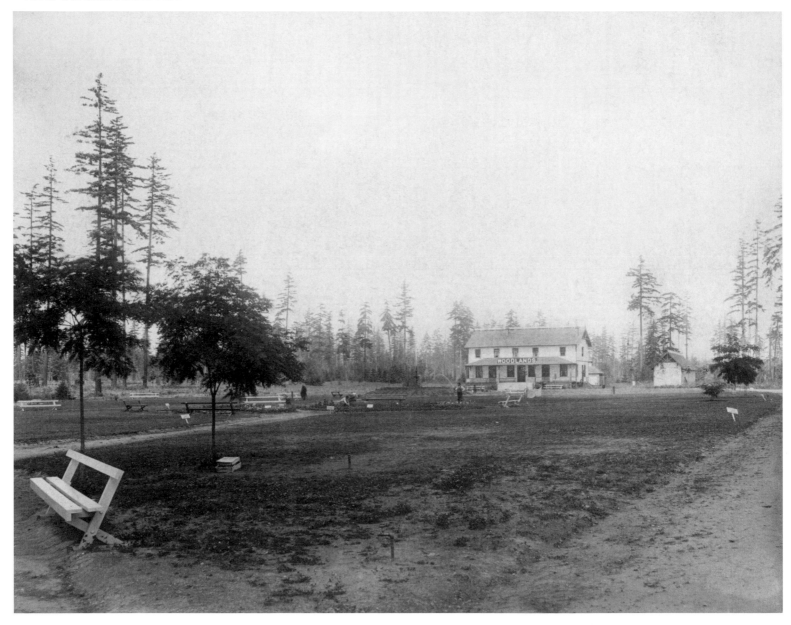

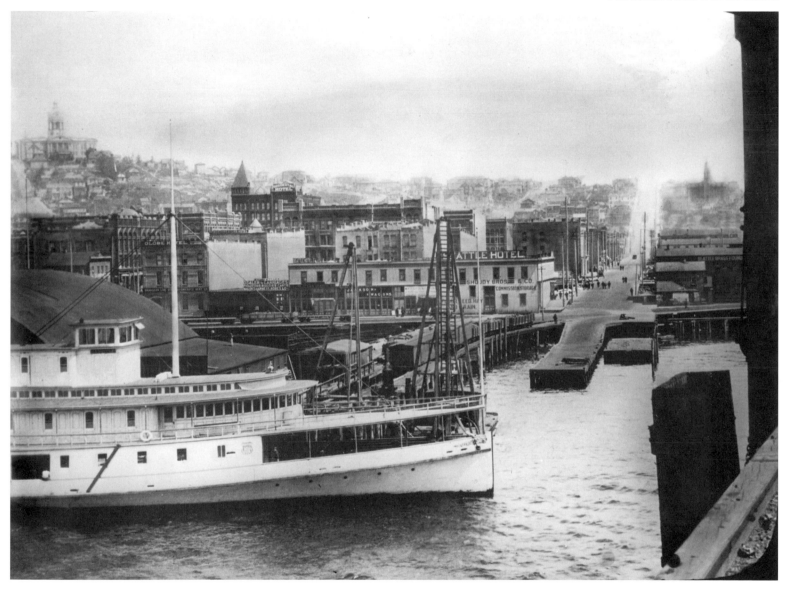

Pioneer Square, from waterfront looking up Yesler.
The Seattle Hotel is in the center.

This trolley traveled around the east side of
Green Lake. (1897)

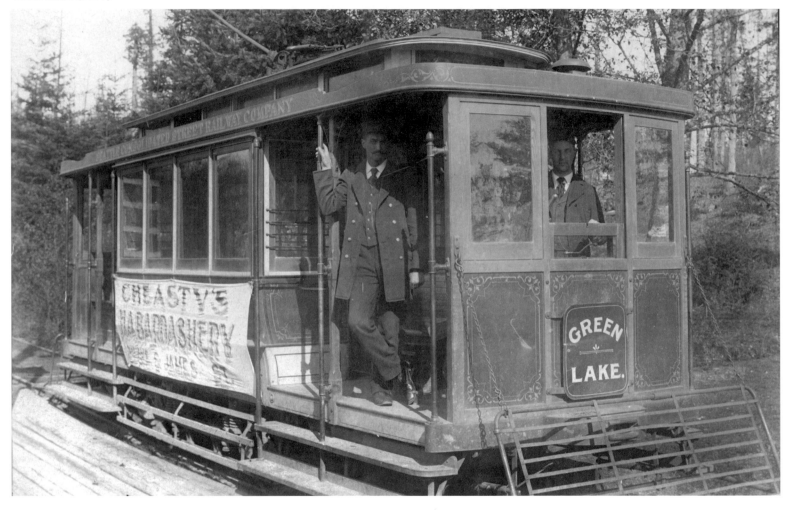

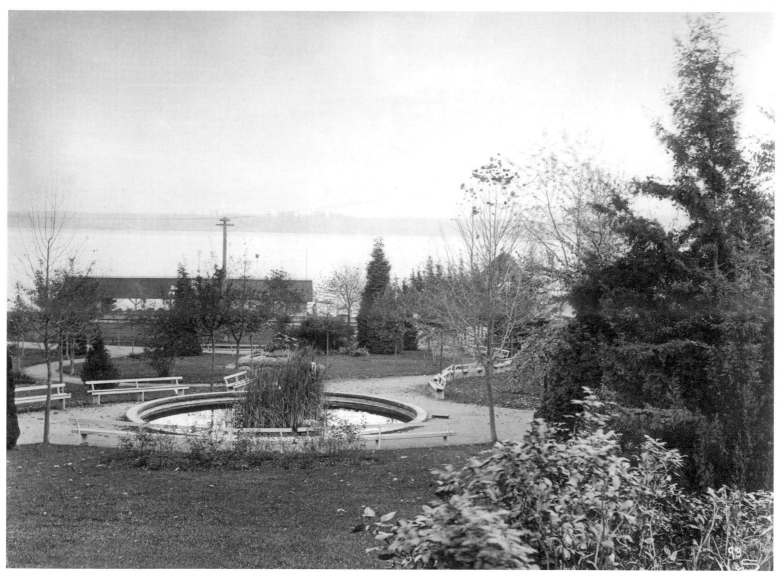

Swimming pool at Woodland Park (near Green Lake) (1897)

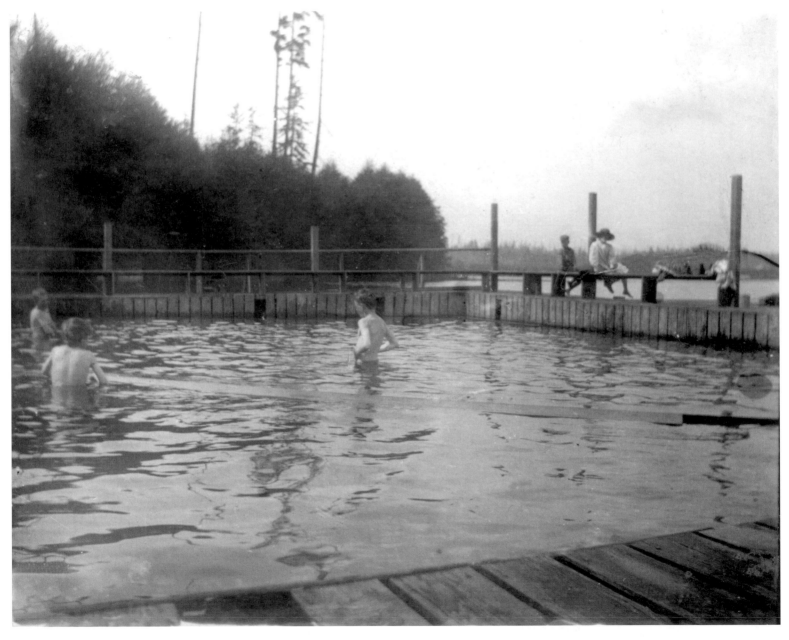

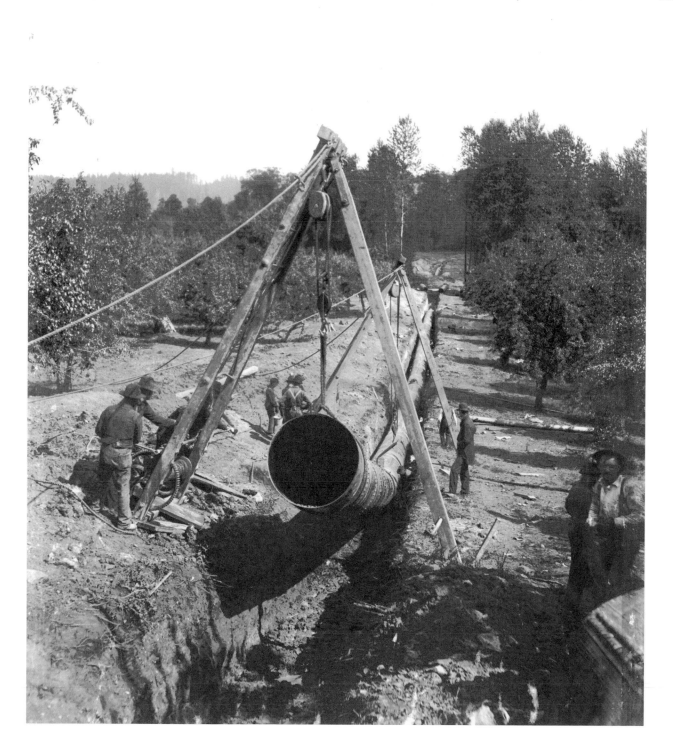

Cedar River Pipeline
No. 1 being laid up Bagley
Hill near Renton (1899)

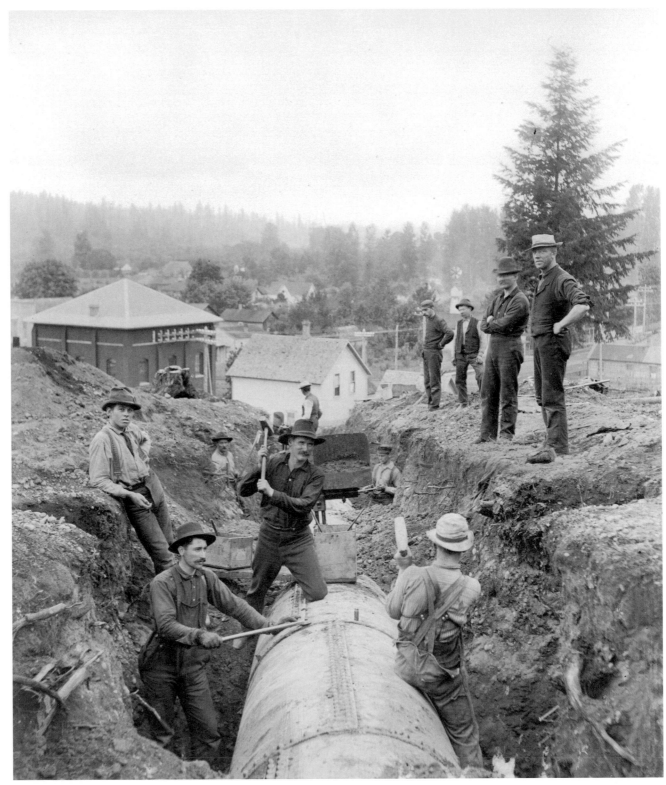

Cedar River Pipeline
No. 1 under
construction on
hill east of Renton
(September 1, 1899)

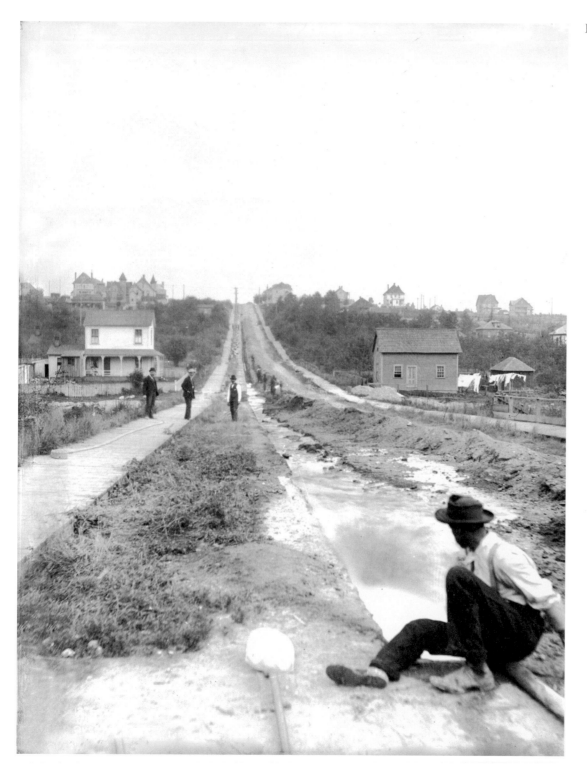

East Harrison Street (1899)

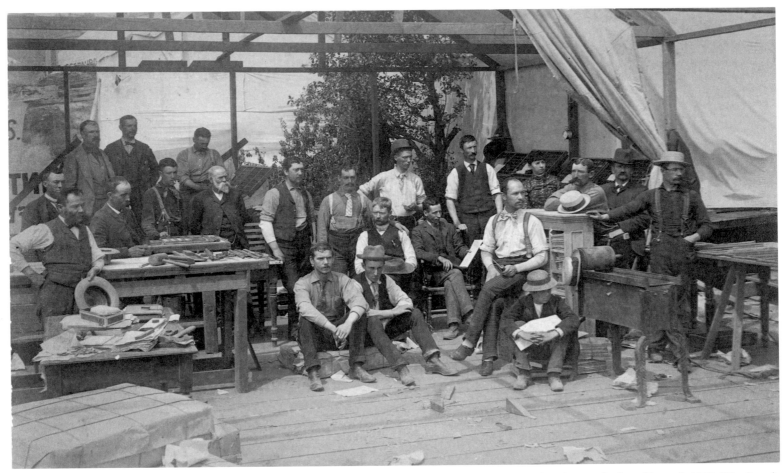

This photo was taken the day after the Seattle fire of June 6, 1889. The Seattle Daily Press newspaper staff and equipment are housed in a temporary tent.

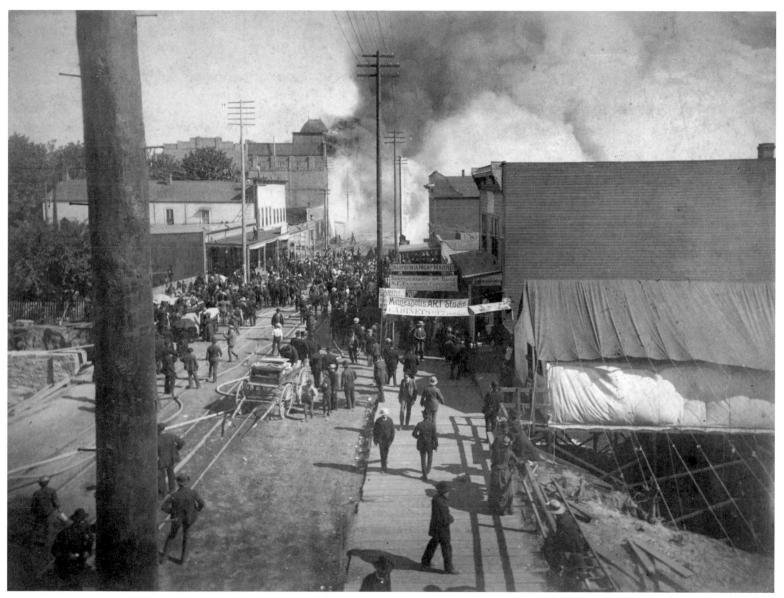

The big fire of June 6, 1889, looking south on 1st Avenue from Spring Street. This is about half an hour after the fire started. In the background the Frye's Opera House is starting to burn.

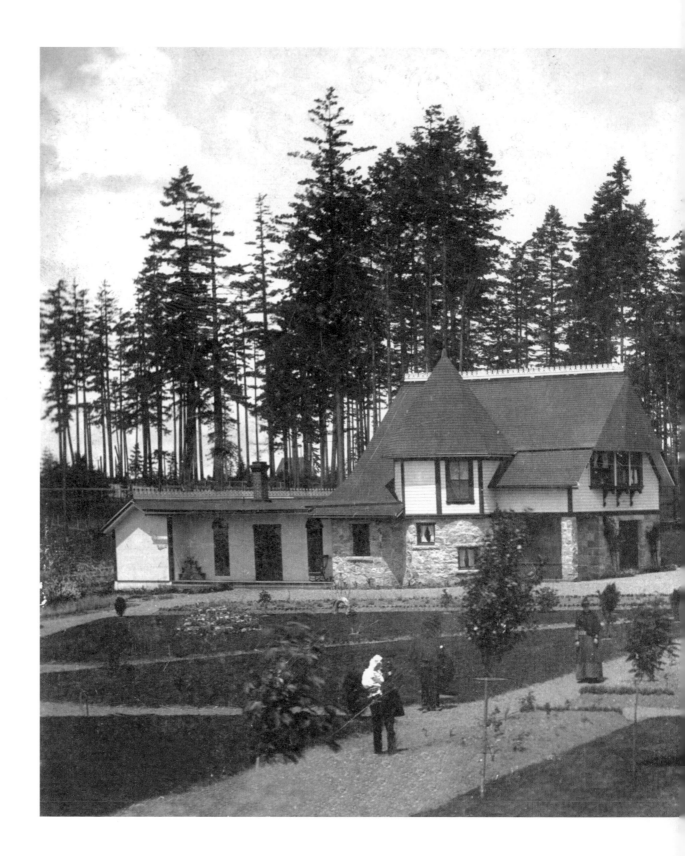

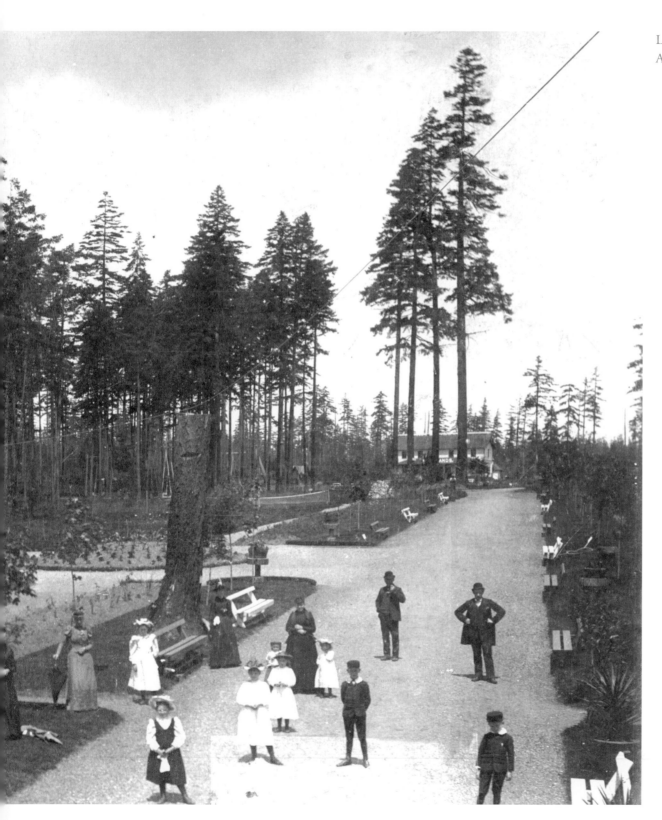

Lodge at left entrance (Fremont Ave.) of Woodland Park

Fremont Ave. entrance, Woodland Park. Owner, Guy Carlton Phinney (1891)

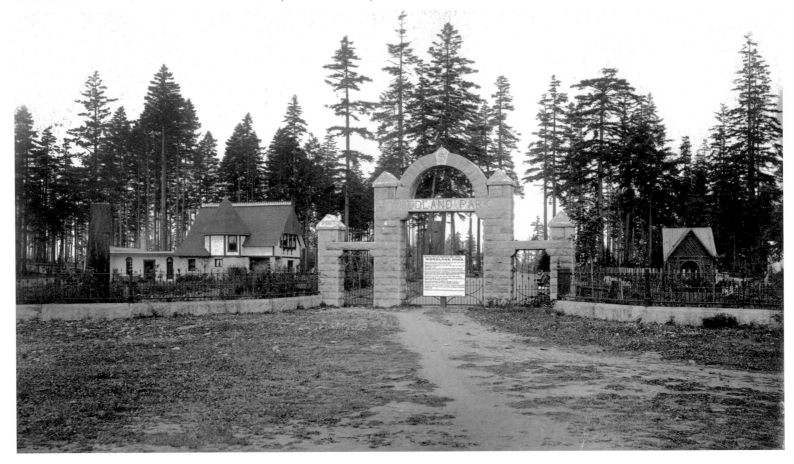

Sullivan Building at right with the Starr-Boyd Building. The cable car turning onto 1st Avenue is one from the Front Street Cable Runway.

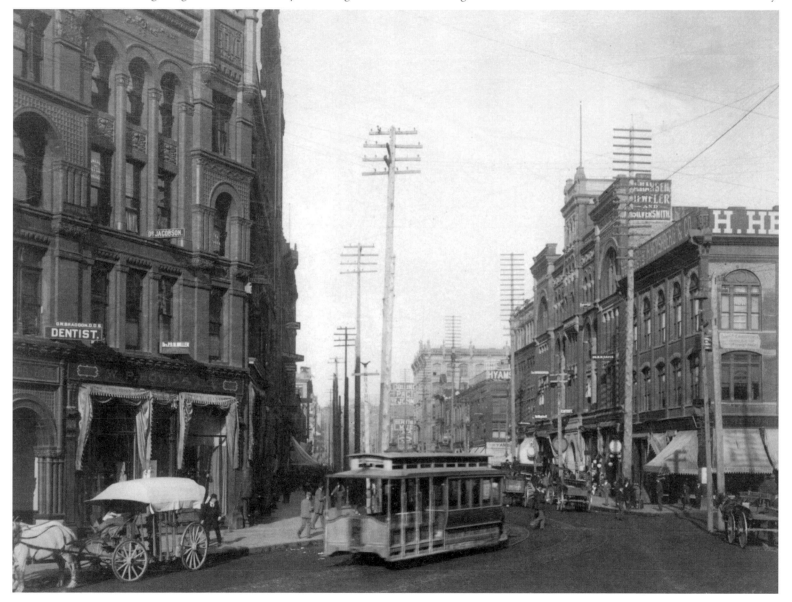

Woodland Park looking south toward Fremont Ave. entrance from hotel (1891)

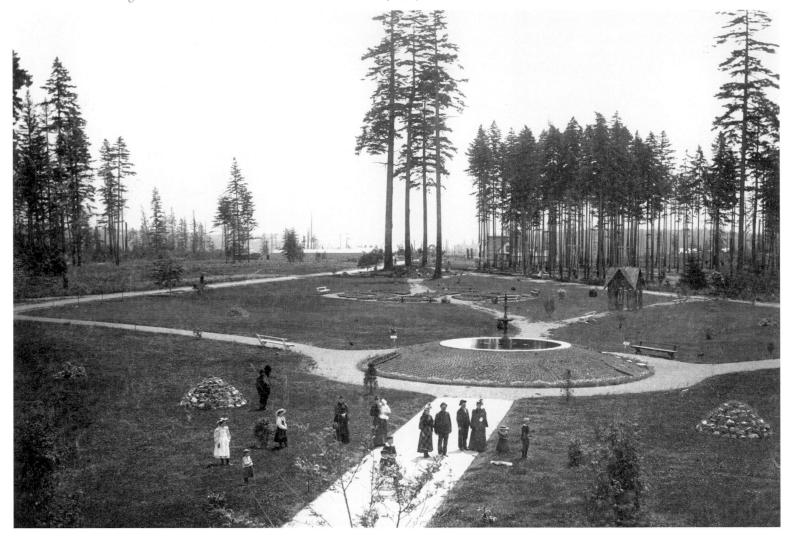

Guy Phinney's private streetcar connected his Woodland Park resort to Fremont.

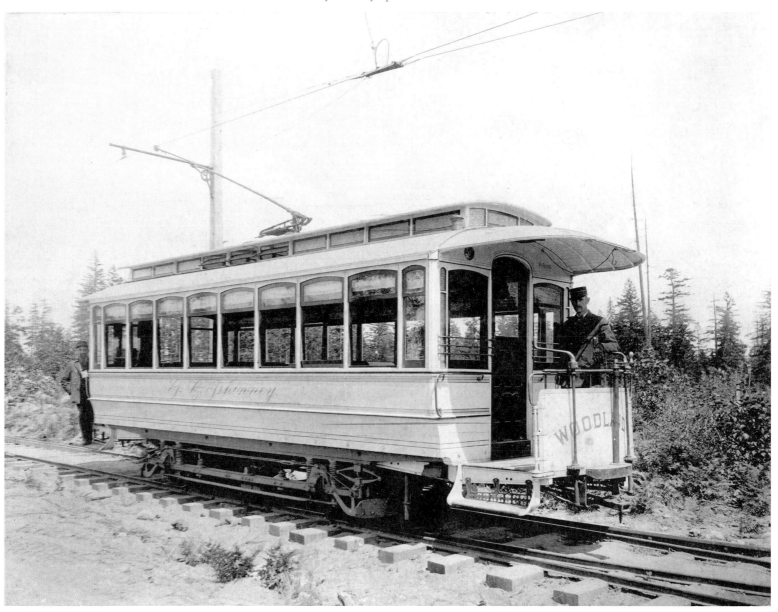

Native American camp at the foot of Washington St. on Ballast Island (1891)

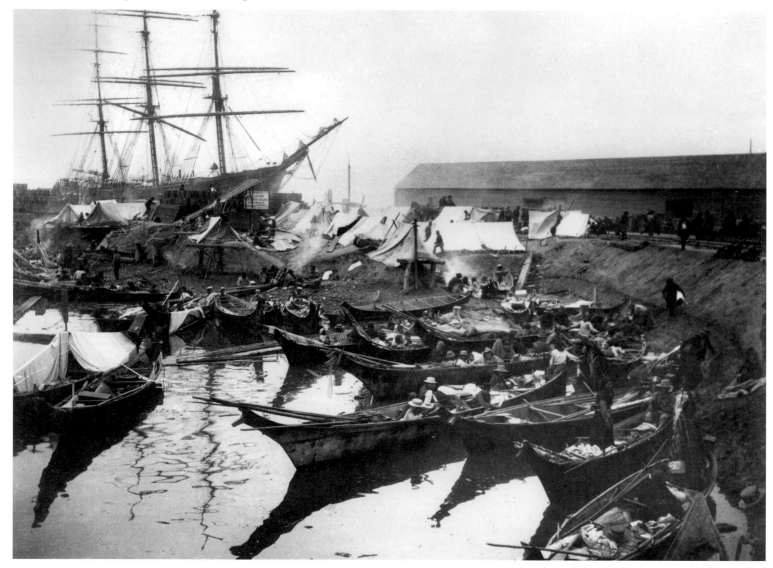

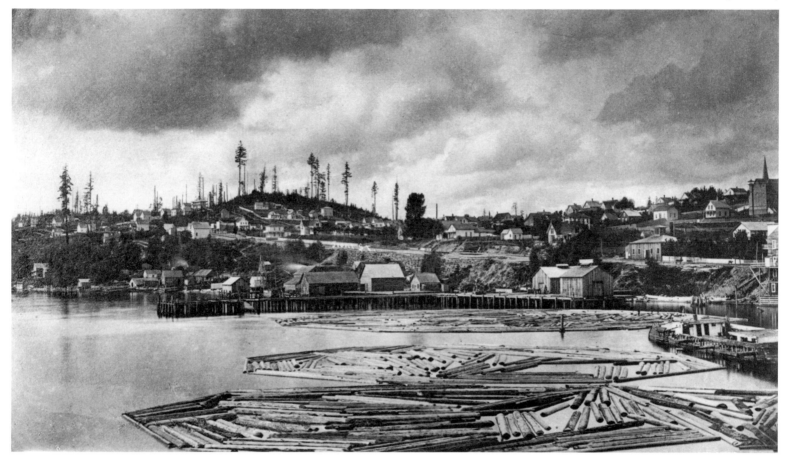

Seattle waterfront (ca. 1878)

Digging a trench in the bottom of
Black River to construct Cedar River
Pipeline No. 1 (1899)

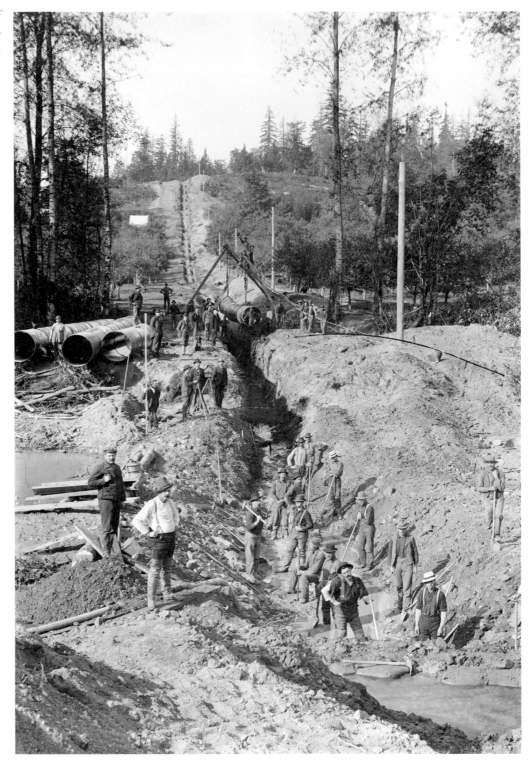

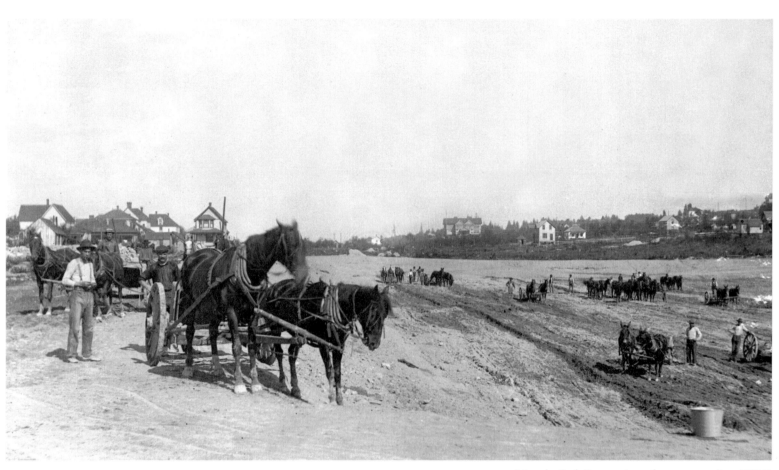

Lincoln Park Reservoir under construction (1899)

Leschi Park, Lake Washington Casino built by showman John Cort in 1890

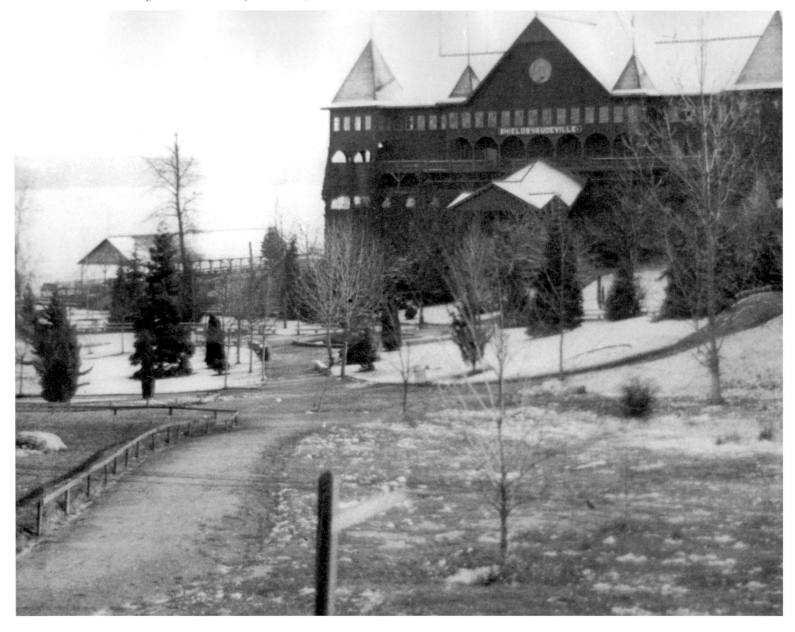

GOLDEN DECADES

1900–1919

Renewed prosperity sparked a development boom as cable car lines and electric street railways fanned out across the city. Many lines terminated in fanciful amusement parks intended to attract homebuyers to suburban neighborhoods. These included Golden Gardens in Ballard, Guy Phinney's Woodland Park resort and zoo near Green Lake, Madison Park baseball field and pavilion, Leschi Park, where cable cars connected with Lake Washington ferries, and West Seattle's Alki Beach natatorium and Luna Park.

Control of the city's streetcar system was consolidated in 1900 by the Seattle Electric Company, a tentacle of the national Stone and Webster cartel, and antecedent of today's Puget Sound Energy. Fear of this monopoly spurred development of a municipal utility, Seattle City Light, which tapped the hydroelectric potential of the Cedar River watershed in 1905.

The teeming harbor was flanked by a wooden "Railway Avenue" crowded with trains and trucks. To relieve some of the pressure, the Great Northern dug a railroad tunnel beneath the city, which terminated in a grand new King Street Station in 1906.

The downtown expanded north from Pioneer Square to fill the University of Washington's former campus. Workers flattened towering Denny Hill, long topped by the empty Washington Hotel, and cleared a vast swath of land from Pine Street to Lake Union for future development. The introduction of steel frame construction gave Seattle its first "skyscraper," the Alaska Building, in 1904.

Seattle doubled in land area in 1907 with the annexation of Ballard, West Seattle, and Southeast Seattle. The famed Olmsted Brothers were retained by Seattle in 1903 and again in 1908 to lay out an ambitious system of scenic boulevards, parks, and playgrounds to serve the city's burgeoning population, which reached nearly a quarter million by decade's end.

Under the leadership of such progressive leaders as engineers R. H. Thomson and Hiram Chittenden, Mayor George Cotterill, City Light superintendent J. D. Ross, and school superintendent Frank Cooper, the city built new utilities and schools, and paved roads for growing numbers of automobiles (the town's first, a Woods Electric, had arrived in 1900). The city's leading women founded Children's Orthopedic Hospital, a bicycle clerk named James Casey set up the forerunner of

UPS, and the city established a "Public Market" at Pike Place in 1907 so consumers could buy produce directly from local farmers.

Seattle celebrated its good fortune in the summer of 1909 by hosting its first "world's fair," the Alaska-Yukon-Pacific Exposition, on the new U.W. campus north of Portage Bay. Nearly 4 million visitors, including President William Howard Taft, paid a call.

With the support of women voters, who gained the vote in Washington in 1910 a decade ahead of the rest of the nation, progressives continued to push forward ambitious plans for social and physical improvements. Foremost among these was the creation in 1911 of the Port of Seattle, a public agency which took over control of the waterfront from private railroad and shipping companies.

That same year, Seattle staged its first "Golden Potlatch" summer festival. The 1912 event turned ugly when the offices of the Industrial Workers of the World, better known as "Wobblies," and other socialist groups were attacked by mobs whipped up by conservative Seattle Times' publisher Alden Blethen. It was a preview of more trouble to come.

Seattle continued to grow with the expansion of highways, streetcar lines, and neighborhoods. Major department stores were established downtown around the busy intersections of Westlake, 5th, and 4th avenues, and a complex of farmers' stalls and specialty shops formed around the original Pike Place Public Market. Skyscrapers multiplied downtown, but none came close to the new 42-story Smith Tower, which opened July 4, 1914, as the tallest building west of Ohio.

New heights were also reached on June 15, 1916, when William E. Boeing flew off Lake Union in his first airplane, the B&W float plane. If he celebrated the event with champagne, it was illegal: Washington had gone dry at midnight January 1, 1916, three years ahead of national Prohibition.

On July 4, 1914, more history was made on Lake Union as a long-held dream was fulfilled with the official dedication of the Government Locks at Ballard, which connected the fresh waters of Lake Union and Lake Washington with the saltwater of Salmon Bay, Puget Sound, and the Pacific beyond. The idea of such a canal had first been proposed by Thomas Mercer in a speech back in 1854—at the town's first 4th of July picnic.

America's entry into World War I fueled a temporary surge in shipbuilding and orders for Boeing airplanes, whose production shifted from Lake Union to a former shipyard, "the Red Barn," on the Duwamish River. The Armistice did not bring peace to the homefront as the city's restless and radicalized work force demanded better conditions and pay raises that had been deferred during the hostilities. In February 1919, a bitter shipyard strike boiled over into the nation's first true general strike, which shut the city down for a week before collapsing in disarray. Fearing a local version of Russia's 1917 Bolshevik Revolution, local and national authorities clamped down on "Reds" everywhere, and the labor movement would not fully recover until the 1930s.

Endolyne Park (Fauntleroy) (1900)

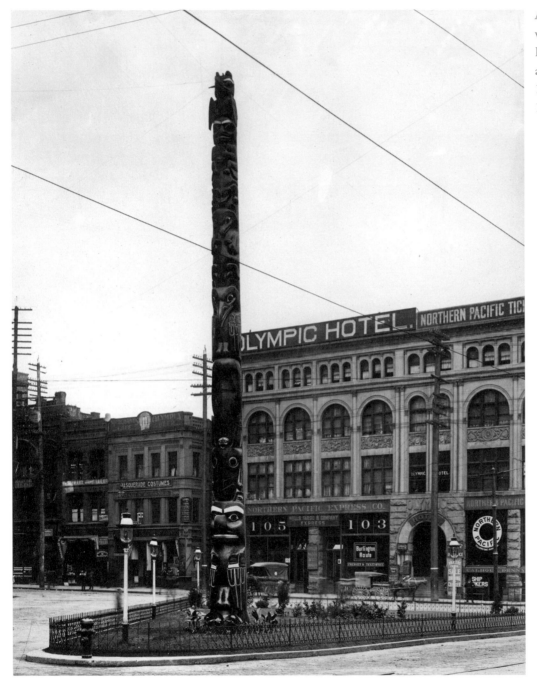

A Tlingit totem pole was erected at Pioneer Place, First Avenue and Yesler Way, in 1899 (shown here in 1904; since replaced).

Madison St. Pavilion, Madison Beach (1900)

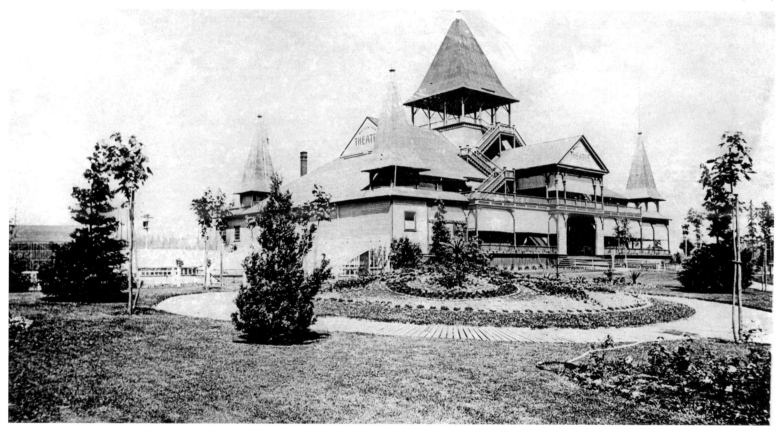

Bicycle path near Fort Lawton that later became Magnolia Blvd. (1900)

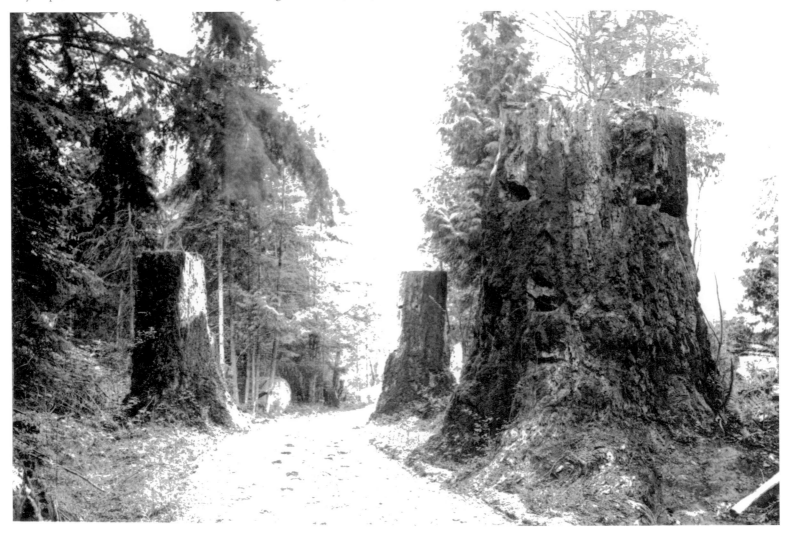

"Indian" encampments at
Leschi

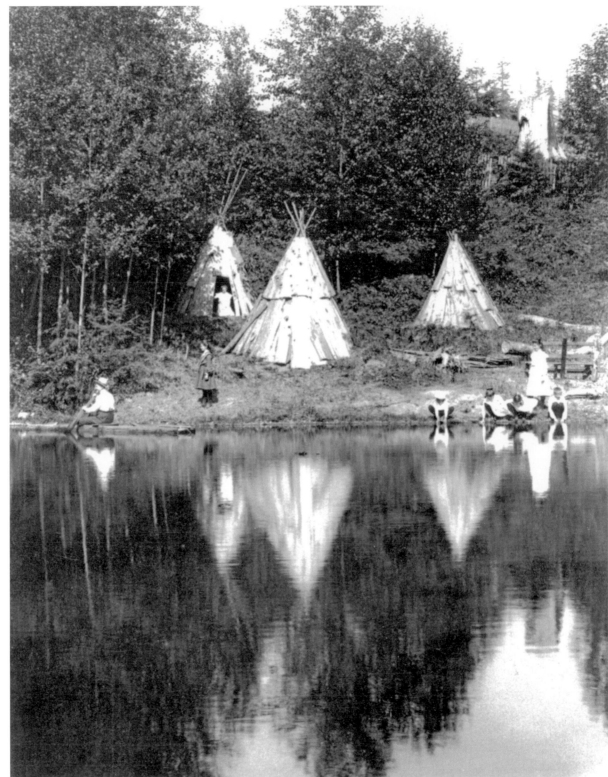

Construction of the Great Northern Railroad tunnel beneath downtown Seattle (1903)

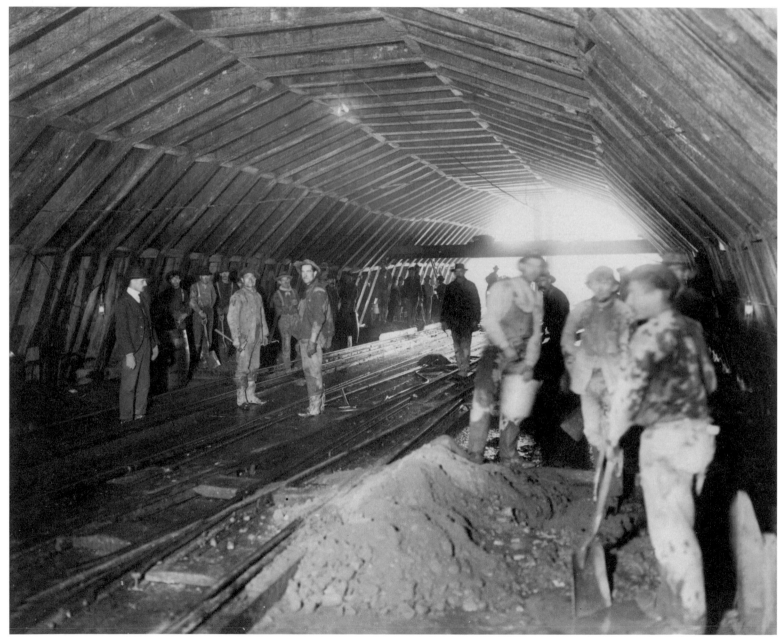

Lake Washington, Madison Park, May 1903

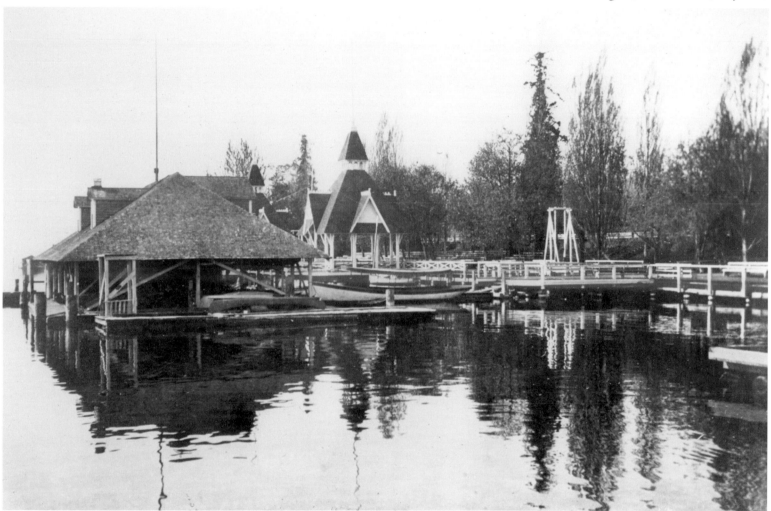

Leschi Park (1906)

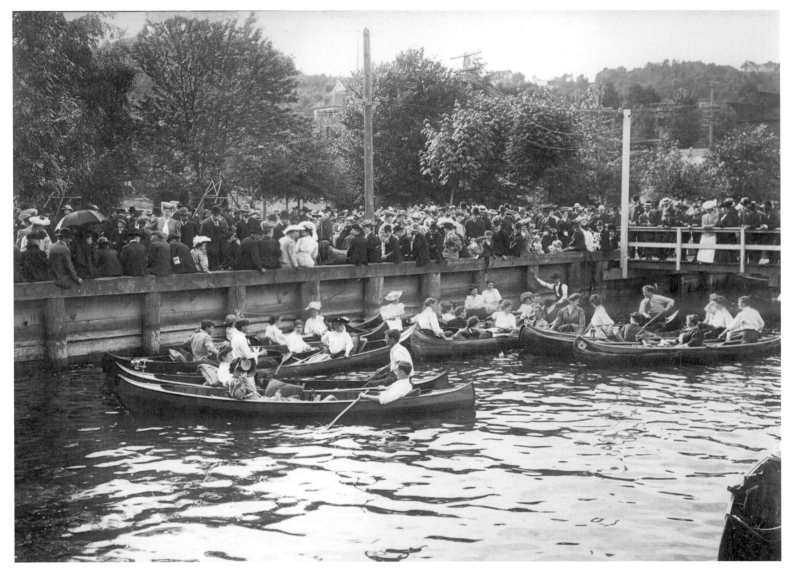

Indoor Pools—Power's Bath House and Natatorium (1907)

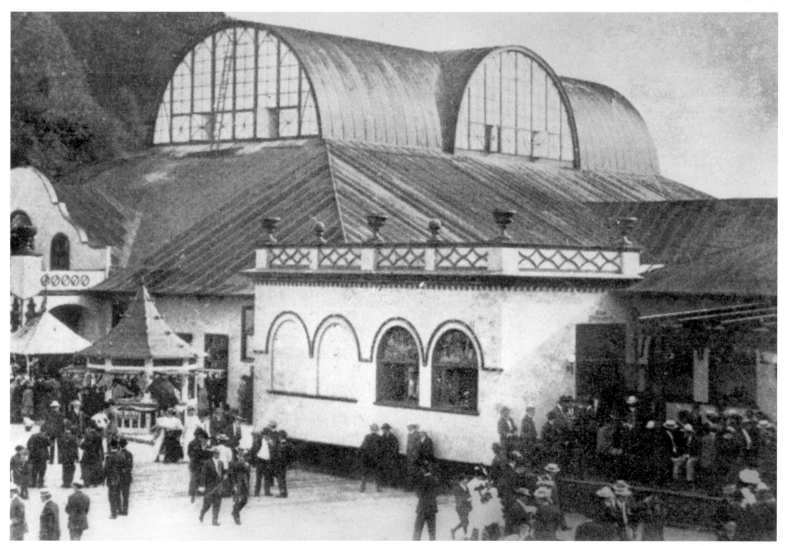

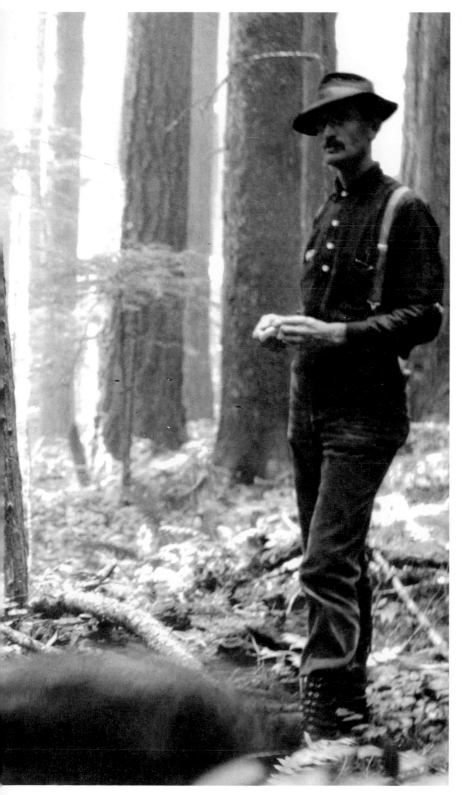

Gigantic merry-go-round with German carousel at Luna Park in West Seattle

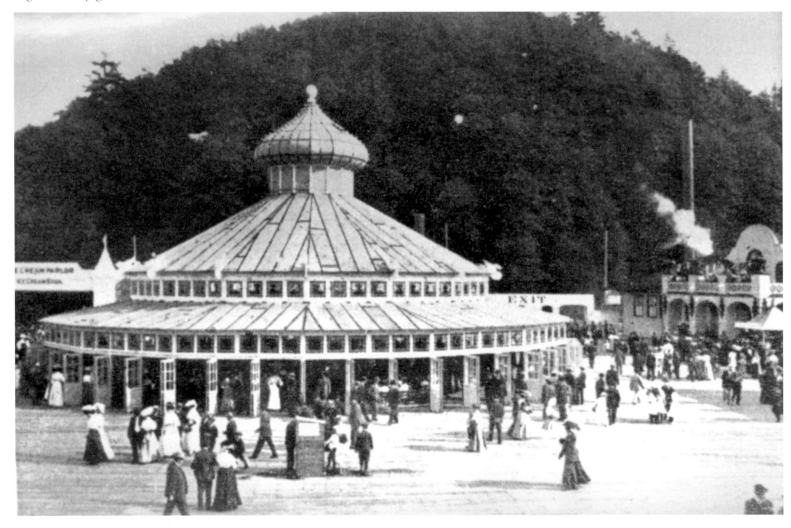

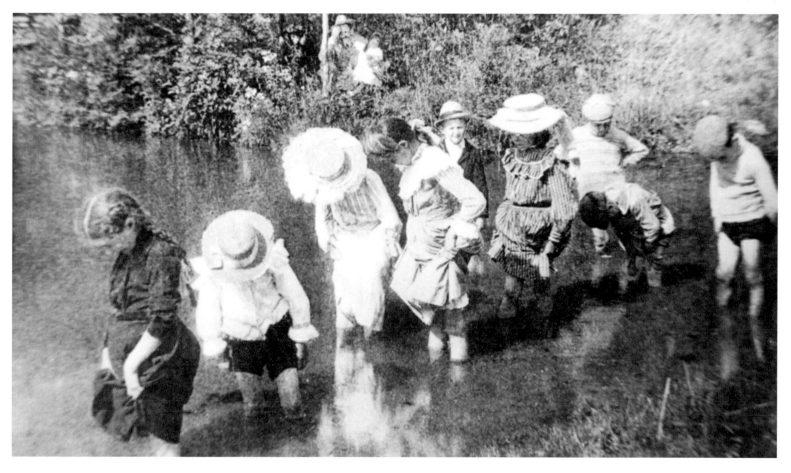

Engine House No. 25 at E. Union
Street (1910)

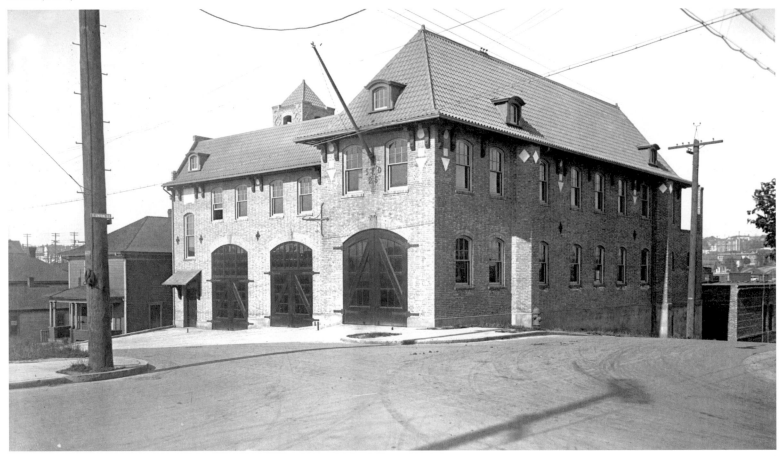

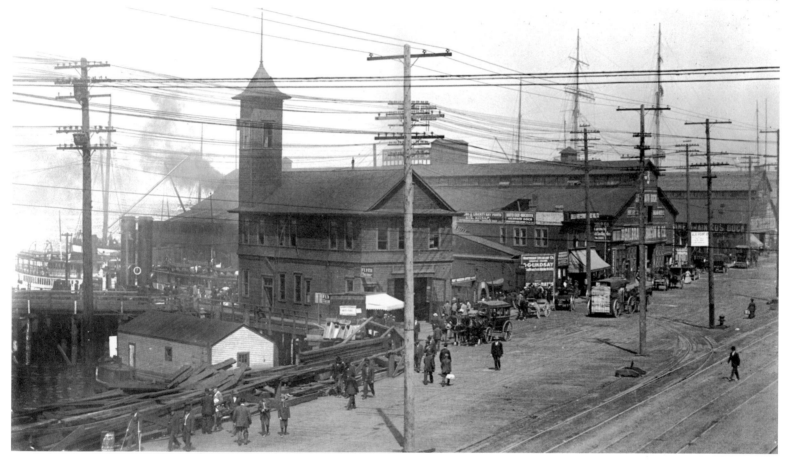

Woodland Park (1910)

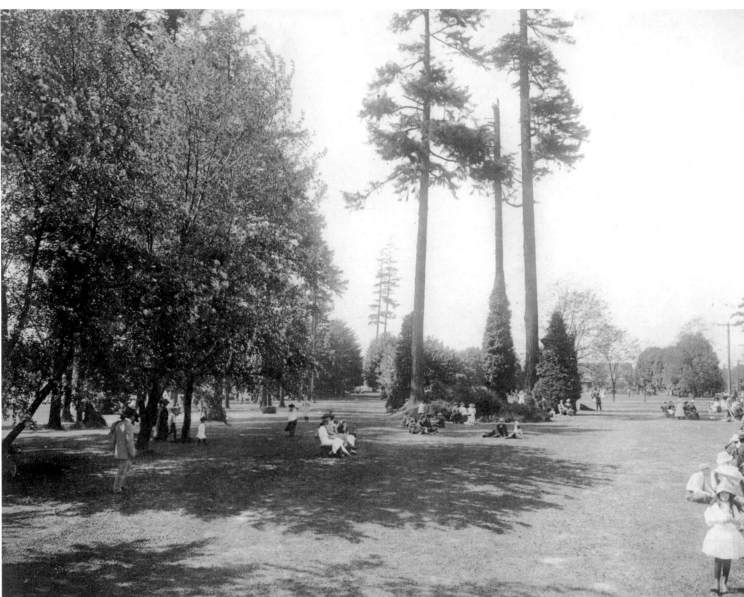

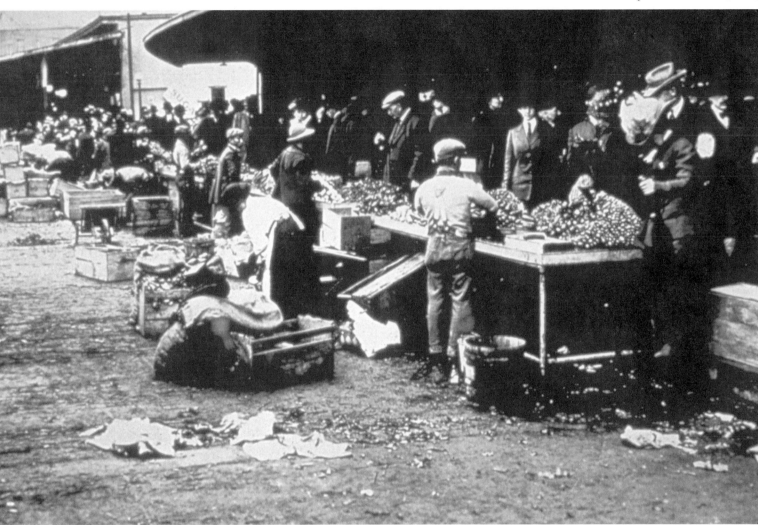

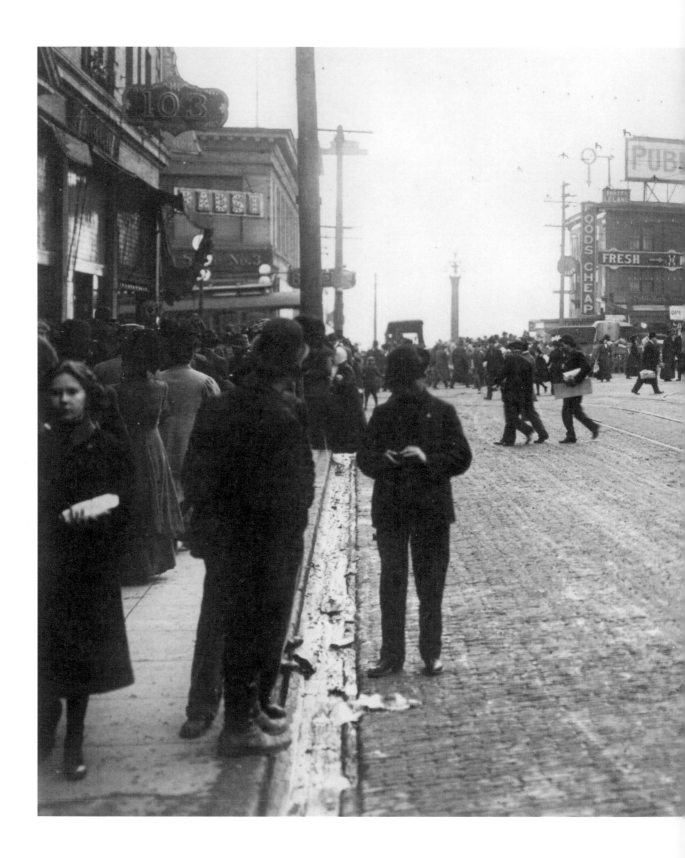

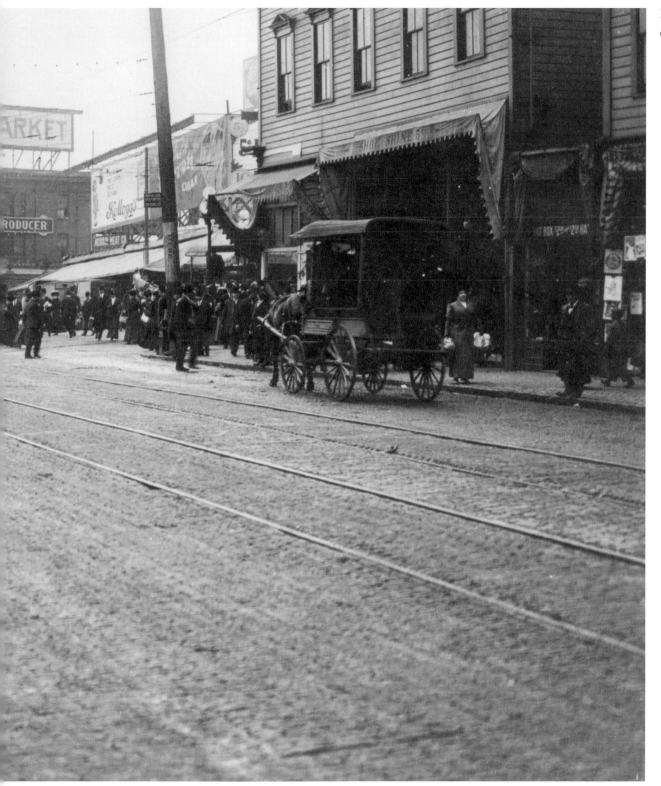

Pike Place Market looking west down Pike Street (1910)

Fire Department Headquarters at Columbia Street between 6th and 7th avenues (1910)

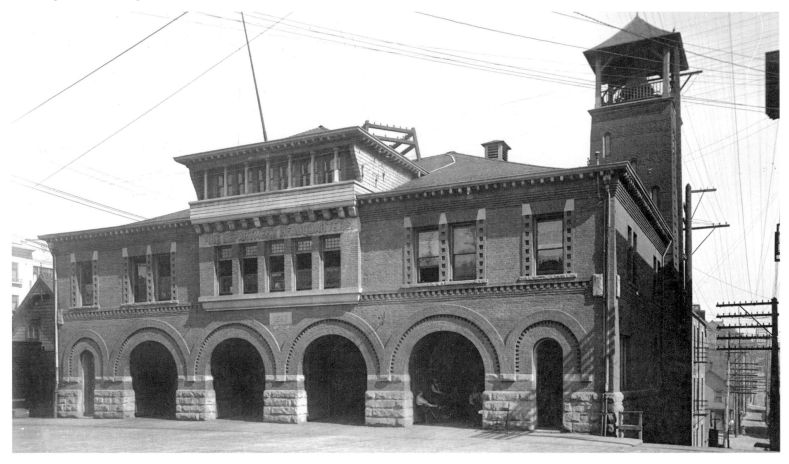

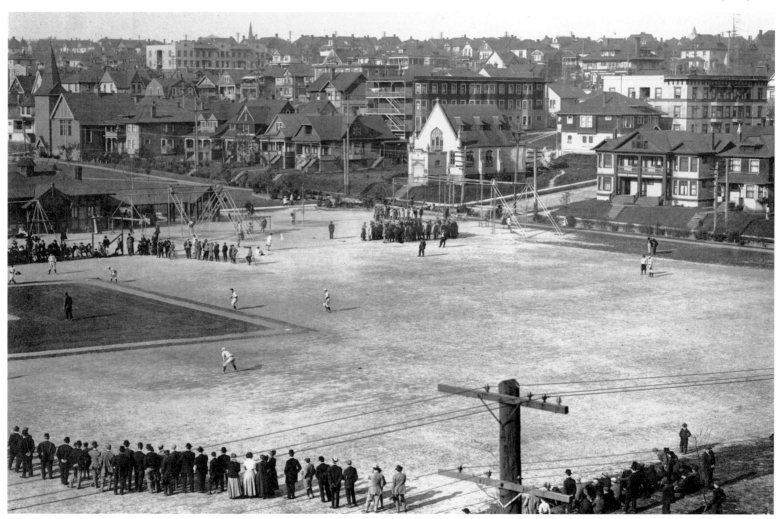

Engine House No. 8 and stand pipe on Queen Anne Hill

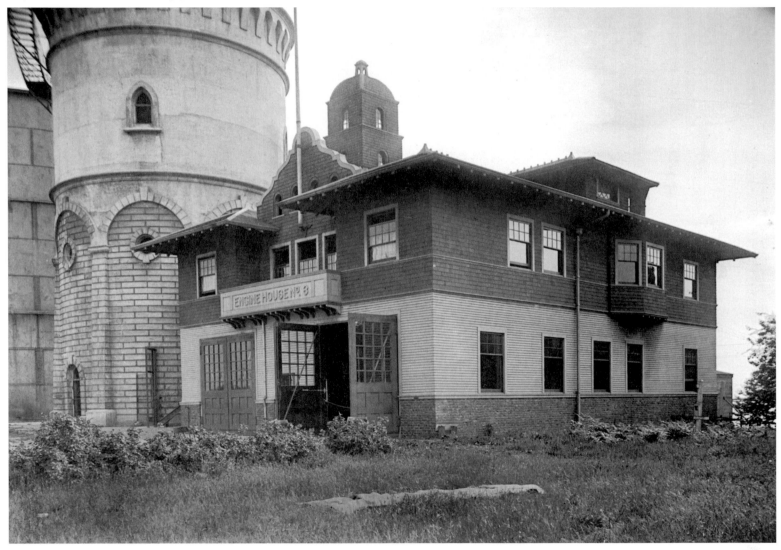

Waterfront Fire Station with fireboats *Snoqualmie* and *Duwamish* (1910)

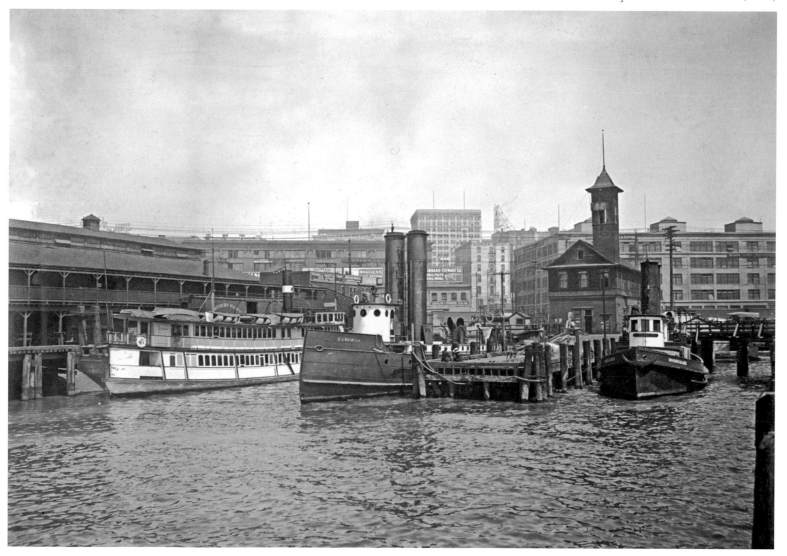

Schmitz Park (1910)

Pike Place, Corner of Pike St., Pike Place, and First Ave. in 1910, before erection of Corner Market Building

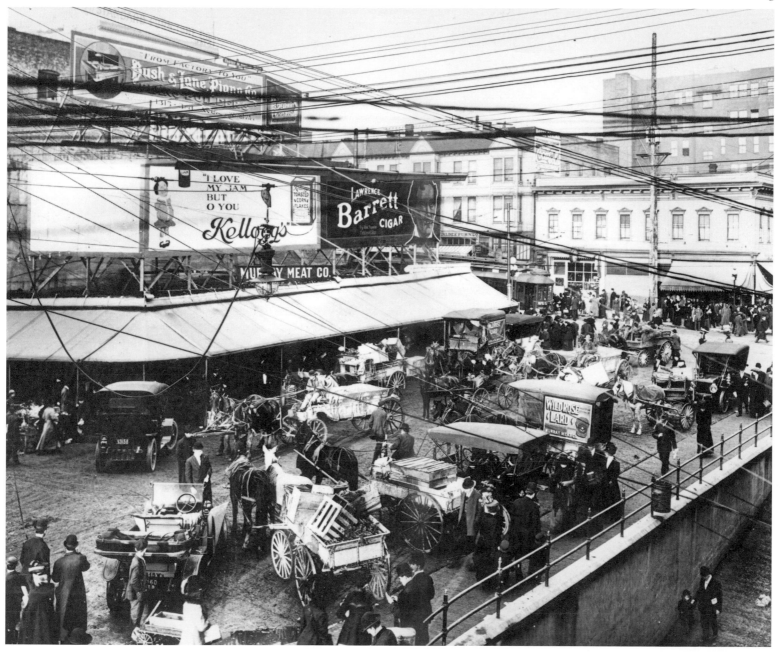

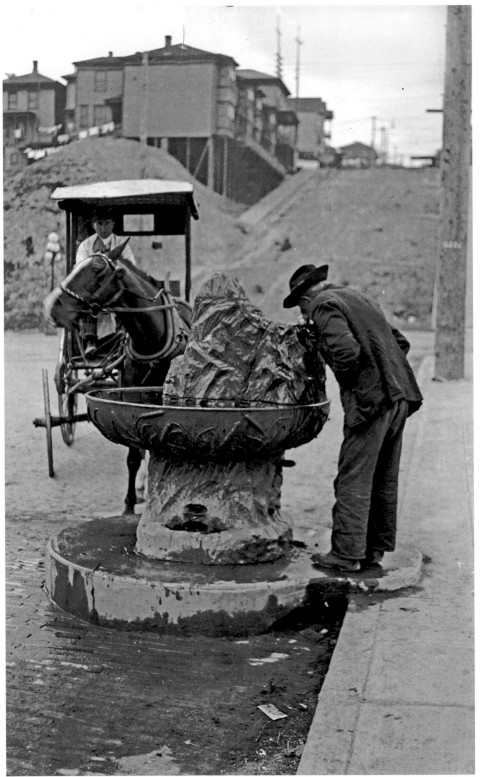

New-style drinking fountain, 7th and
Jackson (1911)

Playground units in the First Golden Potlatch Parade (1911)

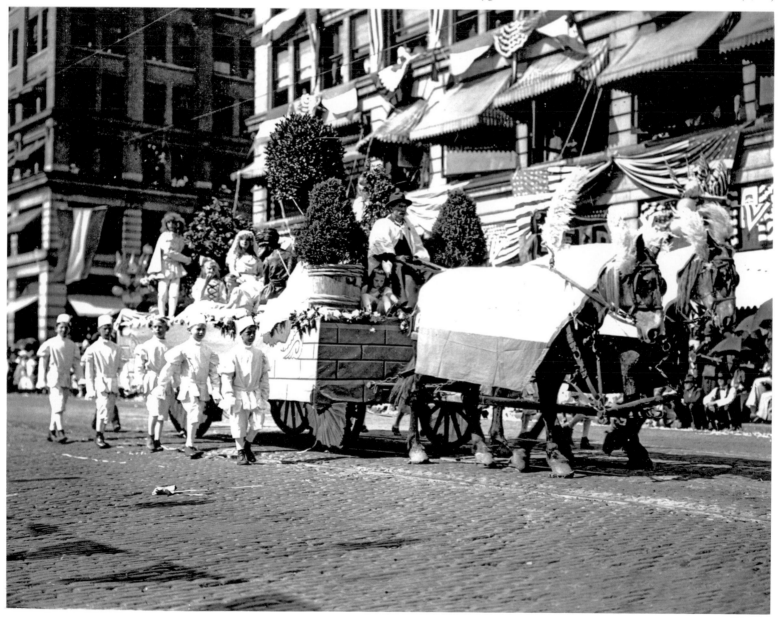

Playground units in the First Golden Potlatch Parade

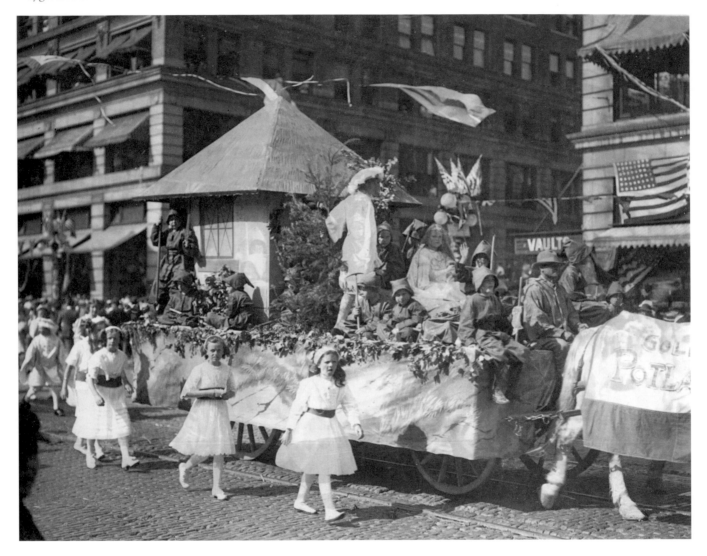

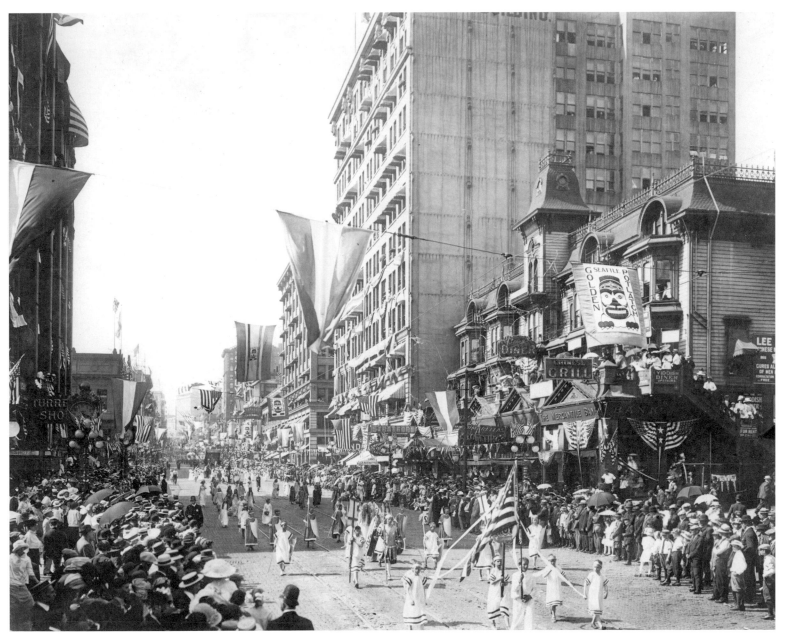

Bathing at Alki Beach (1911)

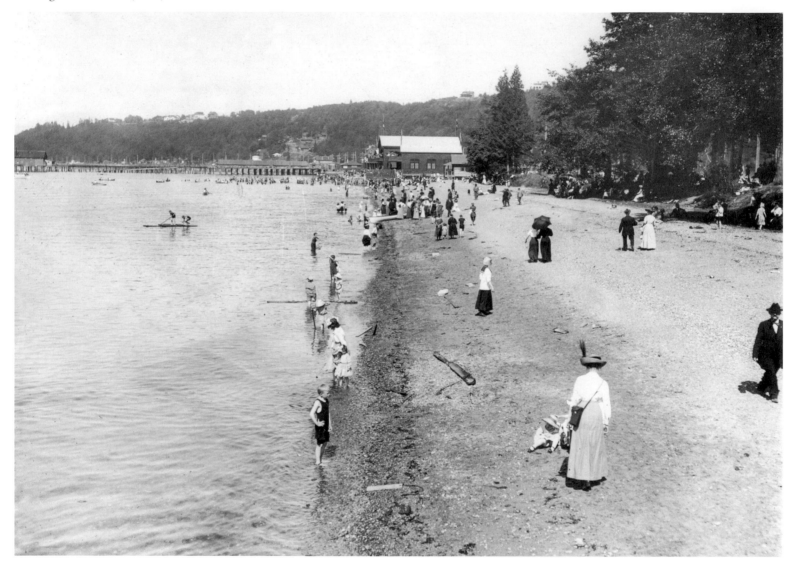

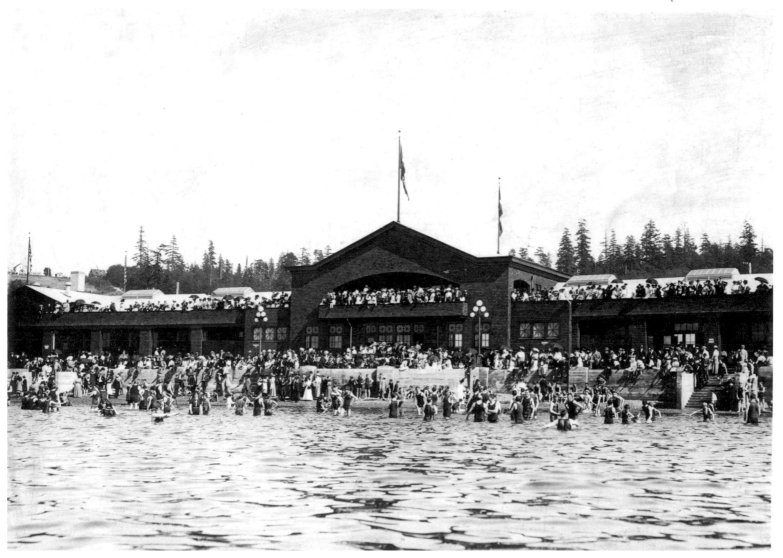

Bathhouse and pavilion, Alki Beach

Alki Beach

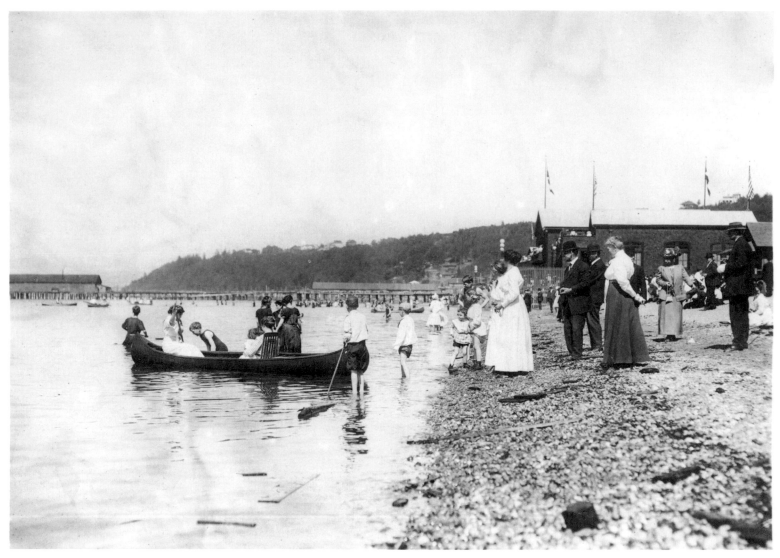

Interlaken Boulevard, just south of Seattle Preparatory. The University of Washington campus and buildings are just across the bay. (1911)

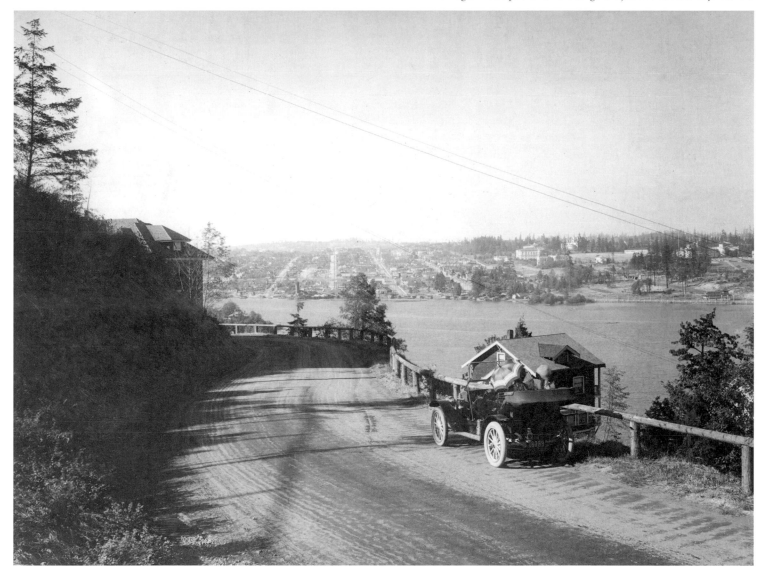

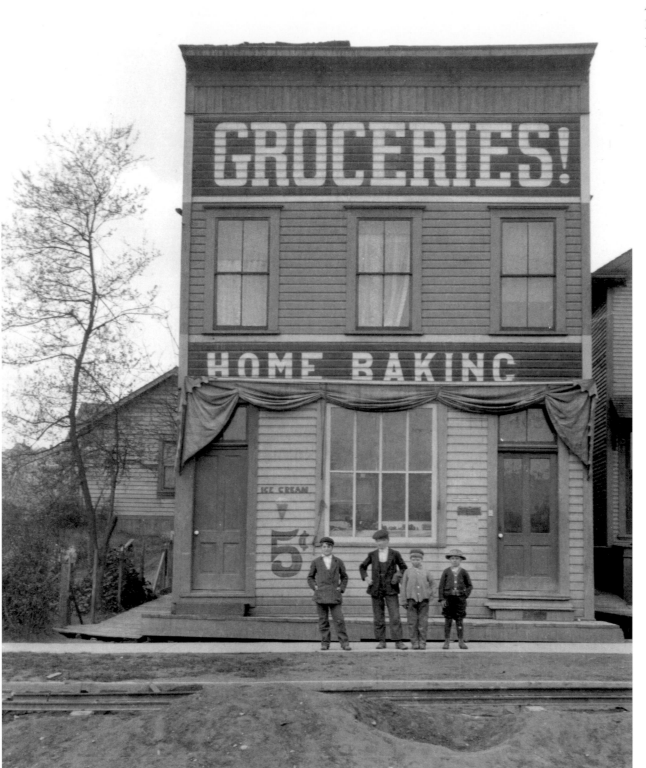

A grocery store at
Dexter Ave. and
Harrison St.

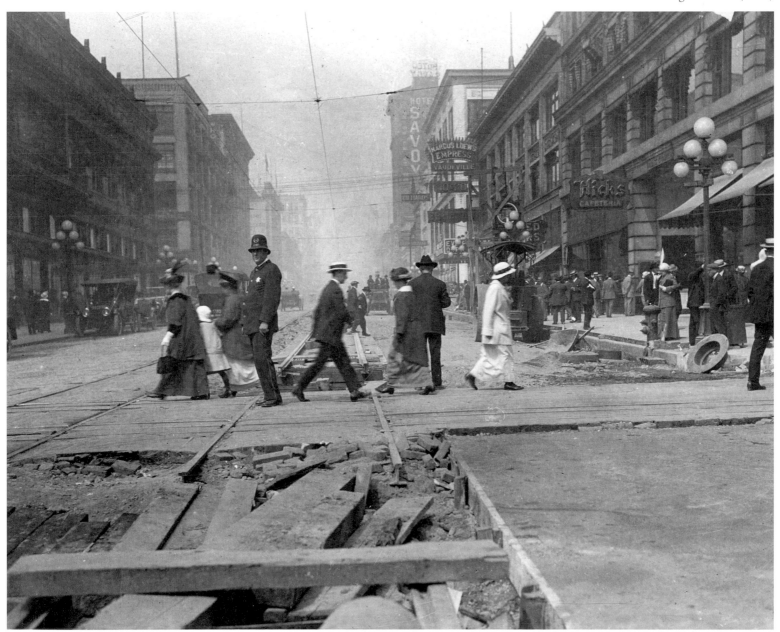

Northern view of 2nd Avenue from Madison Street showing the regrade work (1914)

Meter Testing Room, Seattle Lighting Company (1913)

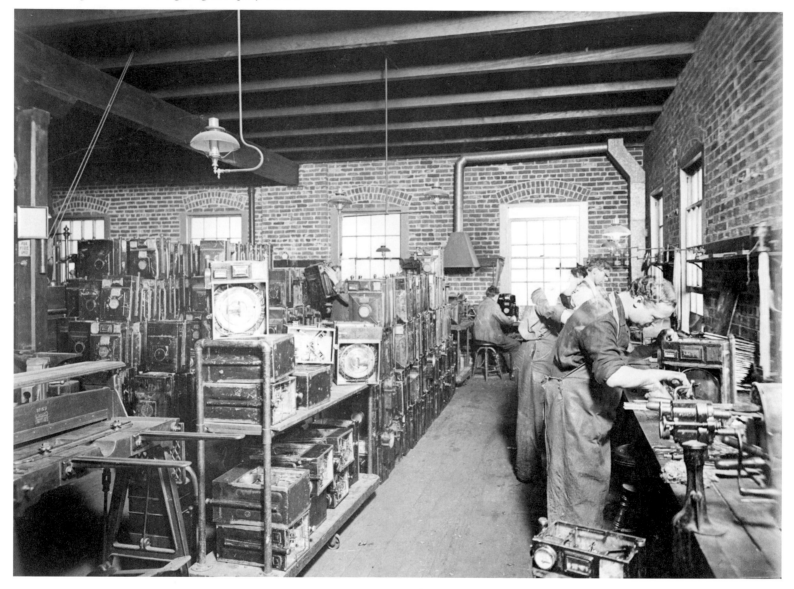

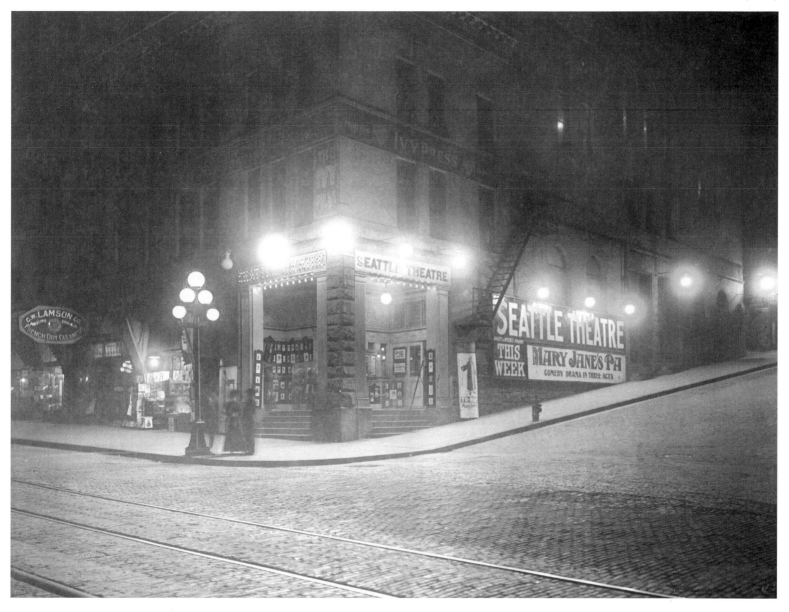

Three men on a small engine on a track at Masonry Dam. The sign reads "The Municipal Light and Power Plant of Seattle America's Best Lighted City 40 miles."

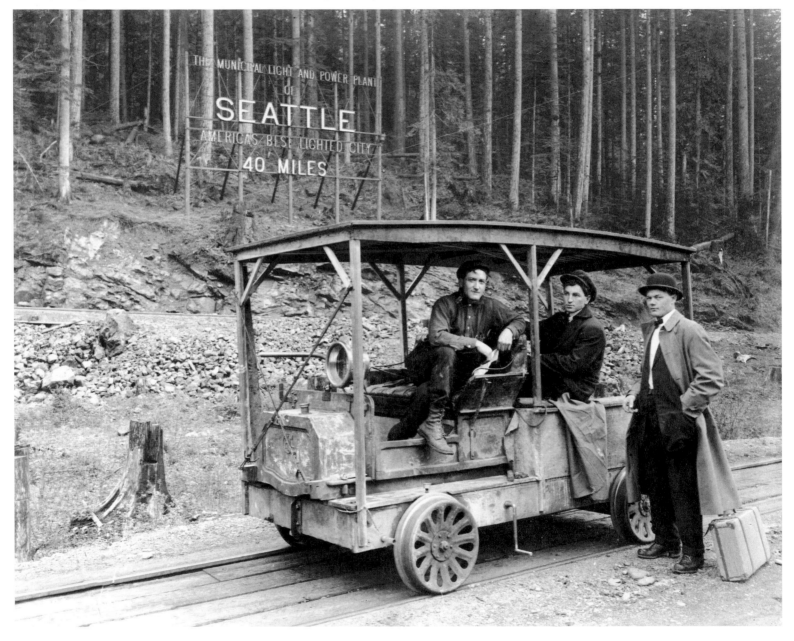

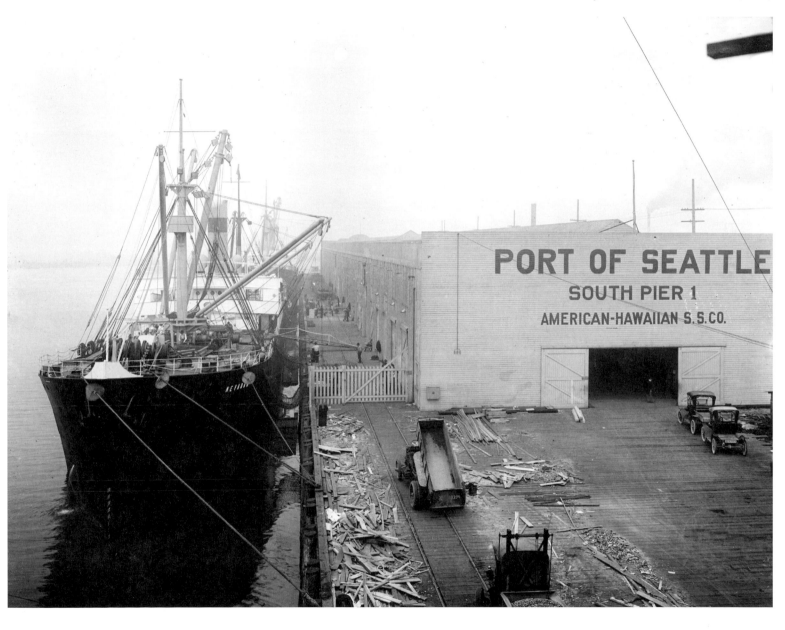

Workmen repave Second Avenue in this scene looking north
across University Avenue. (1914)

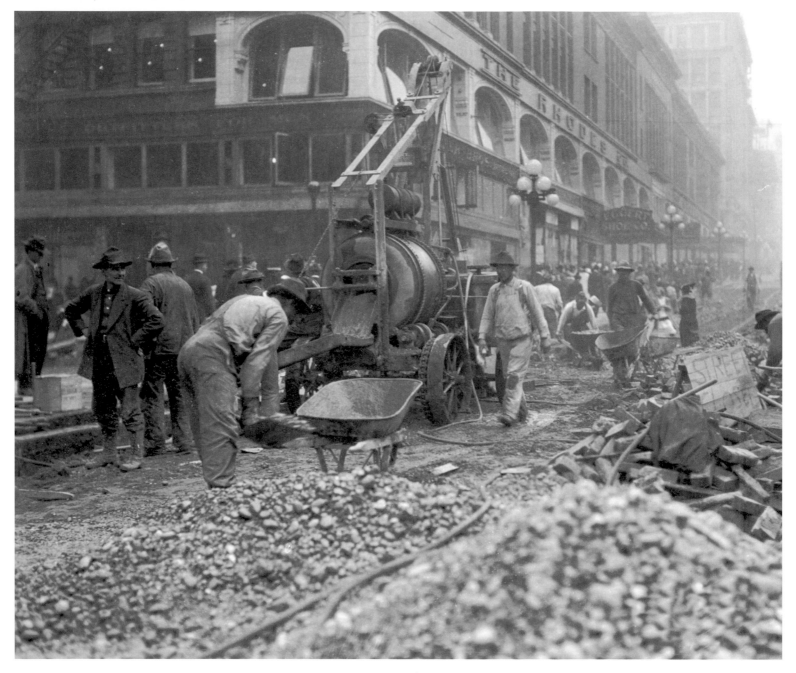

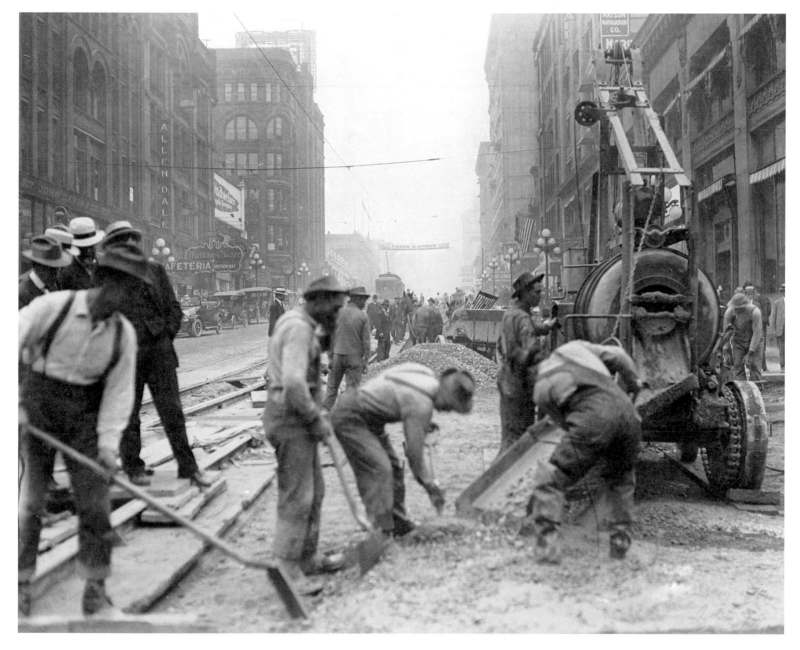

Repaving Second Ave. at the intersection of Columbia

Joe Desimon in Desimon Bros. & Co. produce truck (1915)

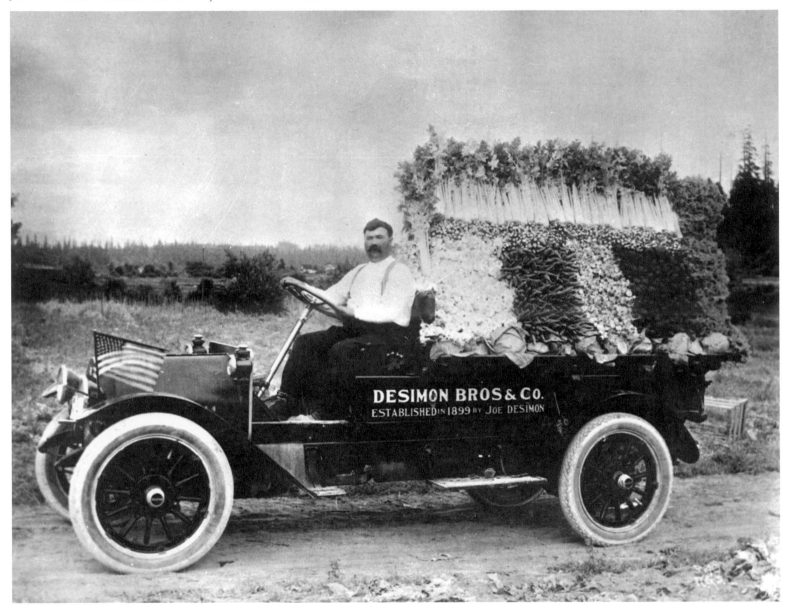

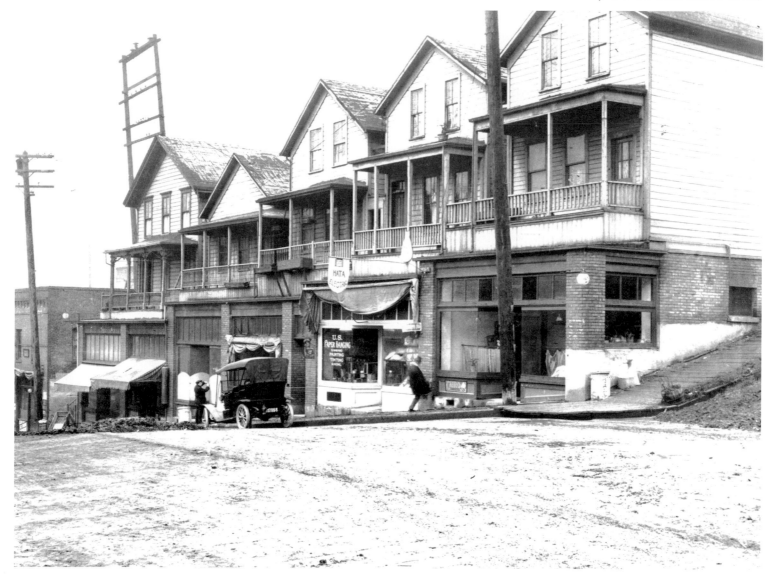

Southeast corner of Maynard Ave. and Main St. (1915)

East Waterway Terminal, Hanford Street Terminal

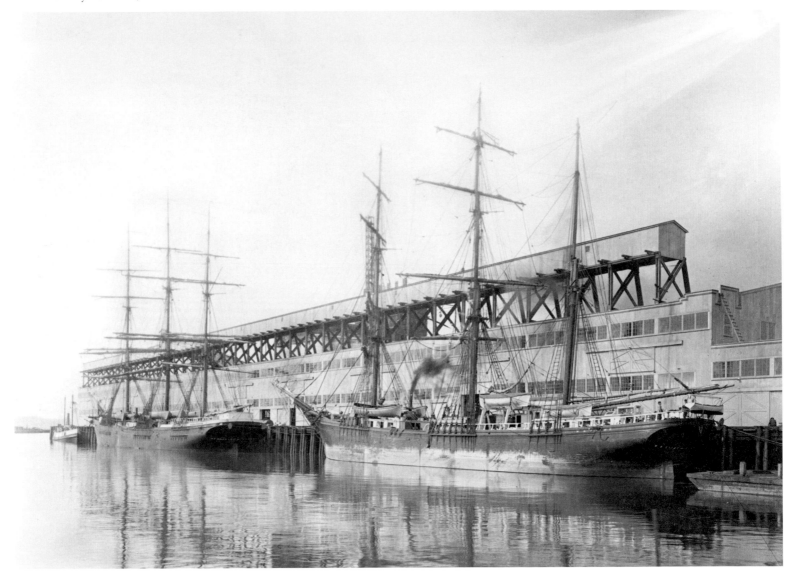

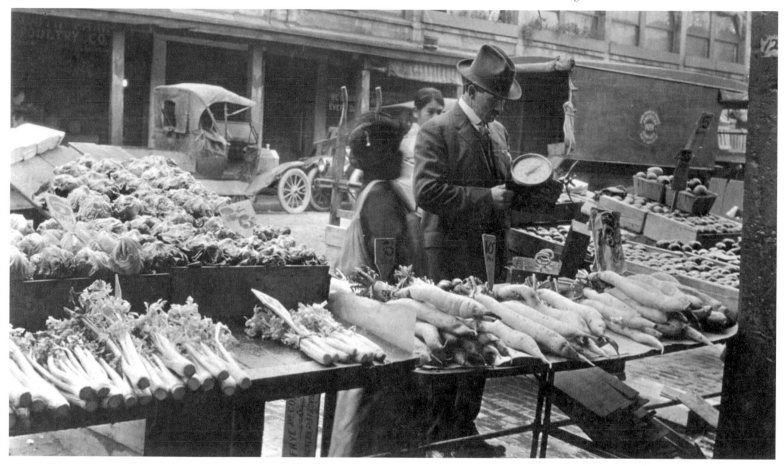

Workers paving the Fremont Avenue Bridge (1917)

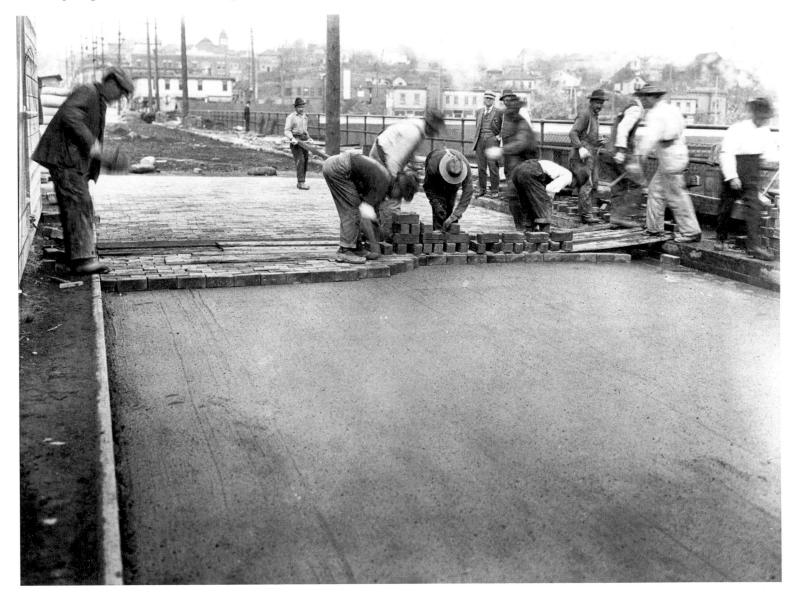

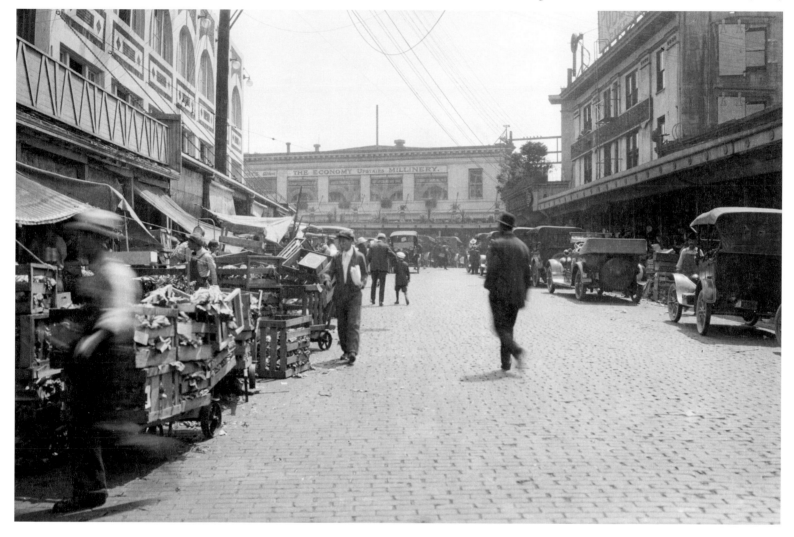

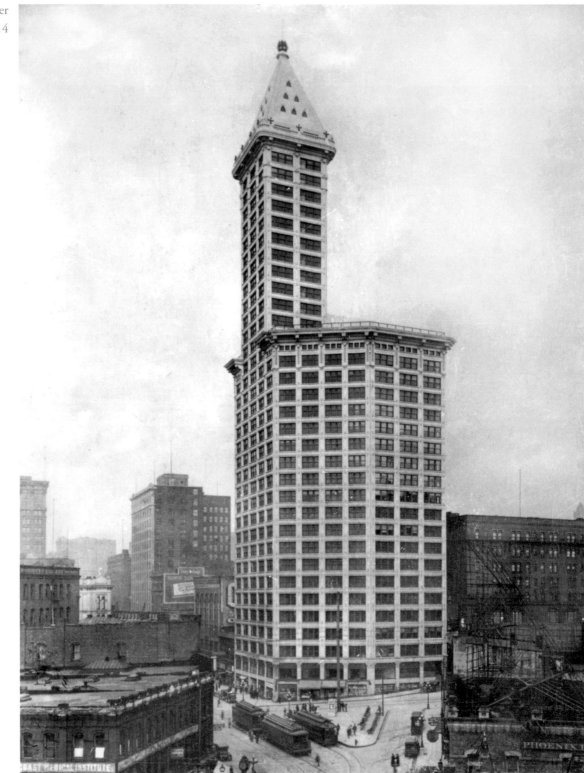

Smith Tower at 2nd Ave. and Yesler
Way, soon after opening in 1914

BETWEEN THE WARS

1920–1939

The private economy roared during the 1920s with expanding Pacific trade. Famed "silk trains" speeded Chinese fabrics from Seattle's harbor to the Eastern mills, and Japan became an eager customer of American steel and resources. New Seattle City Light dams turned the rapids of the Skagit River 90 miles north of the city into electricity for new skyscrapers and factories. The potential for growth seemed infinite as the city census approached 365,000 residents.

Then came October 29, 1929. The Great Depression hit Seattle fast and hard. Foreign trade shriveled, idling the port, and orders for new ships and aircraft evaporated. Downtown construction halted in 1930, and a major new building would not rise for nearly 20 years. More than one thousand unemployed men built a shantytown on an abandoned shipyard south of Pioneer Square. They named it "Hooverville" after President Herbert Hoover.

The state government accelerated road construction to provide relief, and opened the spectacular Aurora Bridge across the Ship Canal in 1932. The end of Prohibition in 1933 brought relief of a different kind, and brewer Emil Sick built the city a new baseball stadium to showcase a team named the Rainiers after his popular beer and a certain mountain.

Franklin Roosevelt's New Deal delivered more help and employed thousands to build new parks, highways, housing projects, and other public improvements. The waterfront's rickety and perilous wooden-planked Railroad Avenue was filled in with soil and sealed with a new seawall, and the world's first floating concrete bridge opened across Lake Washington between Seattle and Mercer Island in 1940. Federal funds also financed the replacement of Seattle's aging streetcars with modern buses and electric "trackless trolleys."

Darkening war clouds over Europe and Asia had silver linings for local shipyards and for Boeing, which introduced its new B-17 bomber in 1936. Civil aviation also boomed thanks in large part to new Boeing aircraft such as the world's first modern airliner, the Model 247, the "Boeing Clipper" flying boat, and the high-altitude "Stratocruiser."

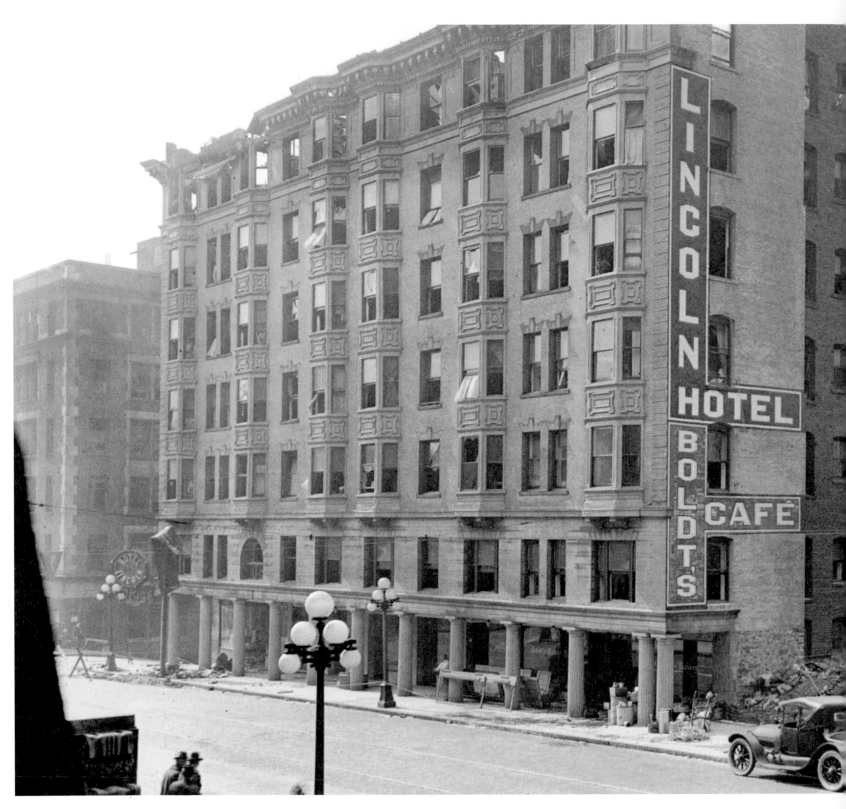

Lincoln Hotel between Third and Fourth on the north side of Madison

Produce and meat vendors

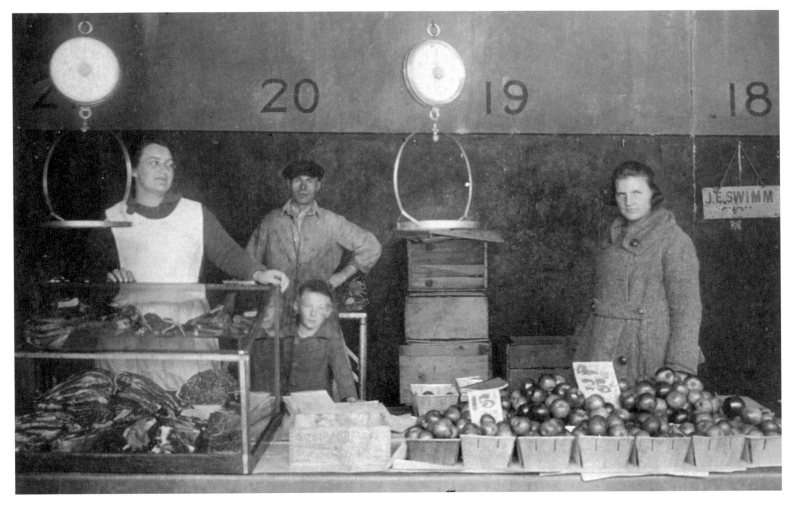

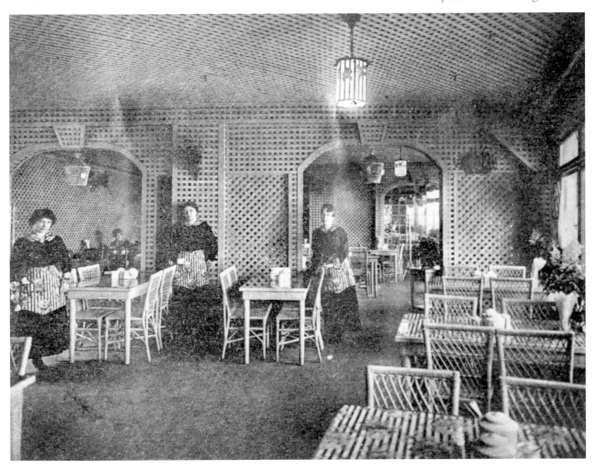

Women working in Crescent Manufacturing Company (1920)

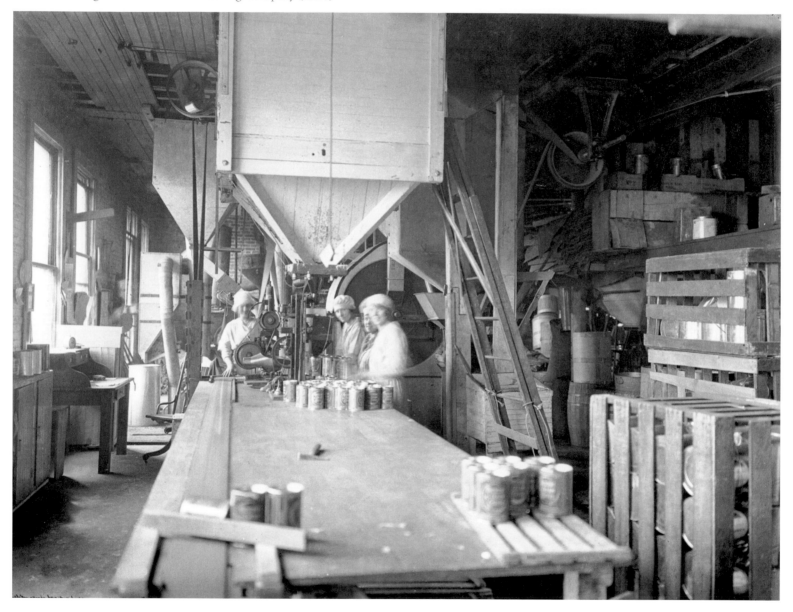

The Figure Eight in Mt. Baker Park Boulevard (1920)

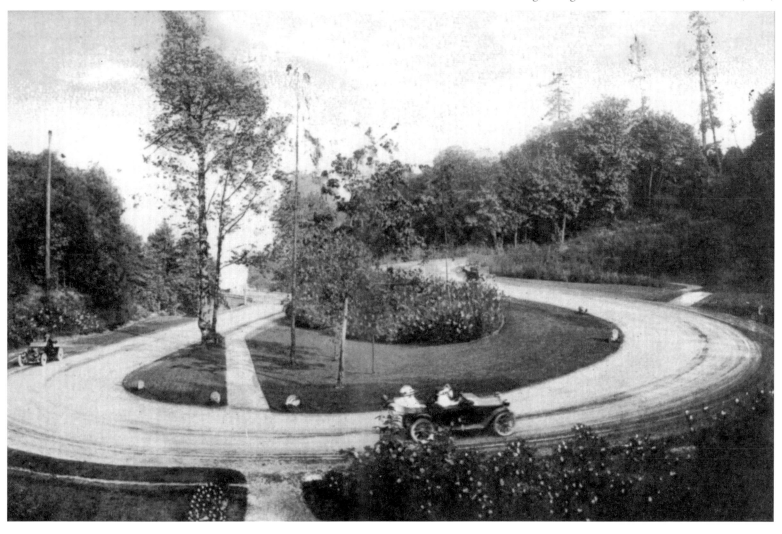

Harbormaster's dock at foot of Washington St. (ca. 1930)

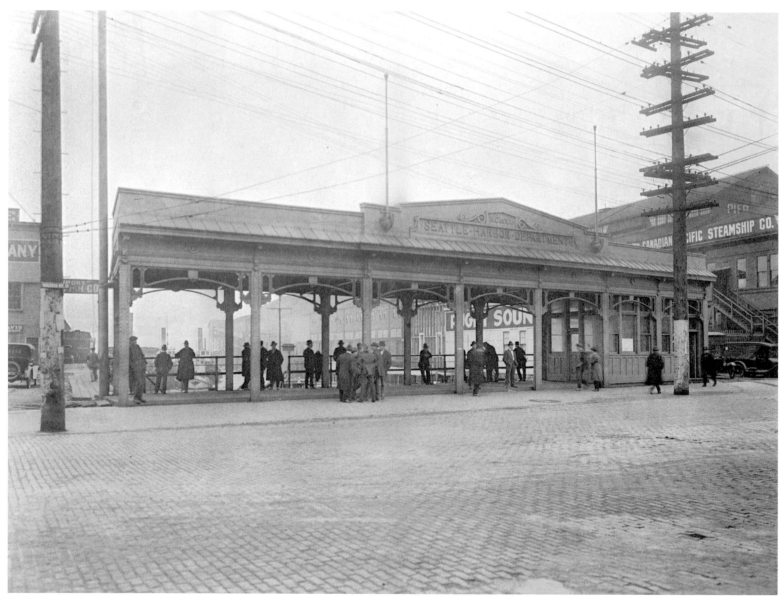

Pike Place looking north

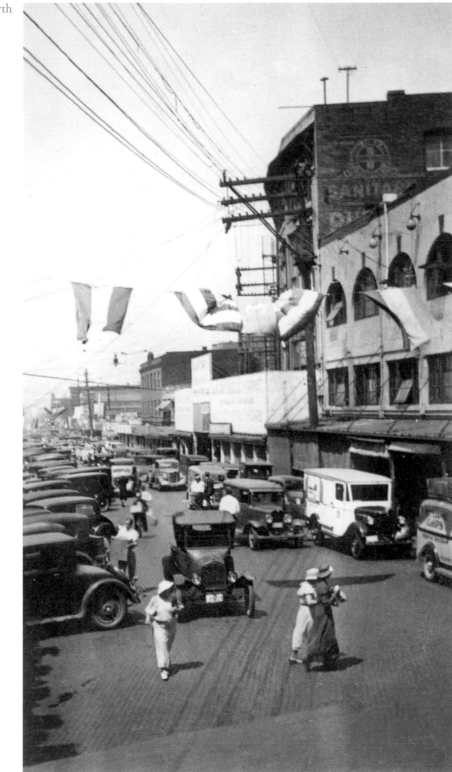

A view down Western Ave. showing construction of the addition to Main
Market and bridges

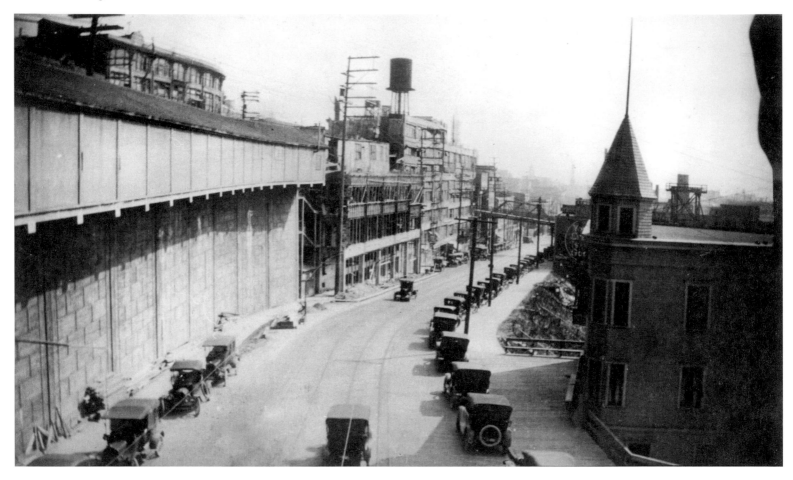

Seattle Public Safety Building (center) on Yesler Way ca. 1920. Tower on left is old King County Courthouse.

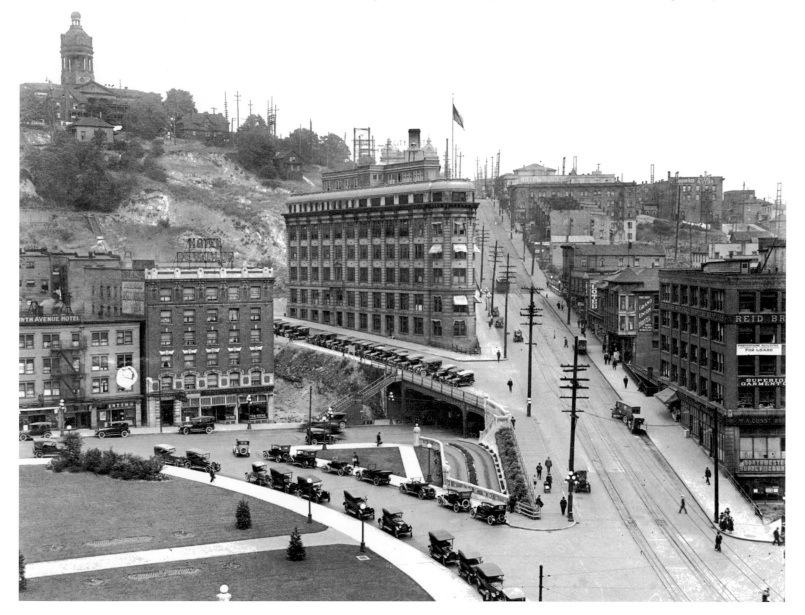

Removing snow from streets of Seattle
following the storm of February 14, 1923

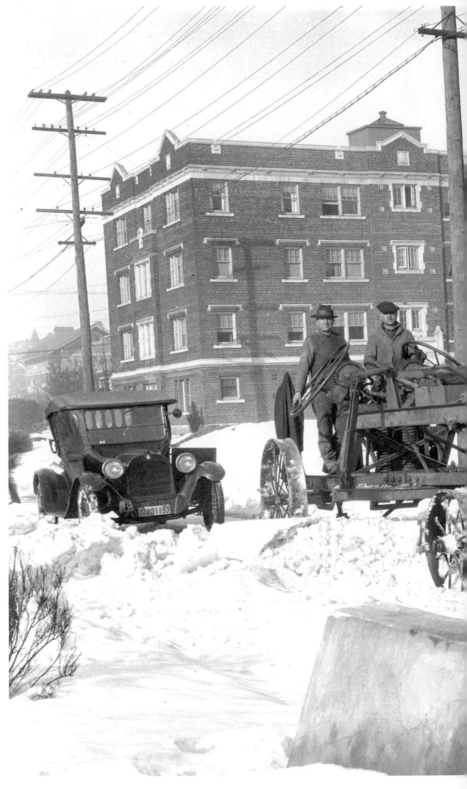

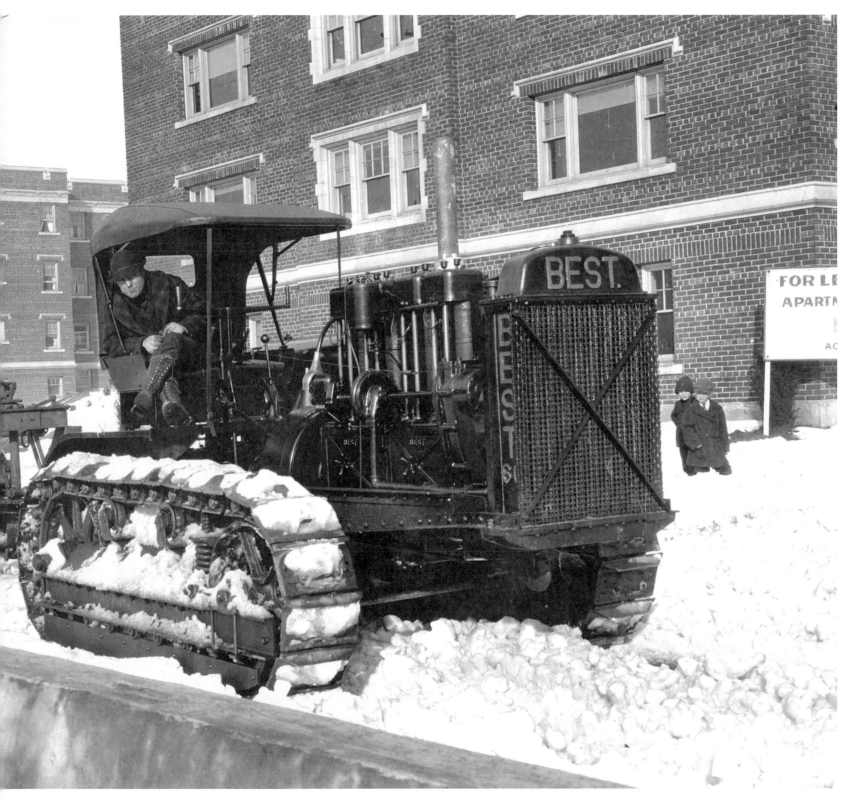

Heavy snowfall required heavy lifting.

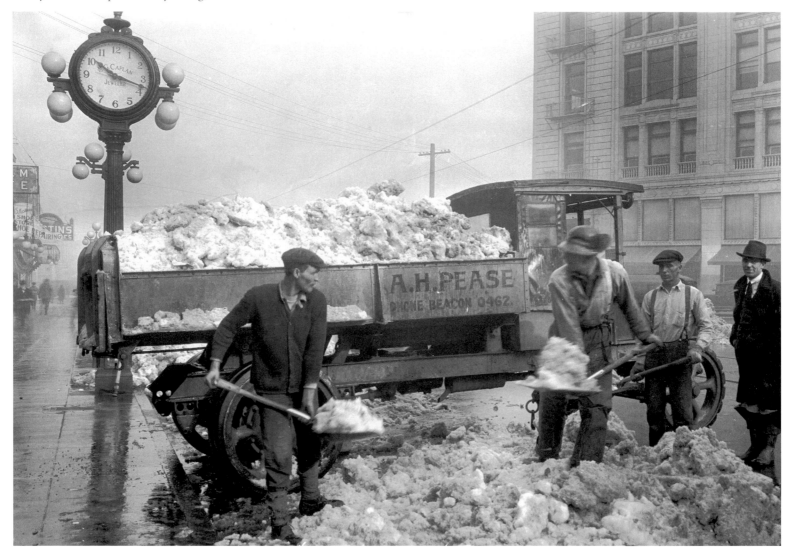

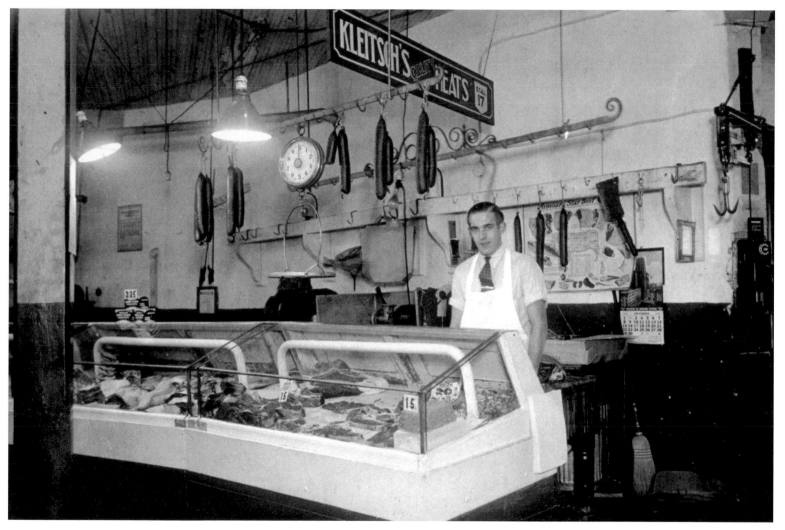

Ben Evans ("Old Woody") and gang at Rogers playfield (1924)

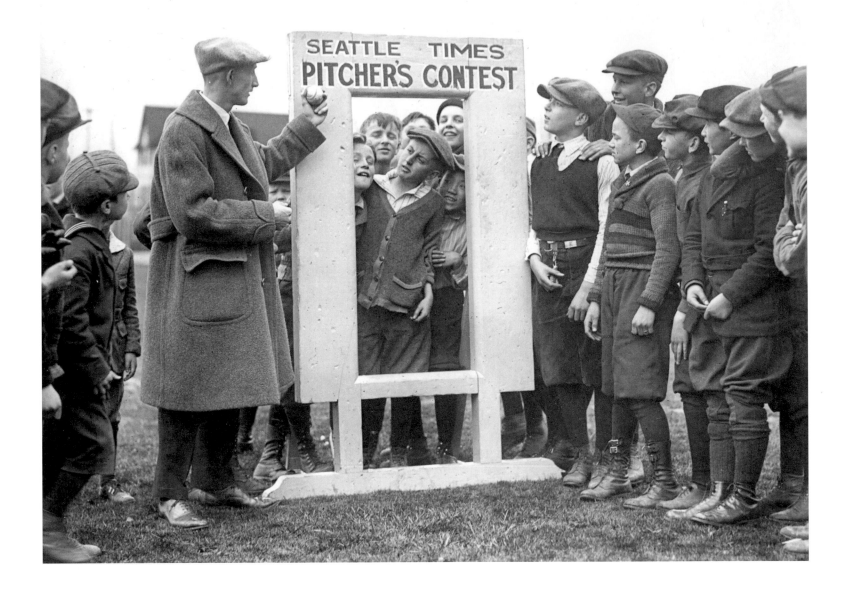

Onlookers of auto accident at Railroad Avenue on the Port of Seattle (1925)

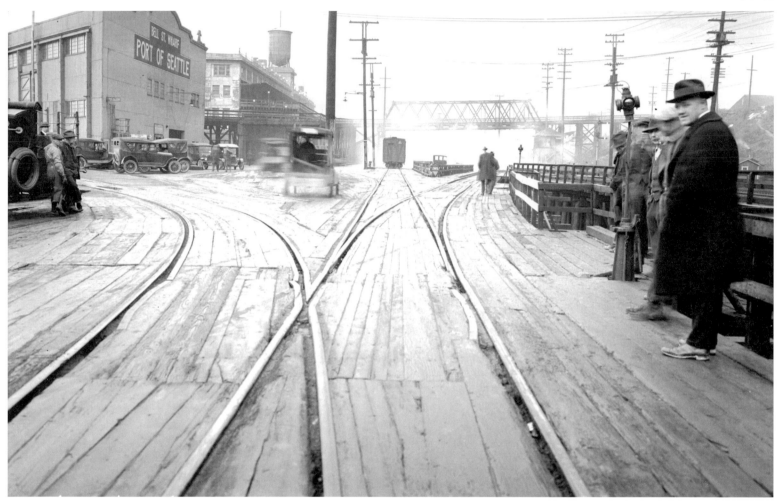

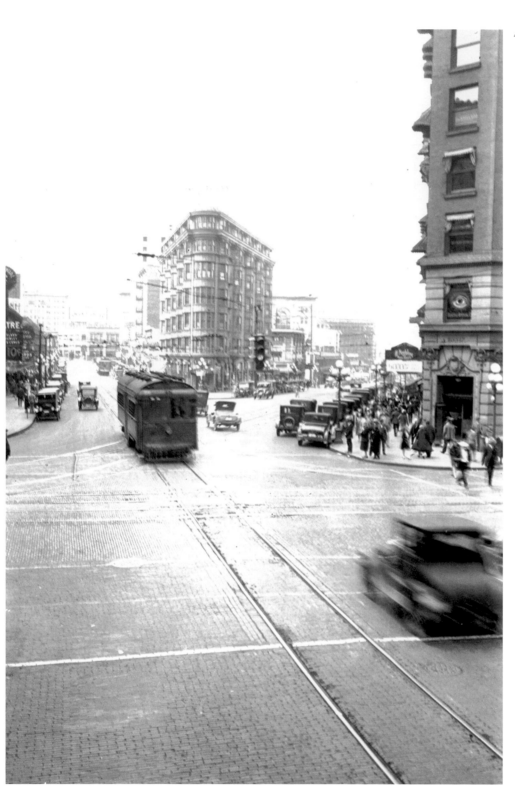

Special newsstand at southwest corner of 4th
Ave. and Pike St.

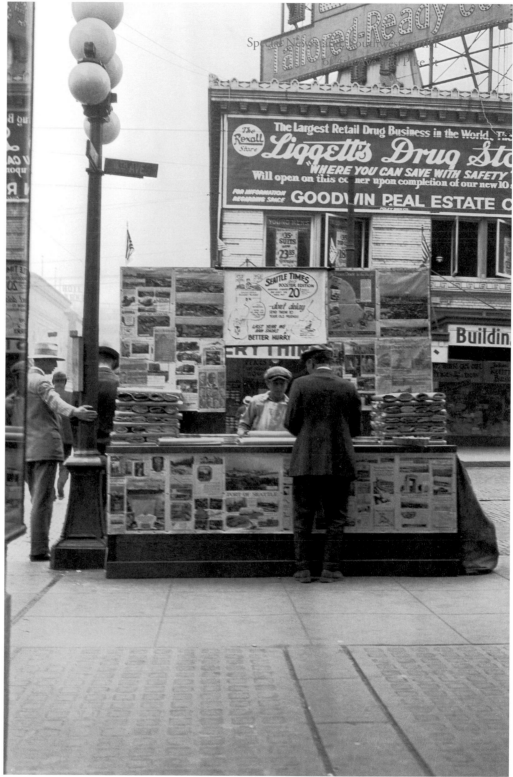

Main Arcade, Pike Place Market

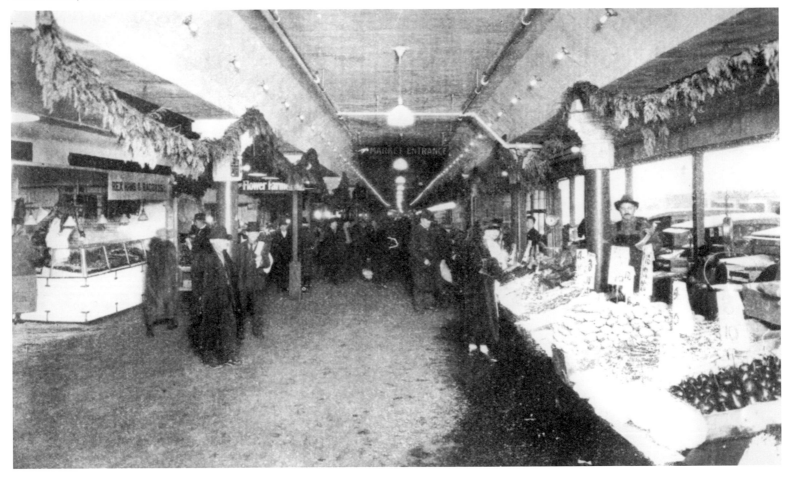

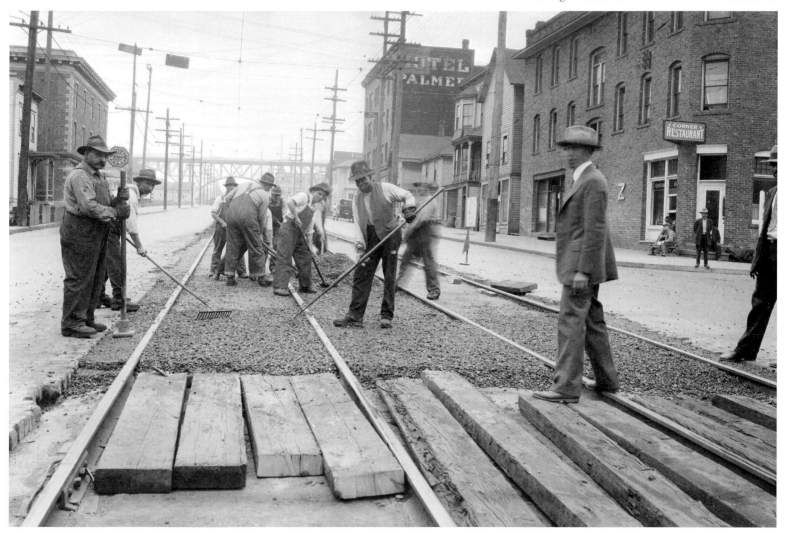

Placing Amiesite at 7th Ave. S. and Dearborn St.

Western Ave. side of Pike Place Market's main building

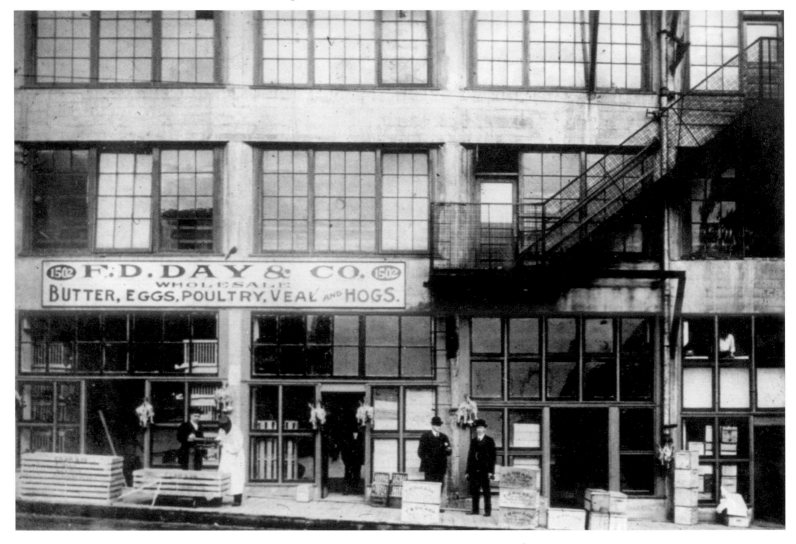

Steel-post and red-headed beacon safety island at 10th Ave. N. and E. 40th St.

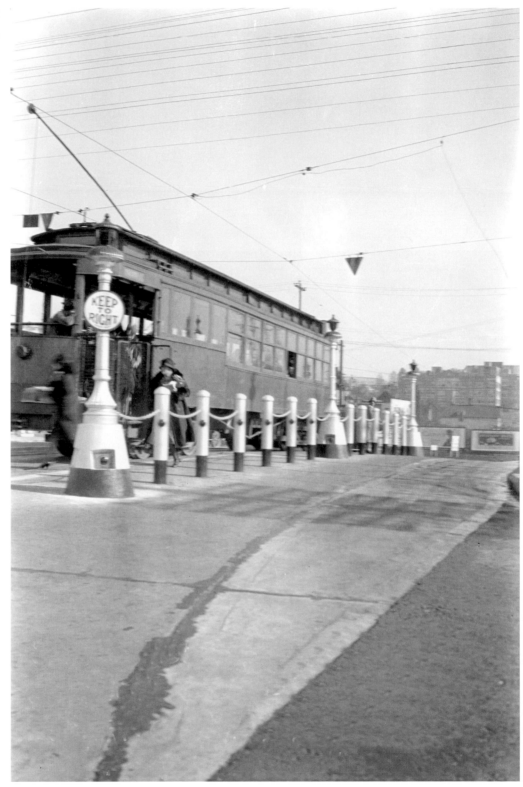

Second Ave. lights from Washington Hotel looking south

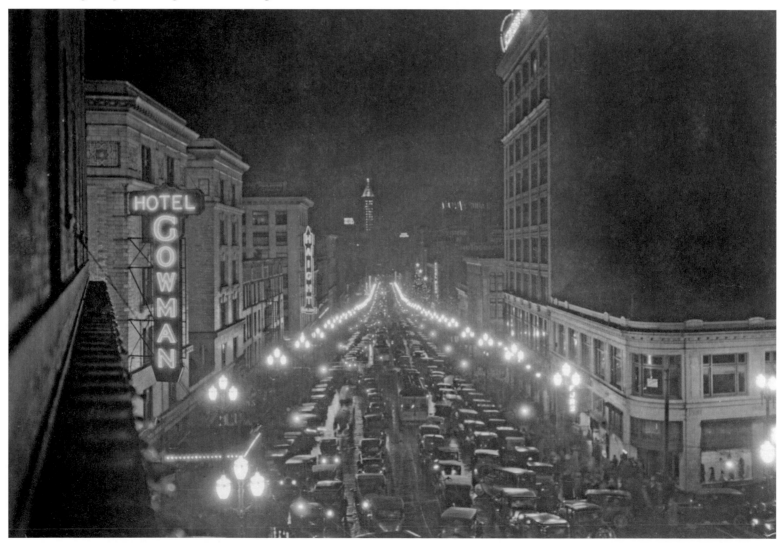

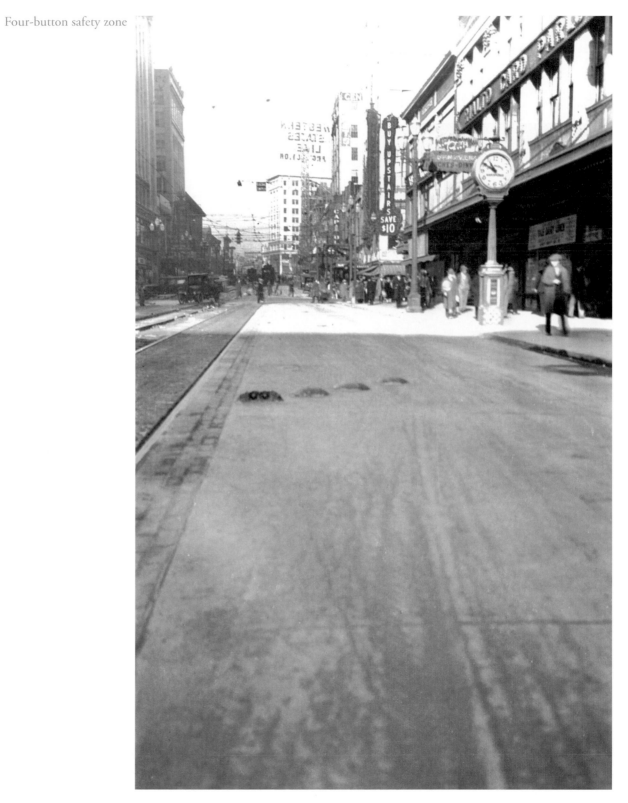

Chauncey Wright Restaurant and New Arctic Hotel on Third Ave. (1928)

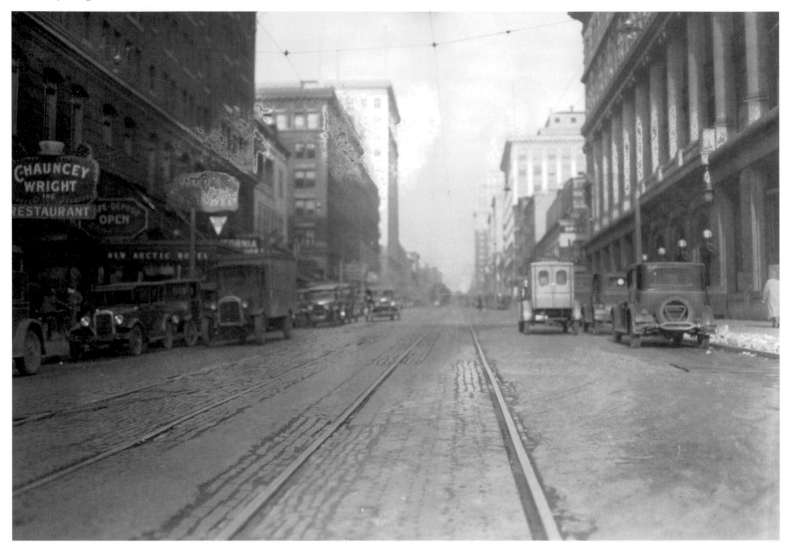

Laying tracks in front of the Federal Hotel (1928)

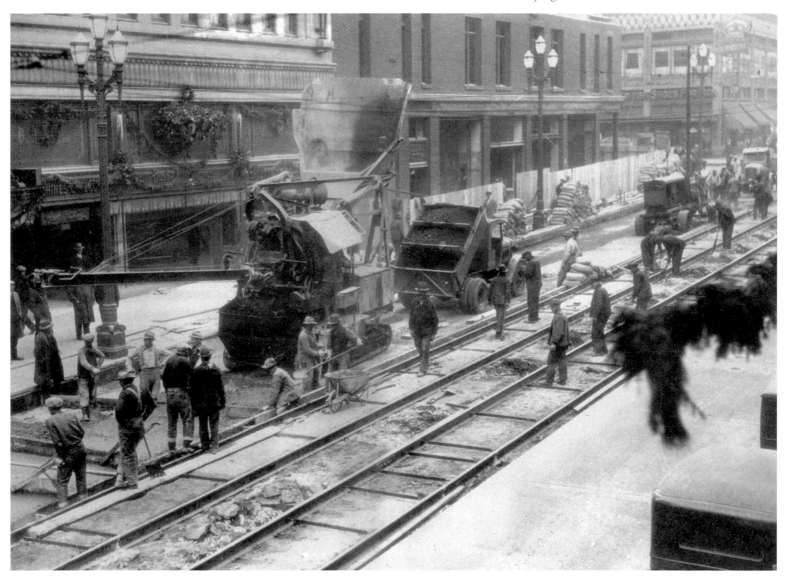

New Richelieu Hotel and Shorey's Bookstore on Third Ave. (1929)

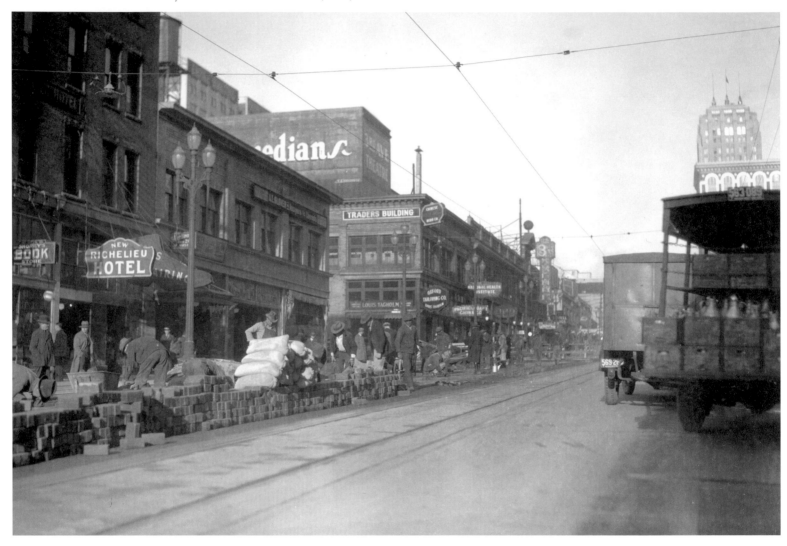

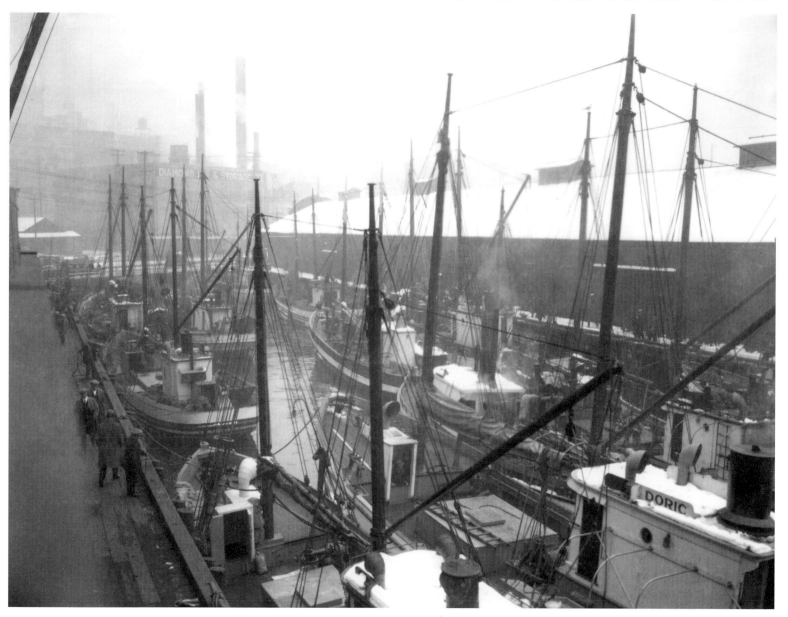

Seattle waterfront and boats near Schwabacher's Wharf at Pier 7

Second Ave. at Jackson

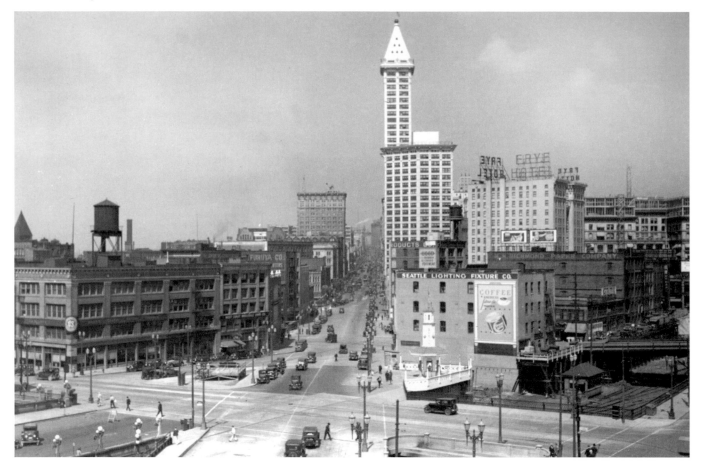

Highway Fruit Company with billboard featuring the Coca-Cola trademark (1930)

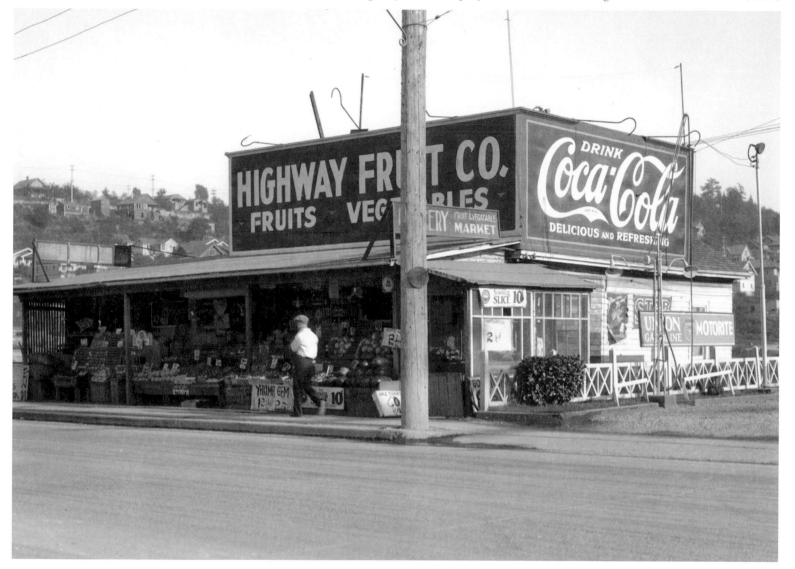

Denny Regrade Fourth Ave. and Blanchard (1930)

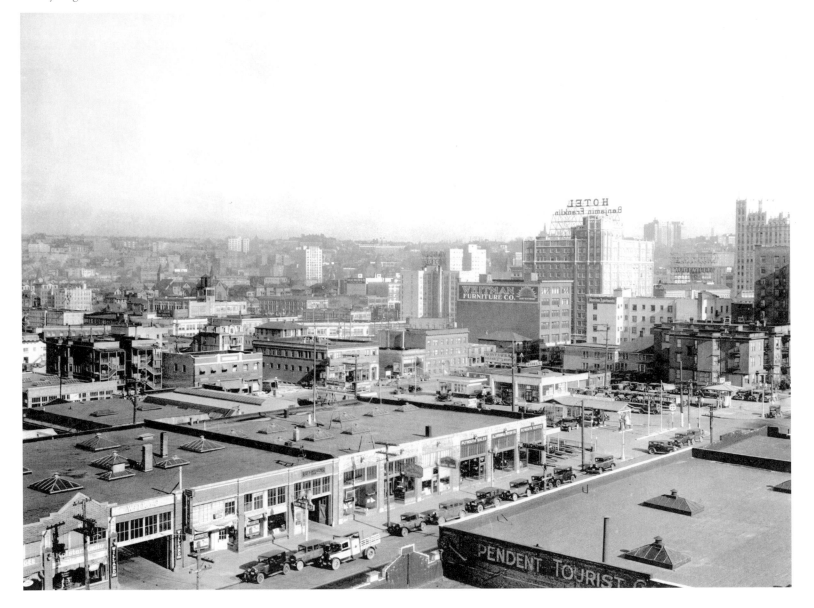

Third Avenue North from Marion showing Oxford Tailoring Co.,
Raymer's Books, Hotel Albany, and the Pacific Coast China Co. (1930)

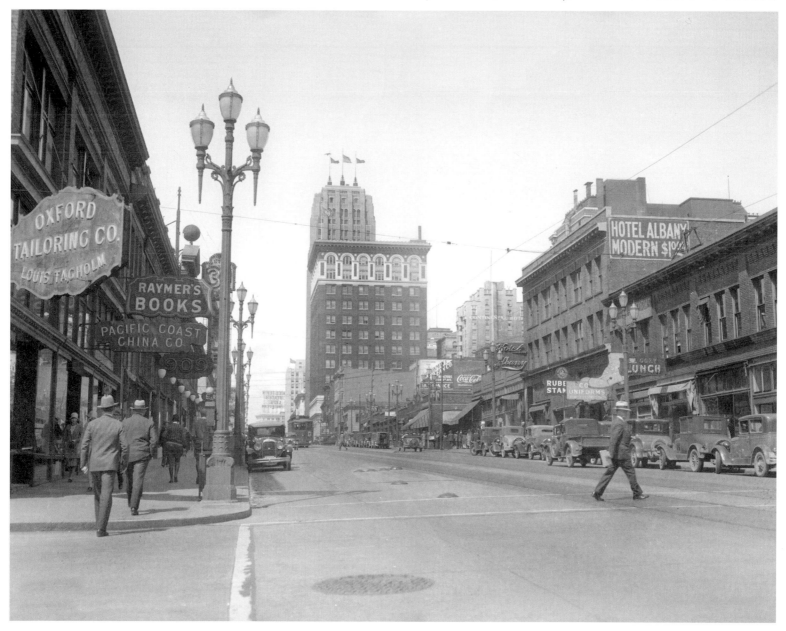

Employees at Manning Tea, Pike Place Market

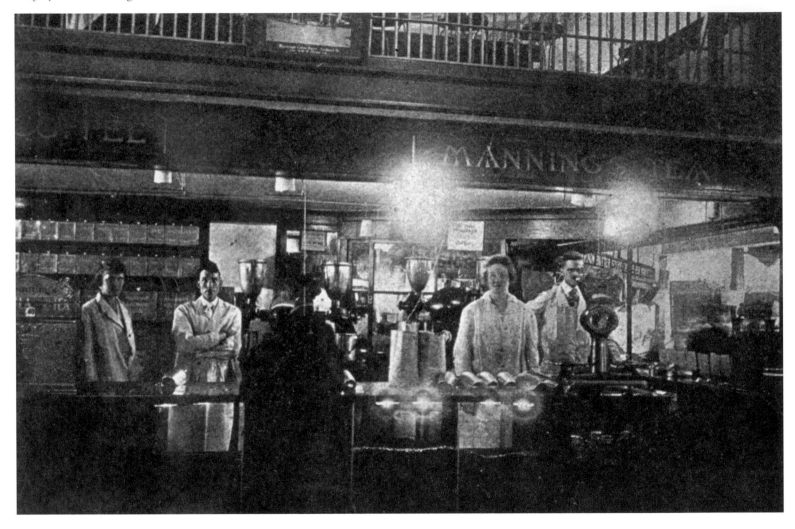

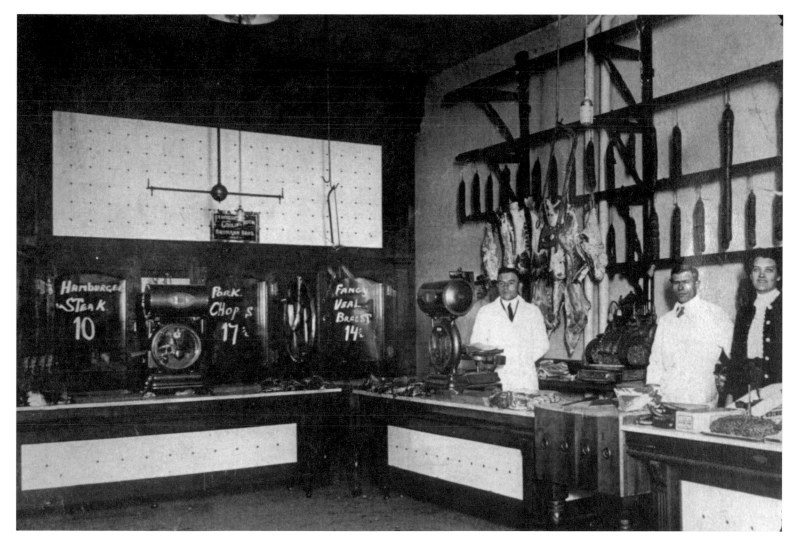

Youngstown Place streetcar viaduct, West Seattle (1930)

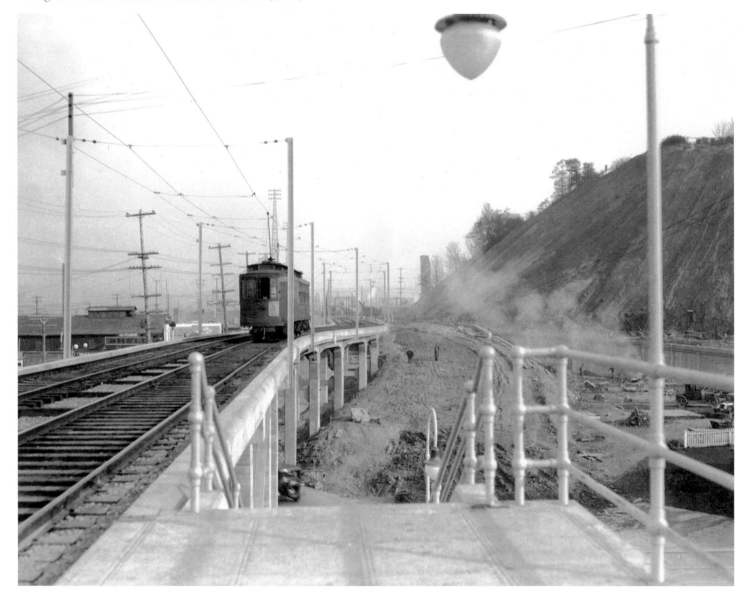

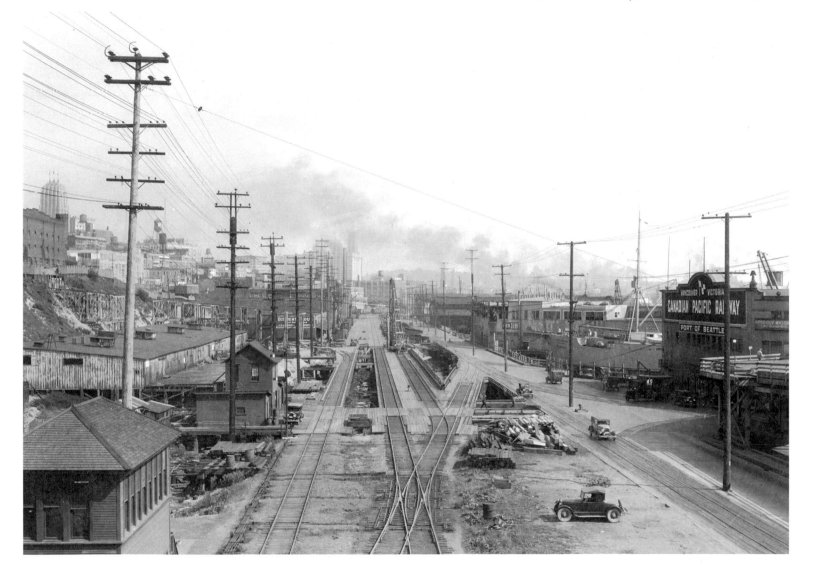

Railroad Ave. (now Alaskan Way) on central waterfront (1930)

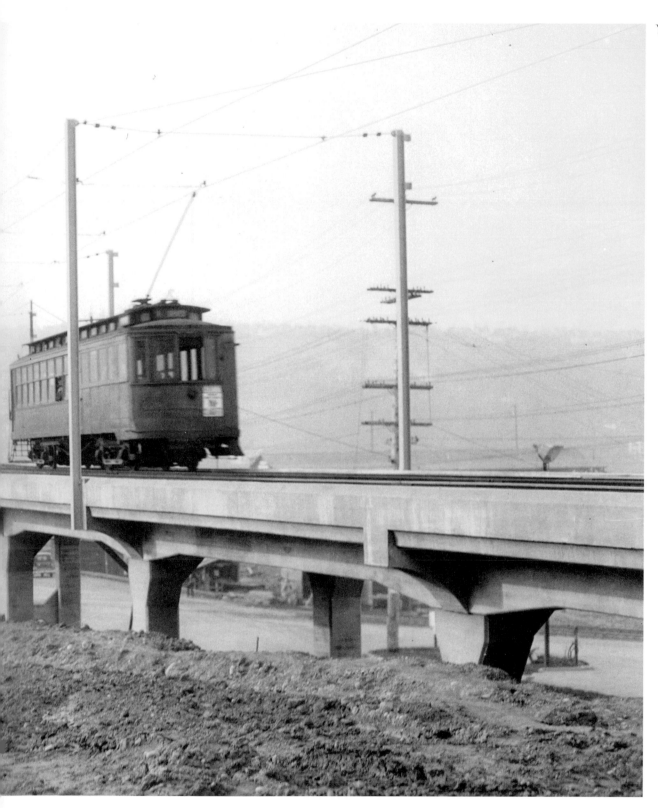

Youngstown Place (1930)

Youngstown Place venues (1930)

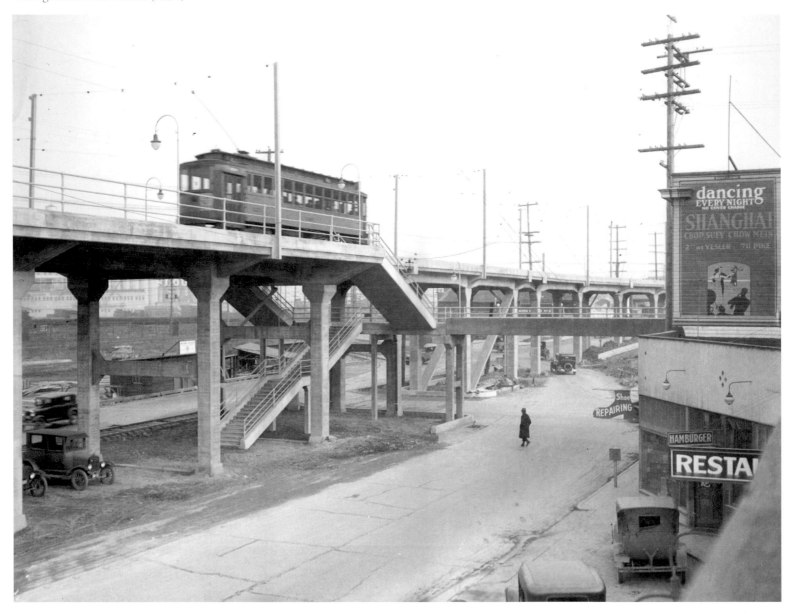

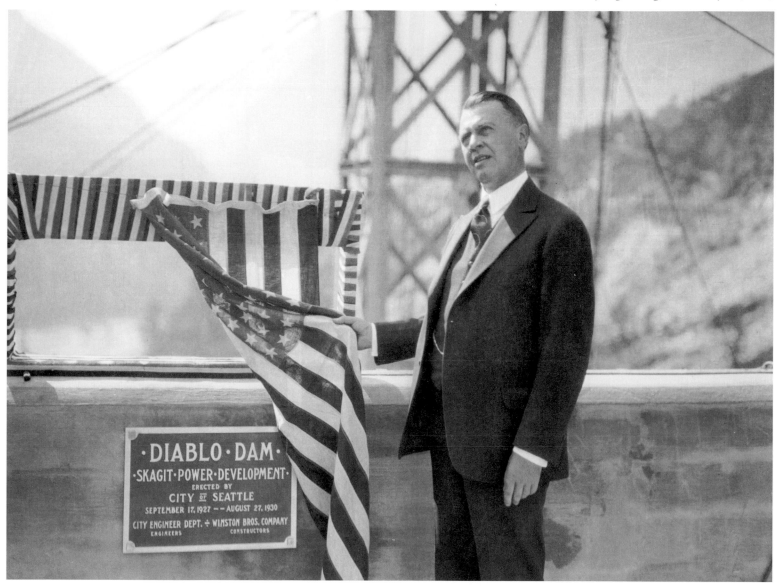

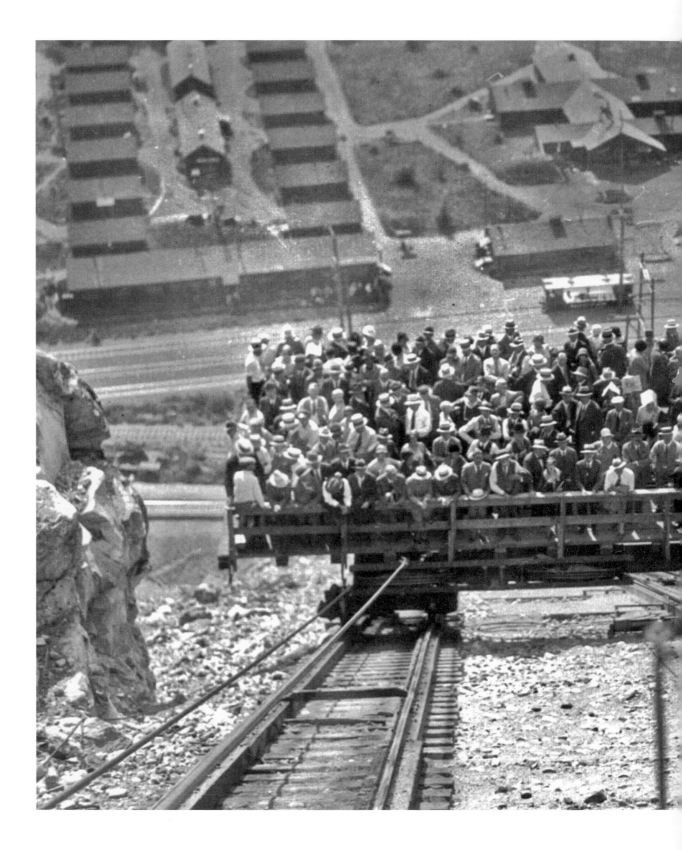

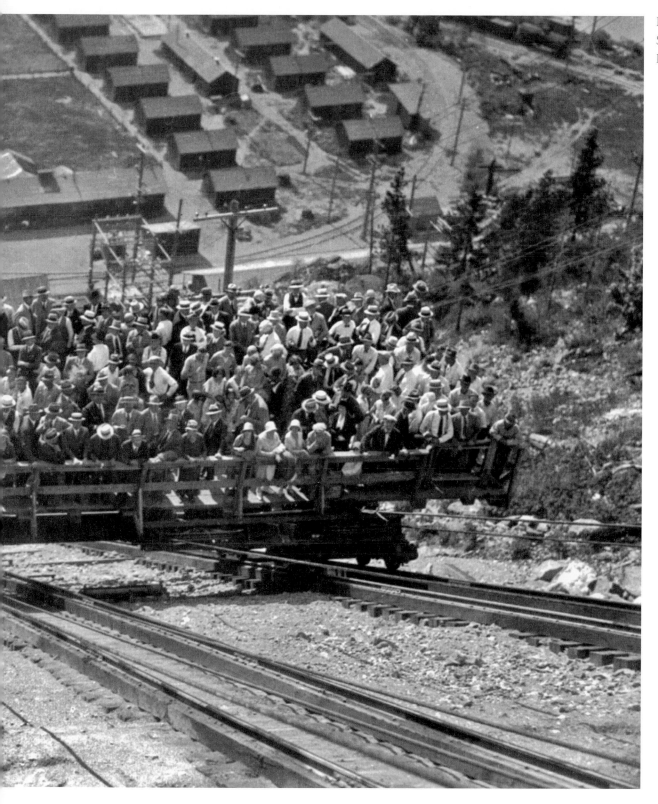

Diablo Dam incline railway,
Seattle City Light Skagit River
Project (1930)

West Garfield Street Bridge

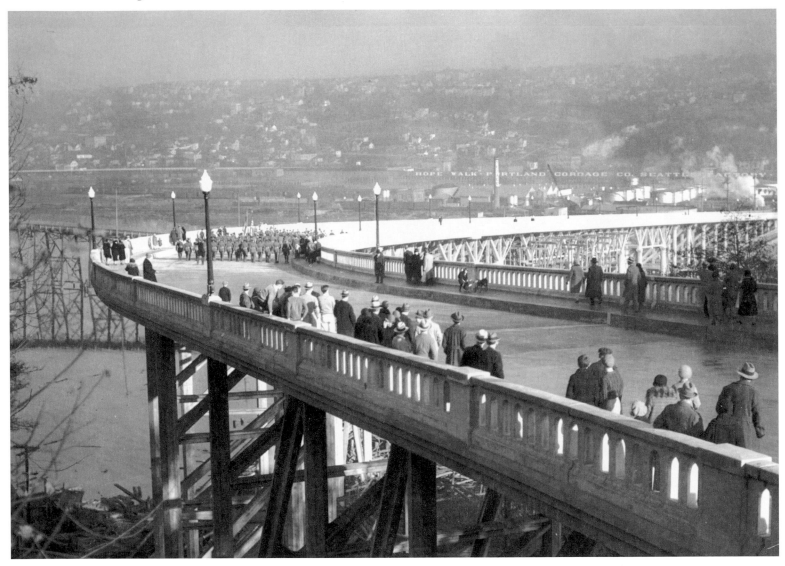

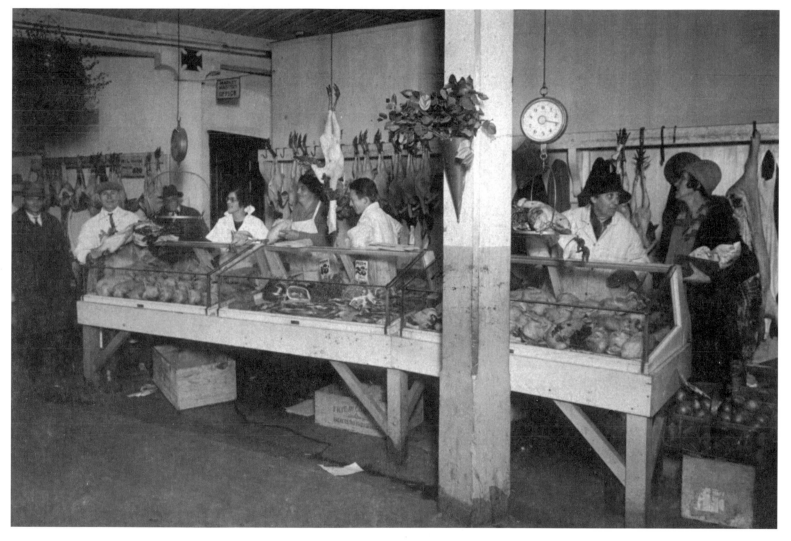

Diablo Dam Tunnel, Seattle City Light Skagit River Project (1930)

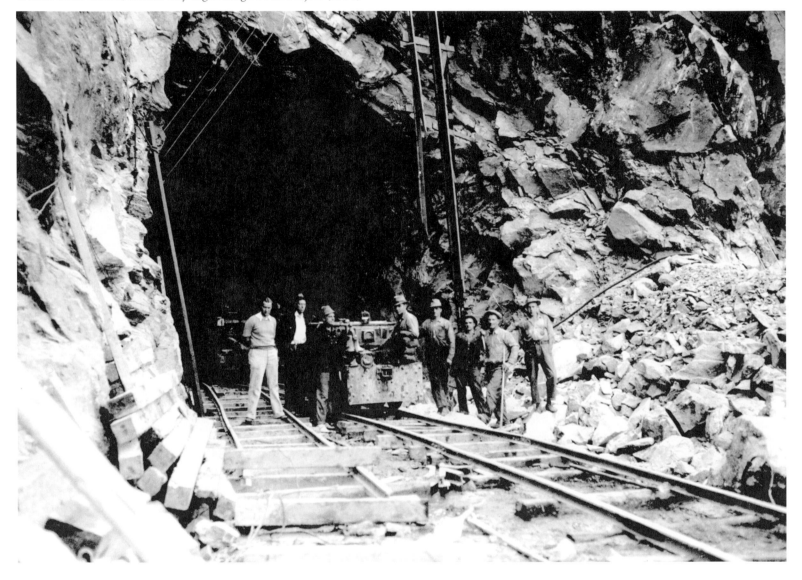

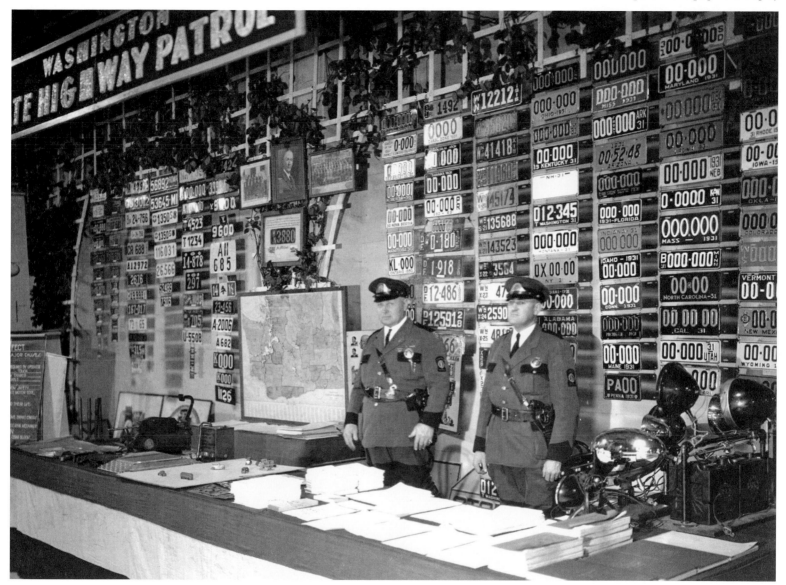

Pike Place Market, meat stall

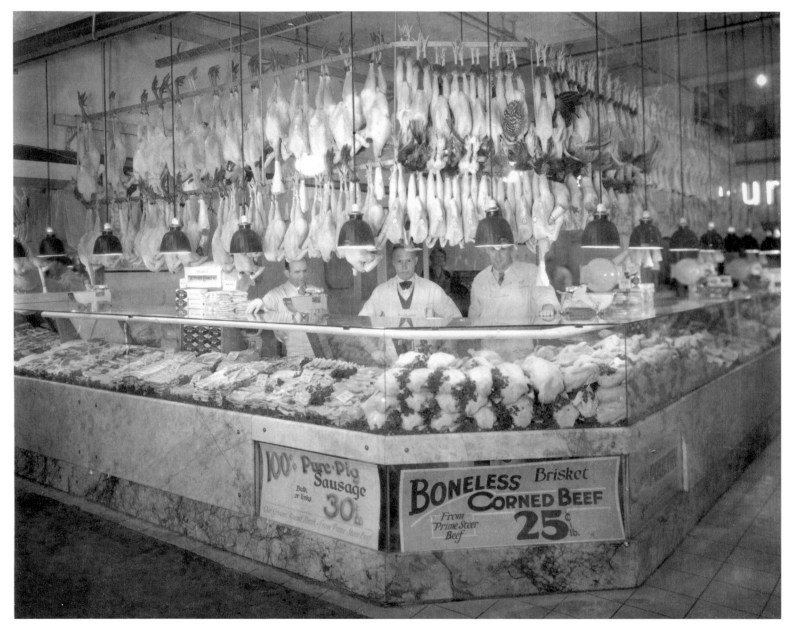

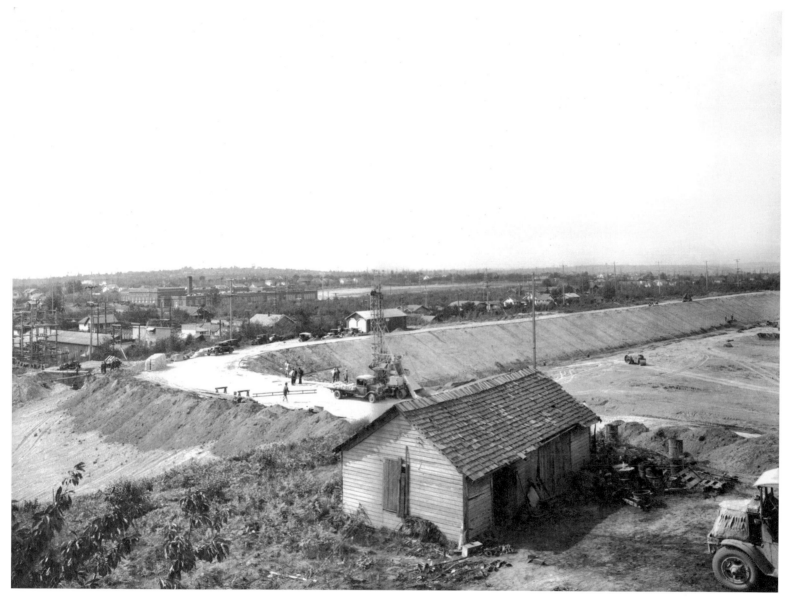

West Seattle Reservoir under construction

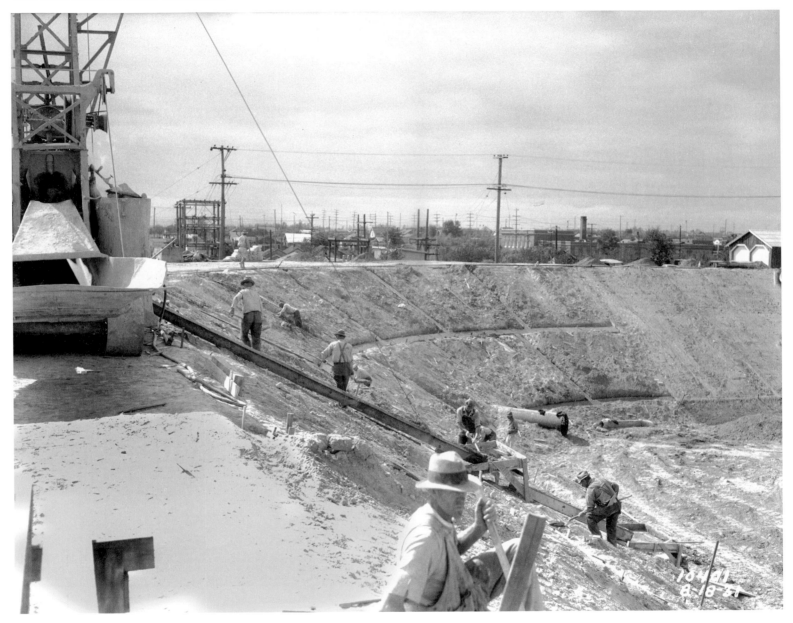

Three Girls Bakery was in the corner of the Corner Market building from 1912 to 1933.

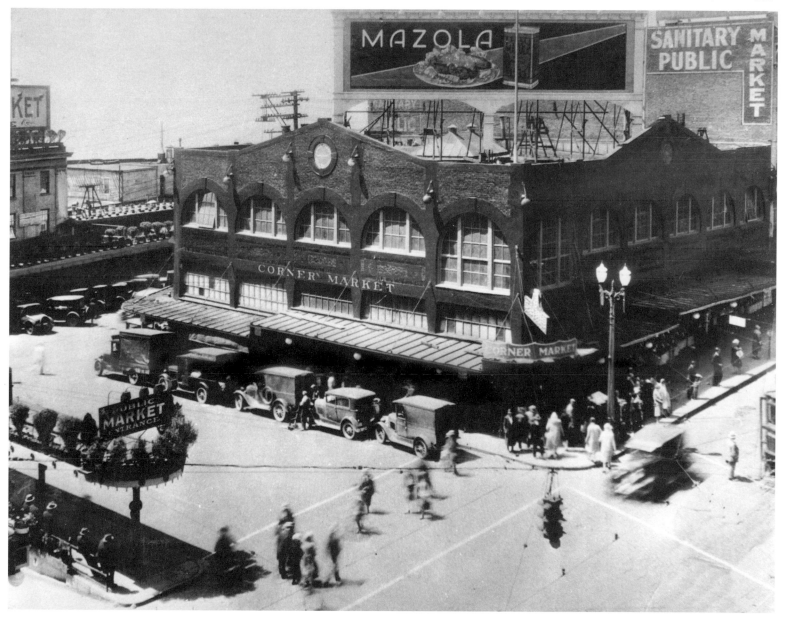

Streetcars at Second and Pike

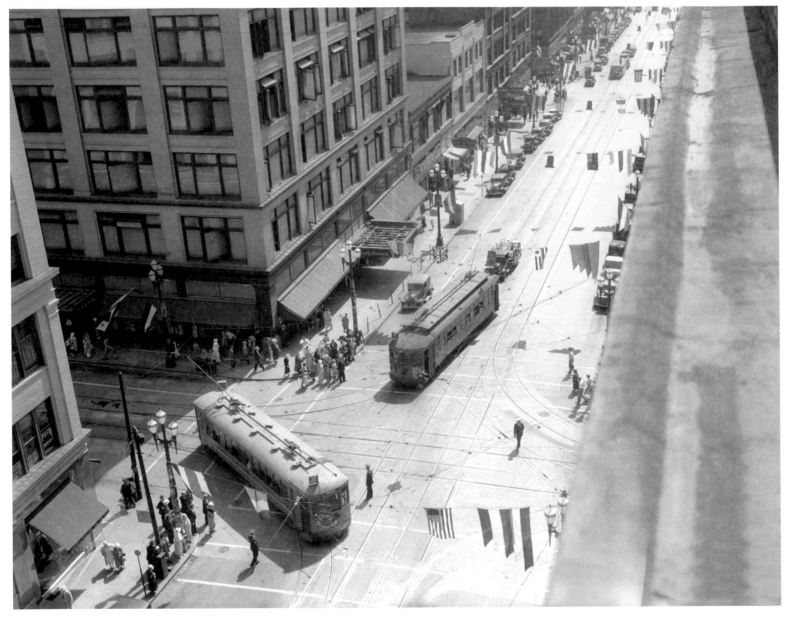

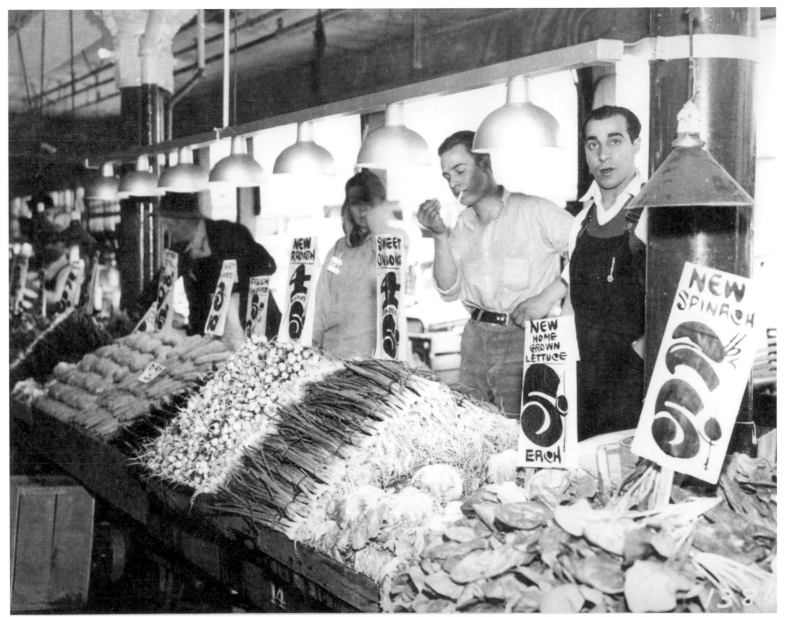

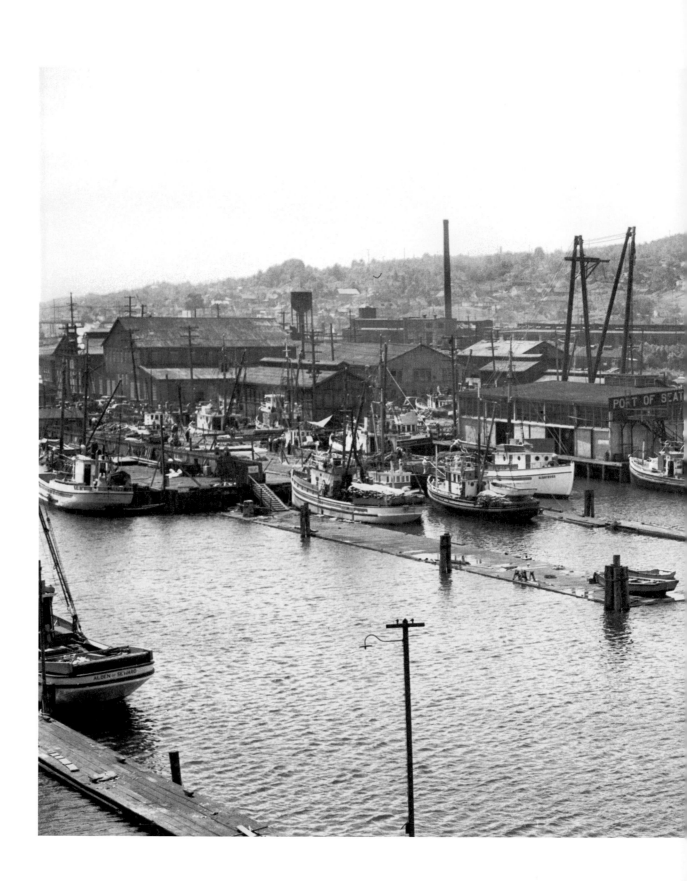

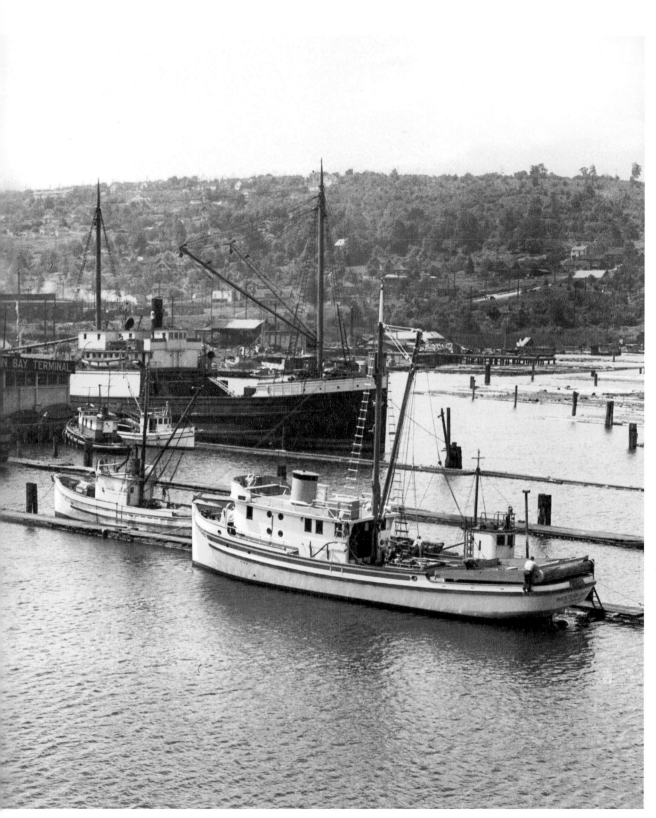

Port of Seattle's Fishermen's
Terminal, Salmon Bay

Salmon Bay Terminal, Port of Seattle (1936)

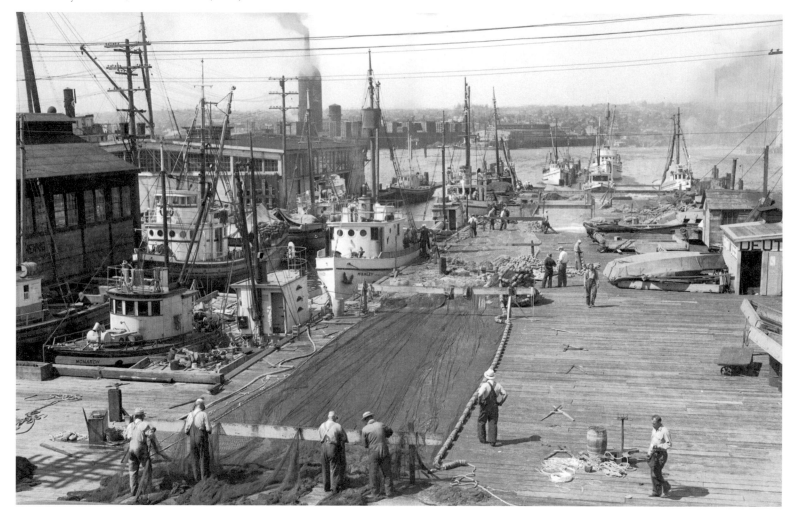

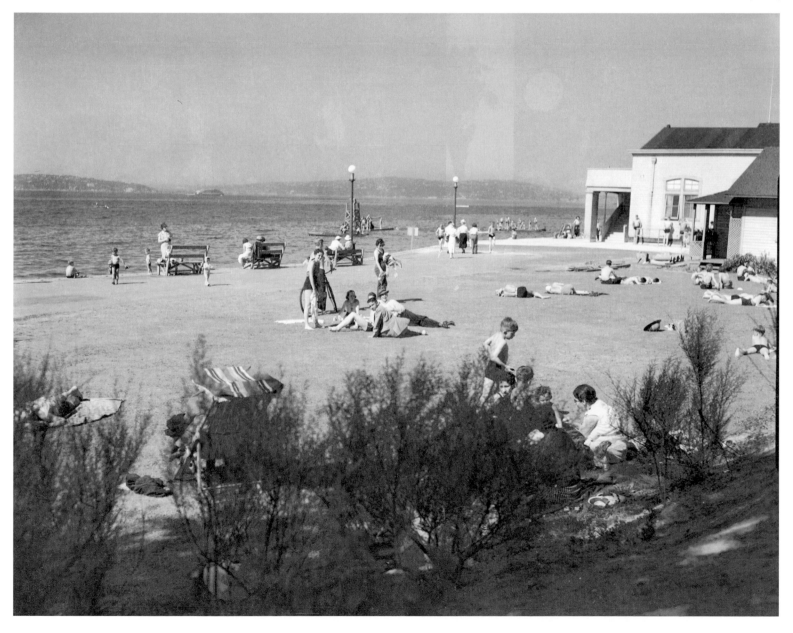

Alki Beach (1936)

Lincoln Park, West Seattle

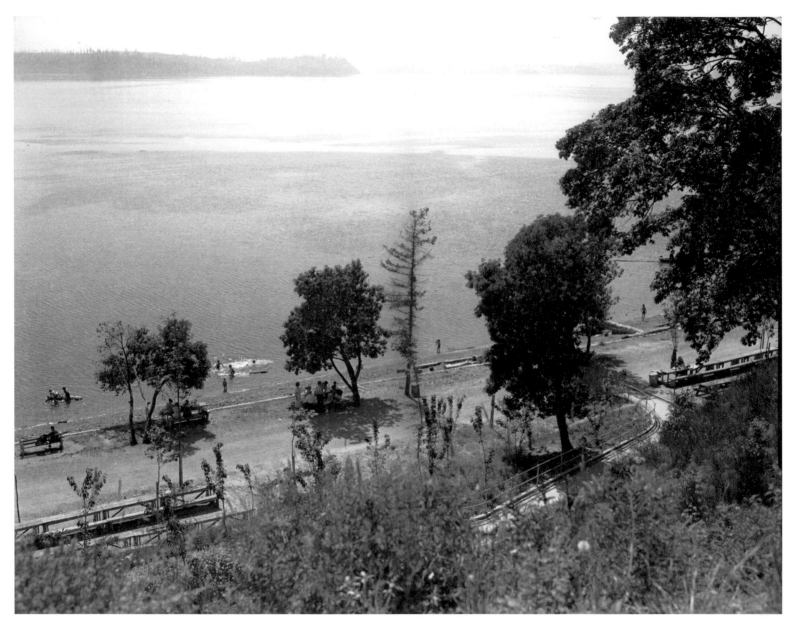

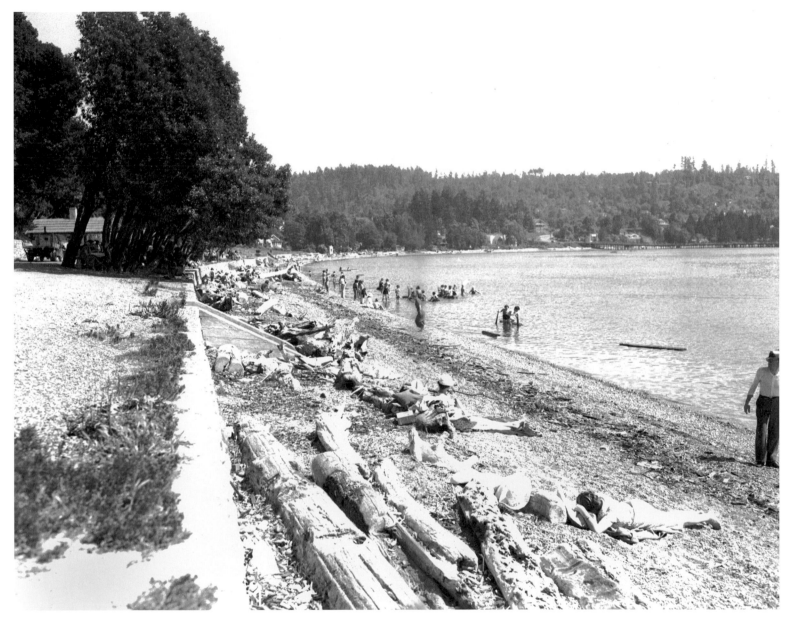

Lincoln Park on the waterfront, West Seattle

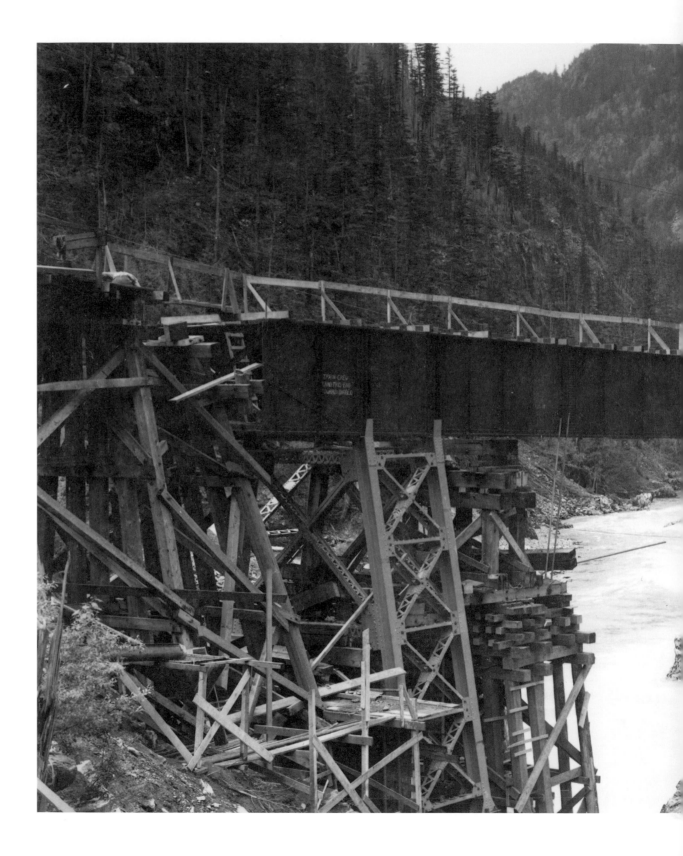

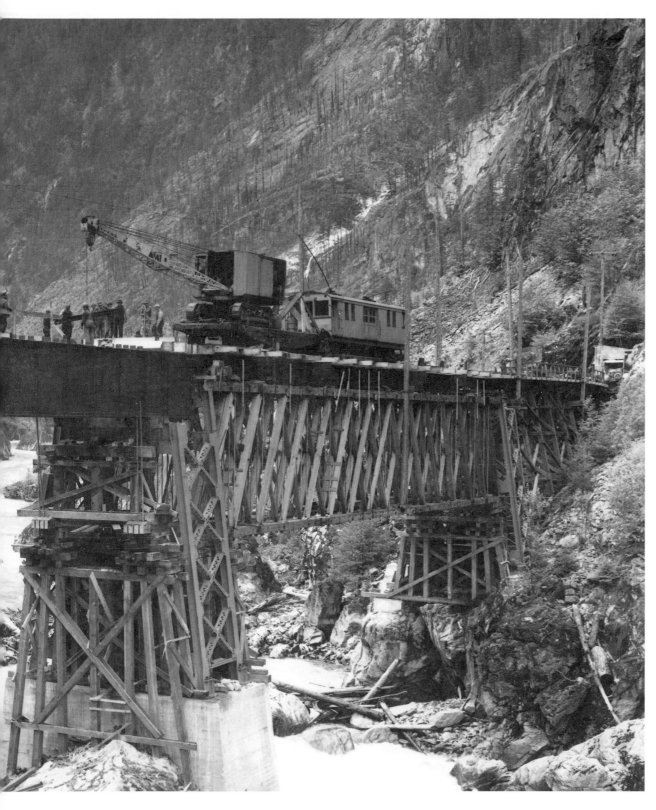

Constructing Devil's Elbow
Bridge, Seattle City Light Skagit
River Project (1936)

Men at work on snow slide above Devil's Elbow Bridge (1936)

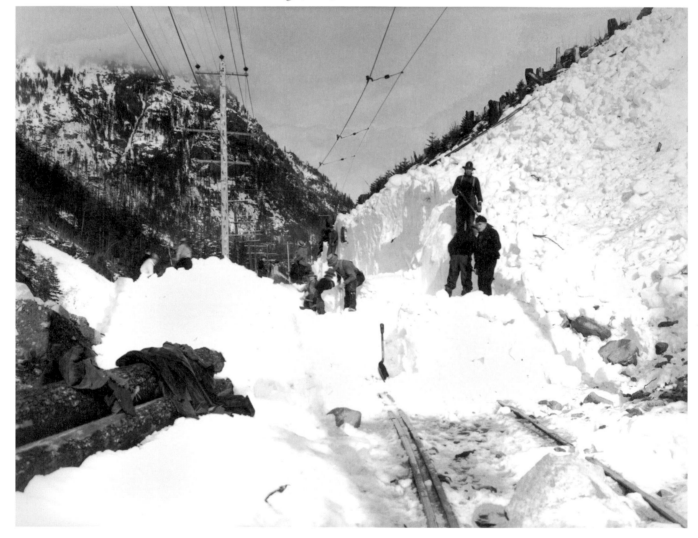

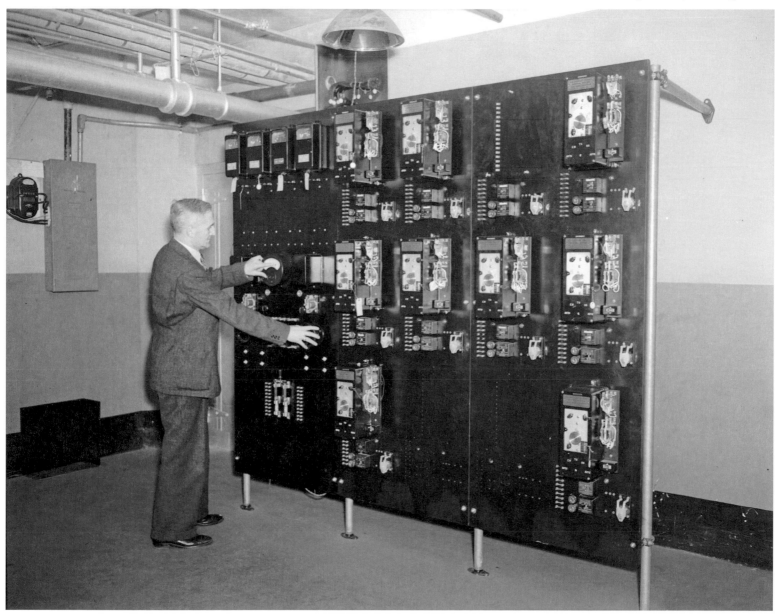

Traffic Control Board at the City-County Building (1936)

Fourth of July parade, City Hall Park. The Frye Hotel stands in the background.

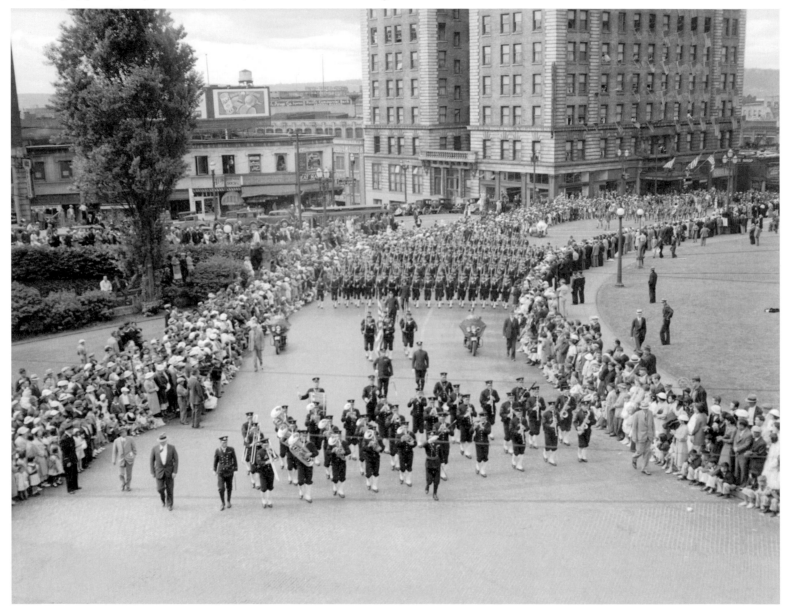

James Wehn's sculpture of Chief Seattle at Tilikum Place, Fifth Ave. and Denny Way (ca. 1920)

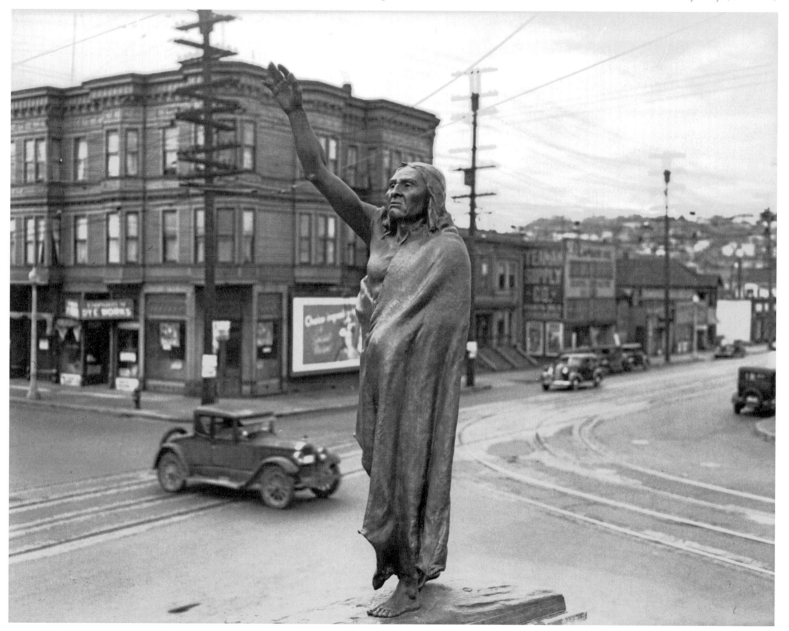

Shrine Parade on Second Ave.

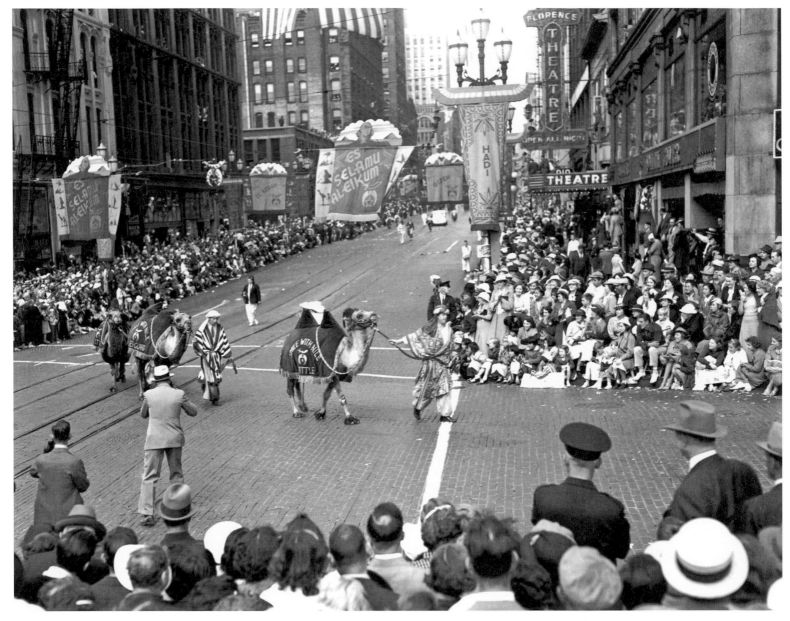

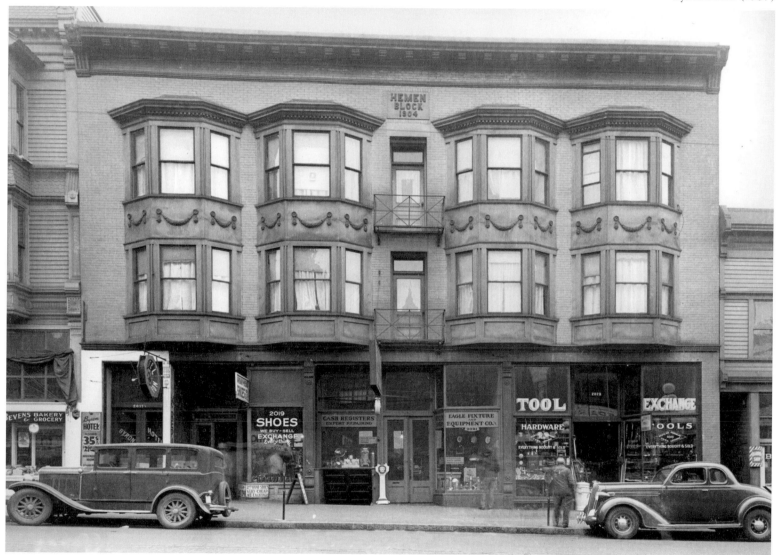

Seattle at night from Smith Tower (1937)

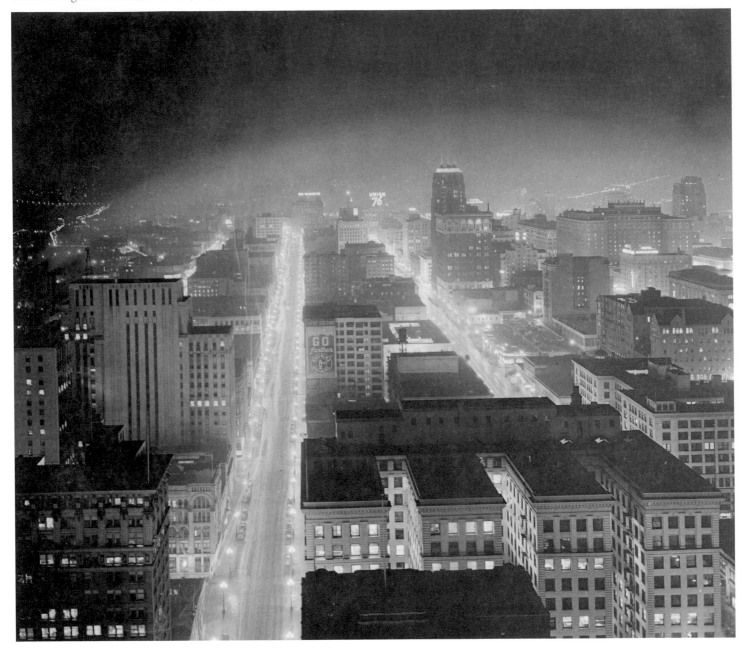

Triangle Building with McDonald's Grocery and Bakery and Market Apartments (1937)

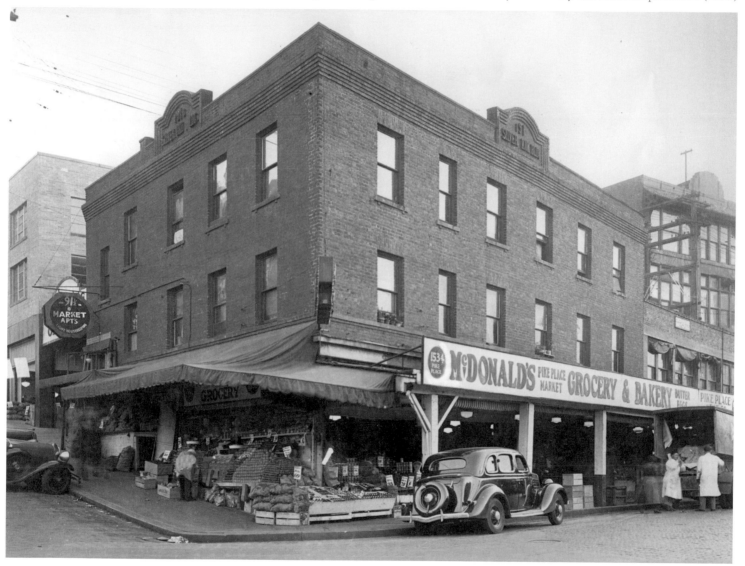

Fourth Ave. trackless trolley wires between Columbia and Marion streets

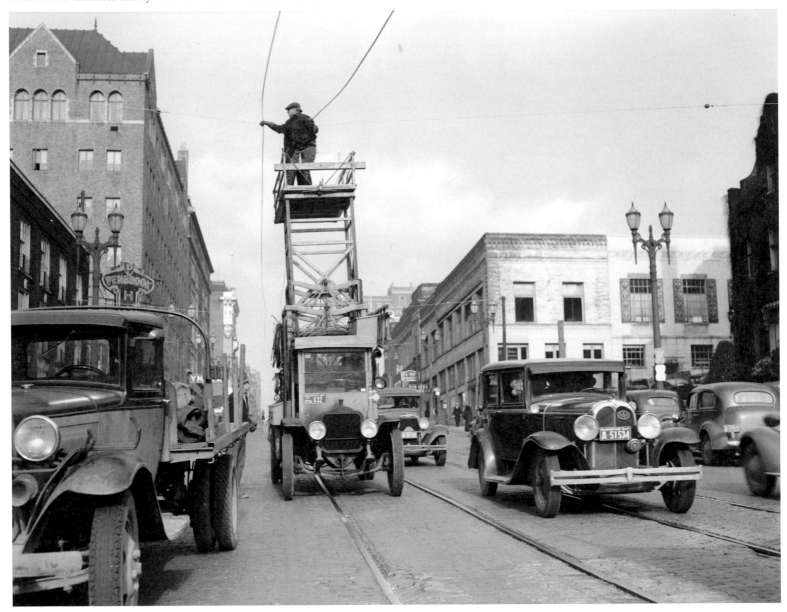

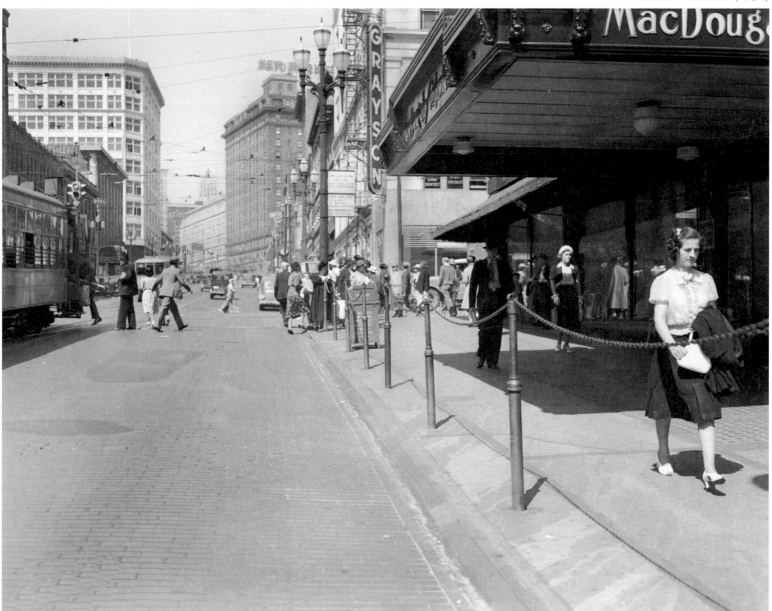

Second and Pike streets (1938)

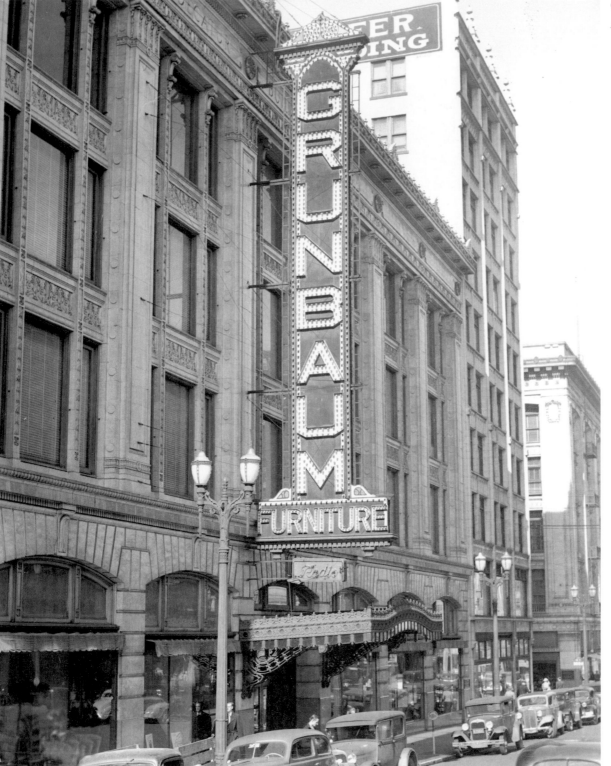

Grunbaum Furniture on 6th
Ave. (1939)

Old-American Fruit Company (1939)

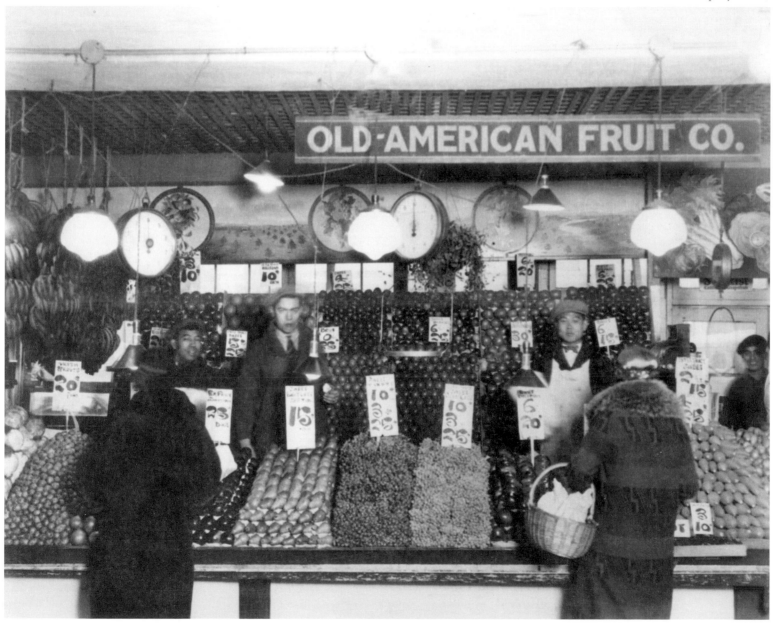

Pike Place Market, Flower Row (1939)

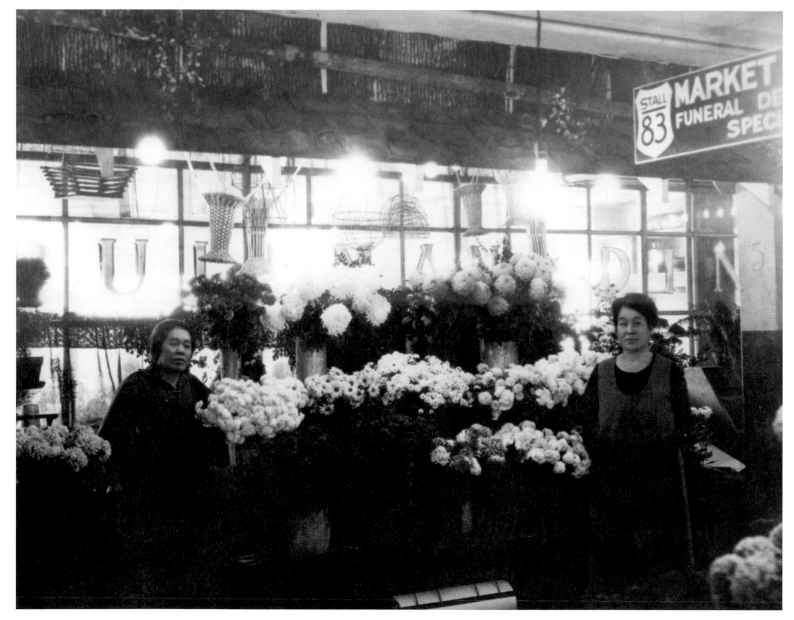

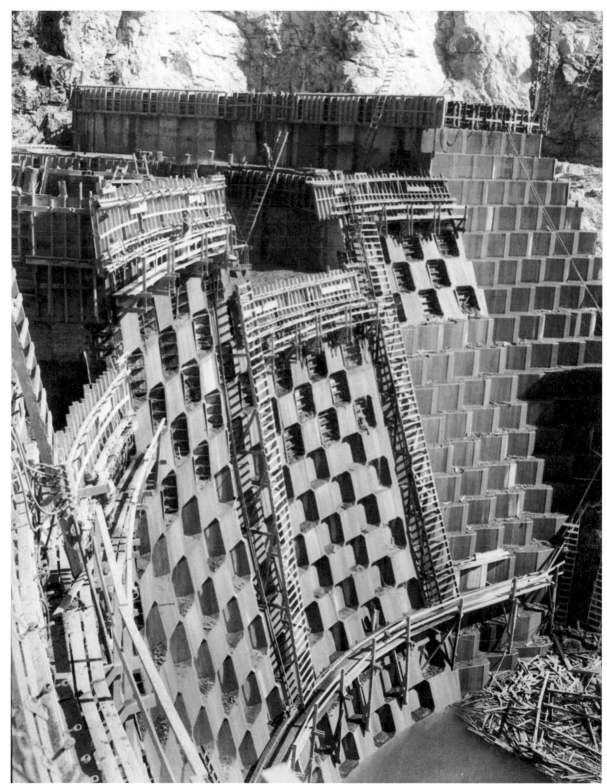

Ross Dam Construction,
Seattle City Light Skagit
River Project (1930)

Looking north on Fifth Ave. from Pike St. (1939)

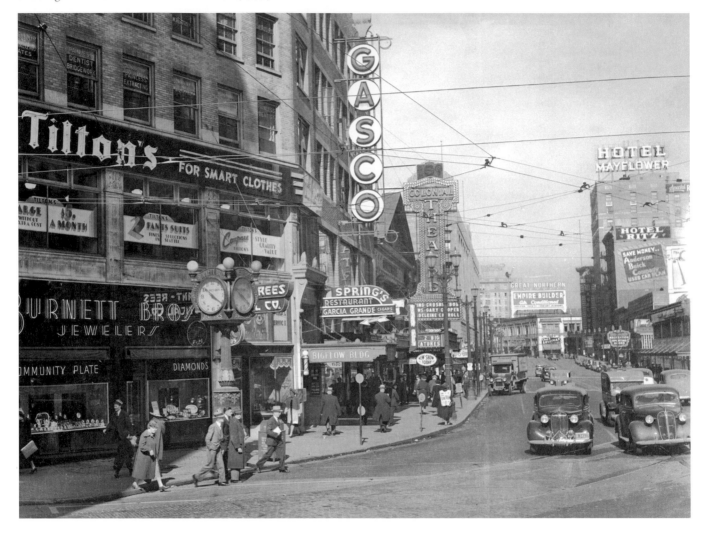

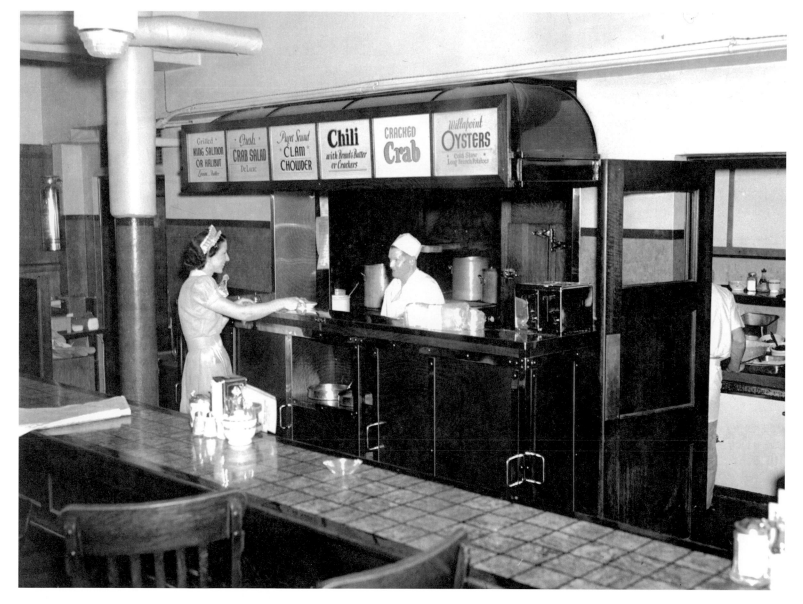

Homeless shantytown known as Hooverville (1937)

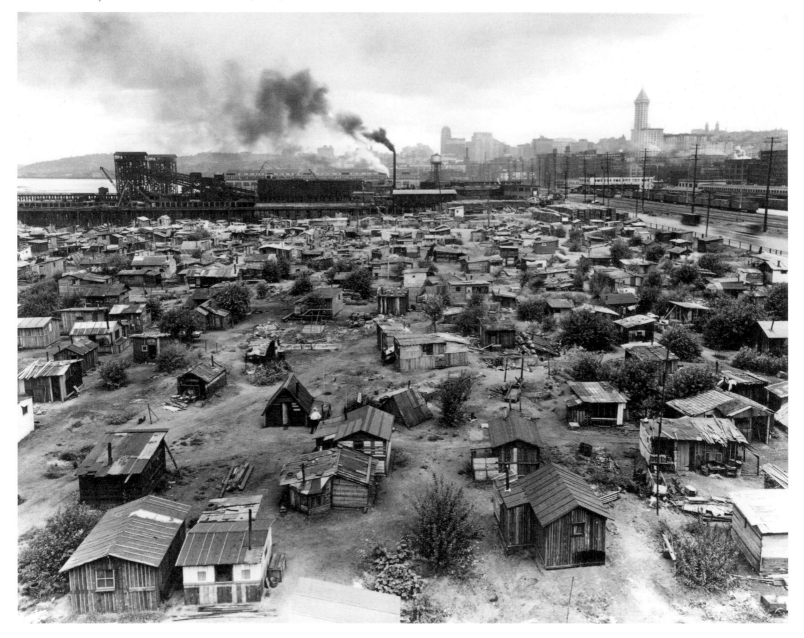

DOOM AND BOOM

1940–1959

The attack on Pearl Harbor on December 7, 1941, stunned Seattle, which fully expected to be an early target if the Japanese fleet pressed on to the West Coast. Amid blackouts and air raid drills, the federal government rounded up more than 8,000 local citizens of Japanese descent, most of them loyal U.S. citizens, and shipped them to inland internment camps. Their homes and neighborhoods were taken over by thousands of African Americans, who migrated north to work in Seattle's shipyards and factories.

Thousands of patriots enlisted or bought war bonds at giant rallies in "Victory Square" in front of the Olympic Hotel, and women, collectively dubbed "Rosie the Riveter," joined the work force to assemble tanks, ships, and airplanes in local factories. With federal funds, the Seattle Housing Authority erected instant neighborhoods to house defense workers, and the Port of Seattle built a new regional airport midway between Seattle and Tacoma.

Boeing quietly designed and tested a powerful new bomber, the B-29, but the secret almost escaped when the second prototype crashed near Boeing Field in 1943. Regardless, the B-29 went into production and two of the aircraft would bring the war to a close by dropping atomic bombs on Hiroshima and Nagasaki in August 1945.

Prosperity did not necessarily follow peace as wartime orders for ships and planes again dried up. The mounting anxiety of the Cold War fueled local anti-communist investigations long before U.S. Senator Joseph McCarthy lent his name to the cause.

As Seattle neared the 1951 centennial of its founding, civic leaders decided it needed a good party. They organized a new summer festival, Seafair, which soon became famous for races featuring the world's fastest hydroplane boats. They also built the city a new museum as a showcase for its history and industry. In 1953, the city's first "freeway," the Alaska Way Viaduct, opened to speed Highway 99 traffic around downtown along the waterfront.

With annexations of northern neighborhoods up to 145th Street in 1954, Seattle's population approached half a million, but growth was accelerating in the surrounding suburbs. The Baby Boom and new road construction spurred outlying housing development, and new shopping centers such as Northgate and Bellevue Square helped to lure residents the way amusement parks had done in the era of streetcars.

Development took its toll as urban and suburban sewage turned Lake Washington into a cesspool. Voters responded by creating a new regional utility, Metro, to take over waste management and clean up the lake, but they rejected more visionary ideas for mass transit, parks, and planning.

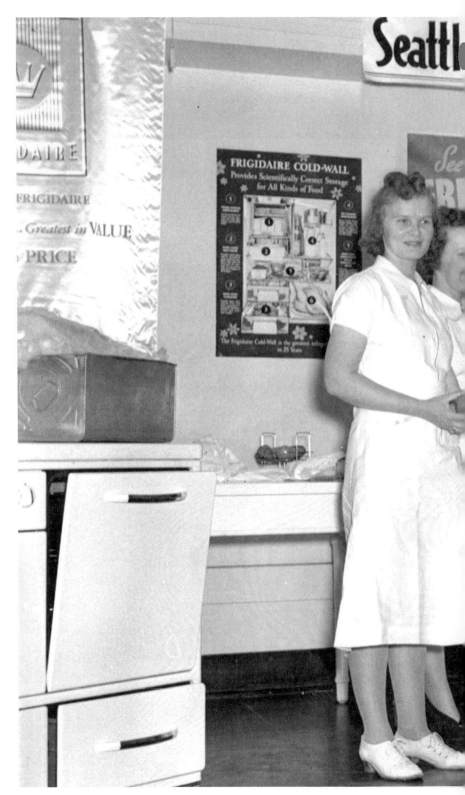

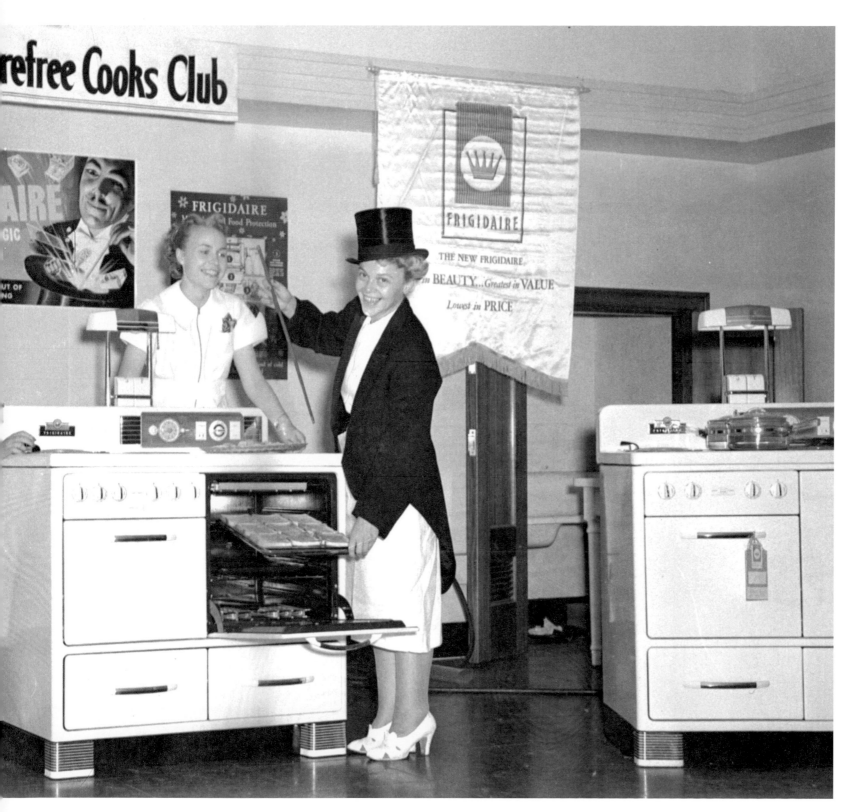

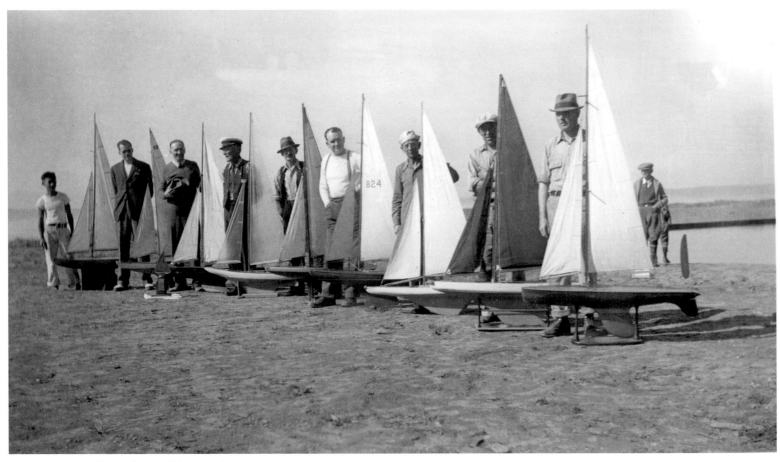

Seattle Model Yacht Club at Golden Gardens

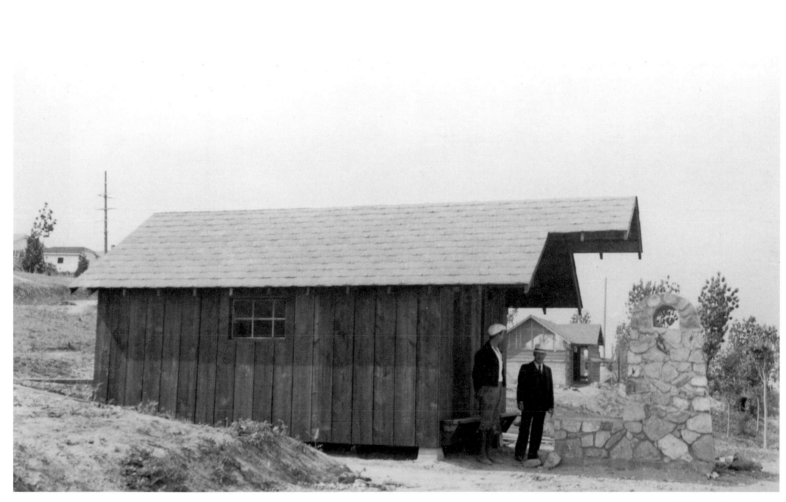

Cabin at Camp Long

Camp Long dedication (November 8, 1941)

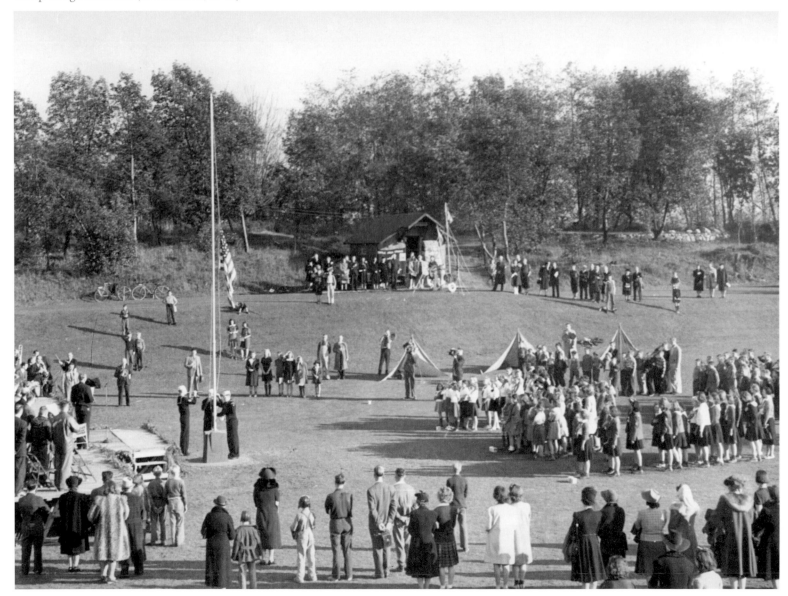

West Seattle branch war bonds promotion. "Buy War Bonds–Back the Attack"

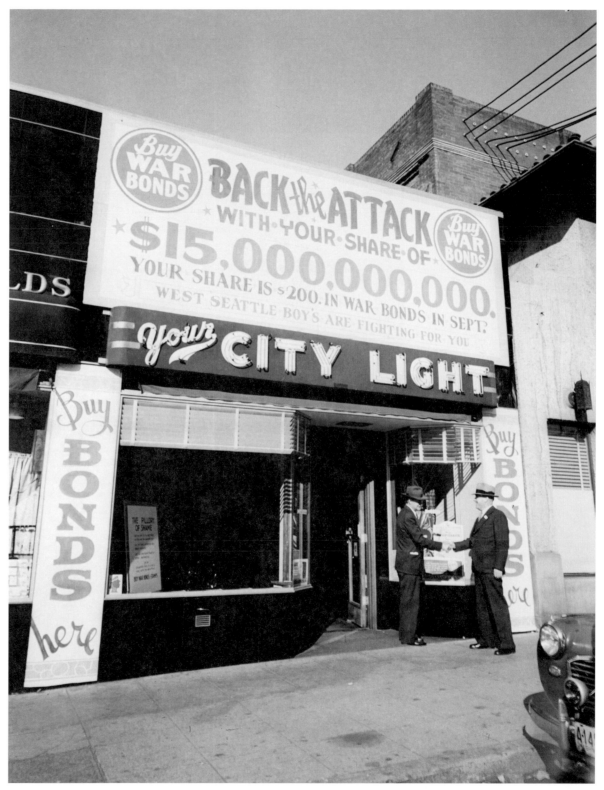

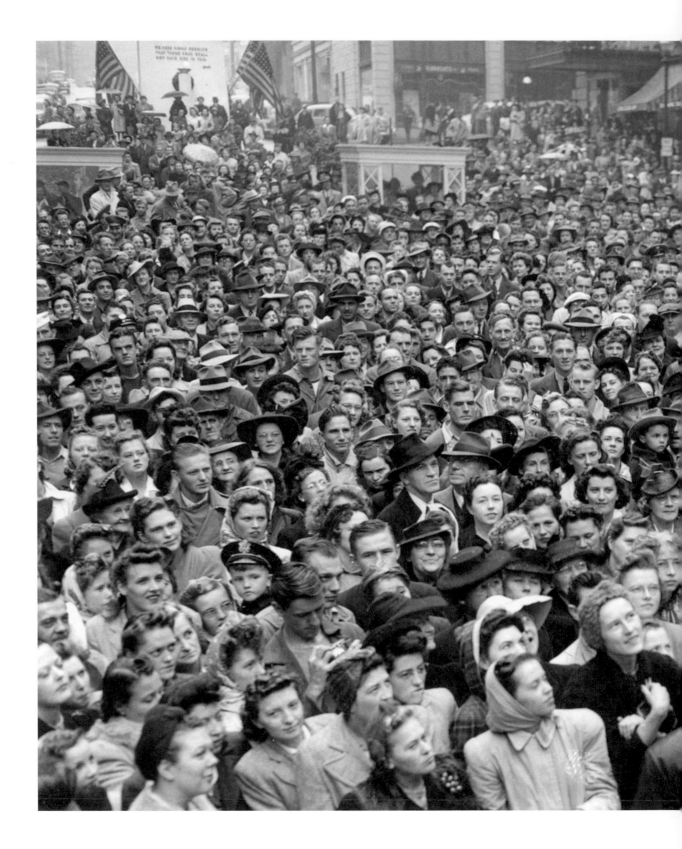

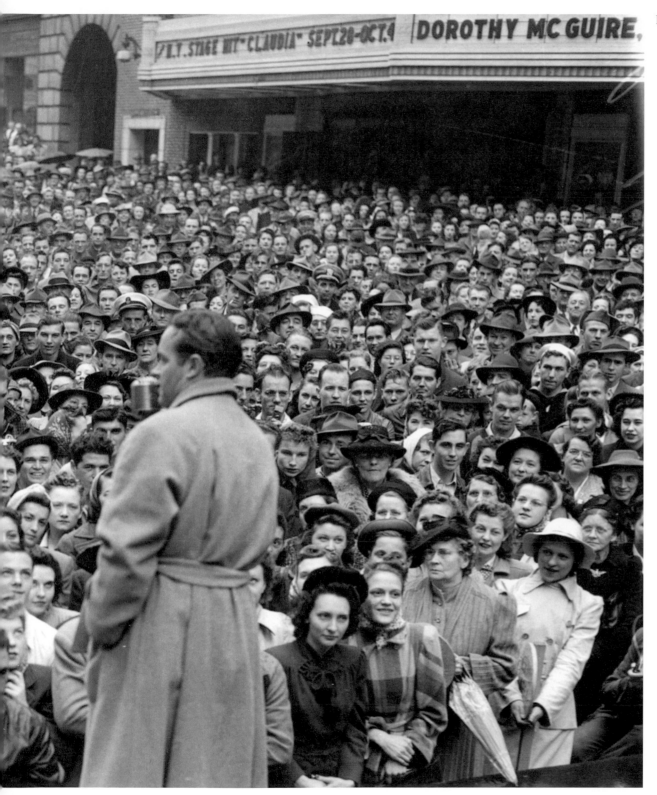

Bob Hope at Victory Square

163

West Seattle Golf Course

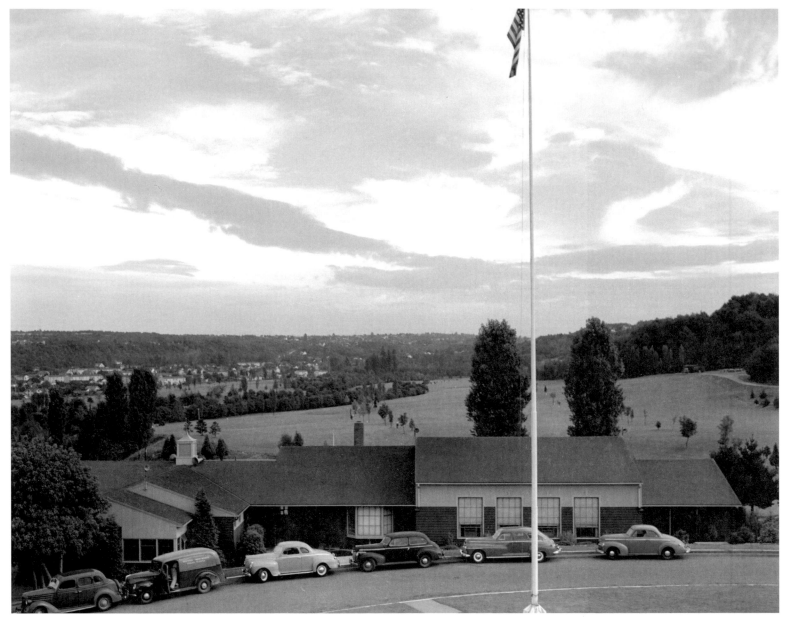

Newsstand, Third and Pike (1946)

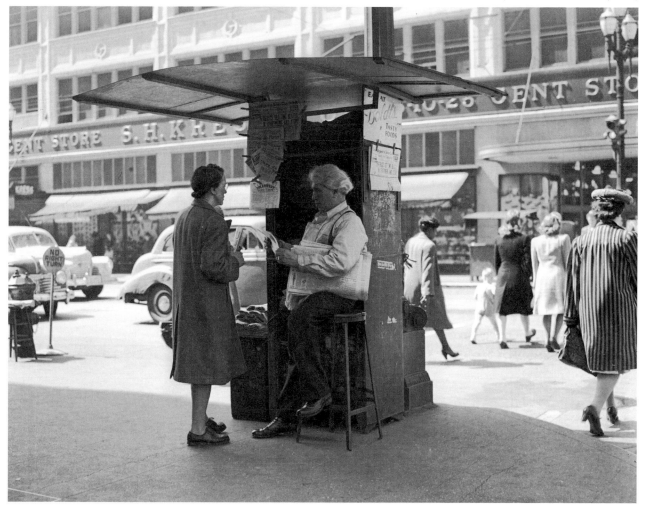

Alki Beach "duck," operated by J. F. Boles of Puget Sound Log Patrol

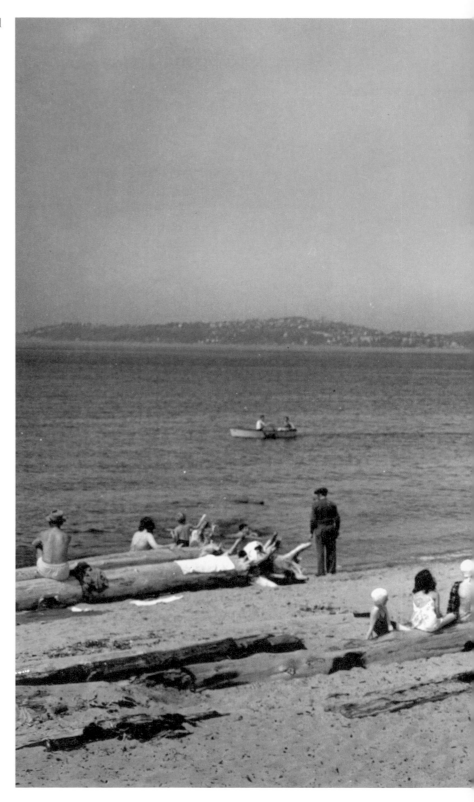

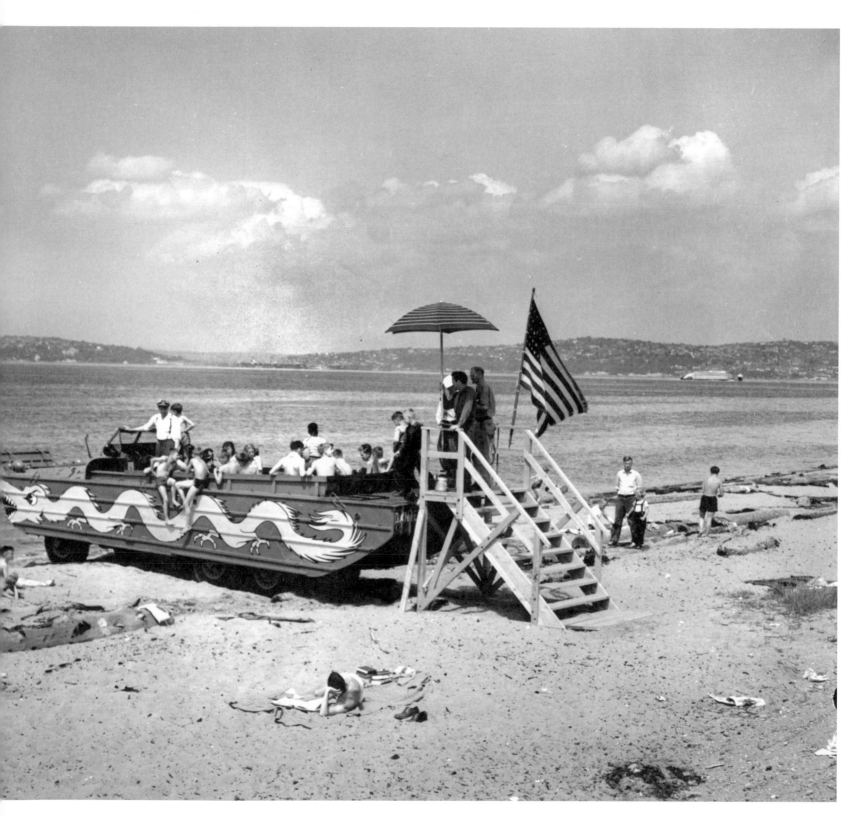

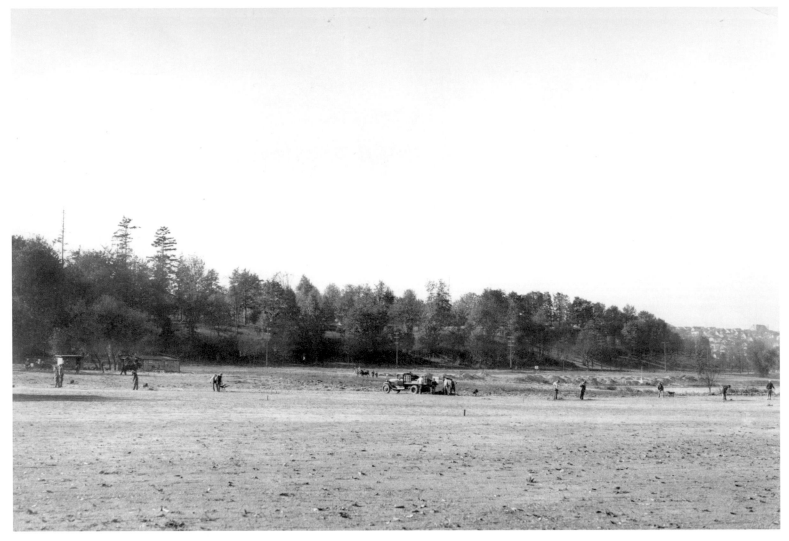

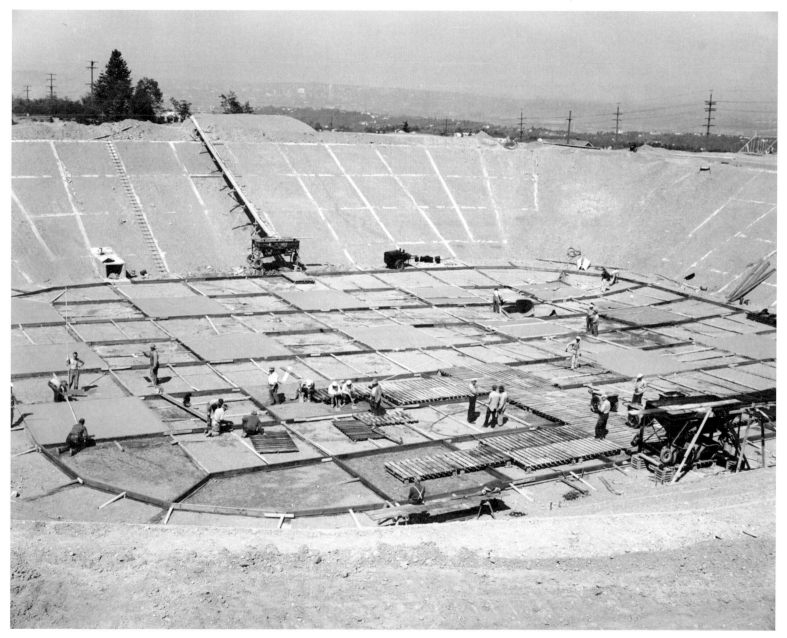

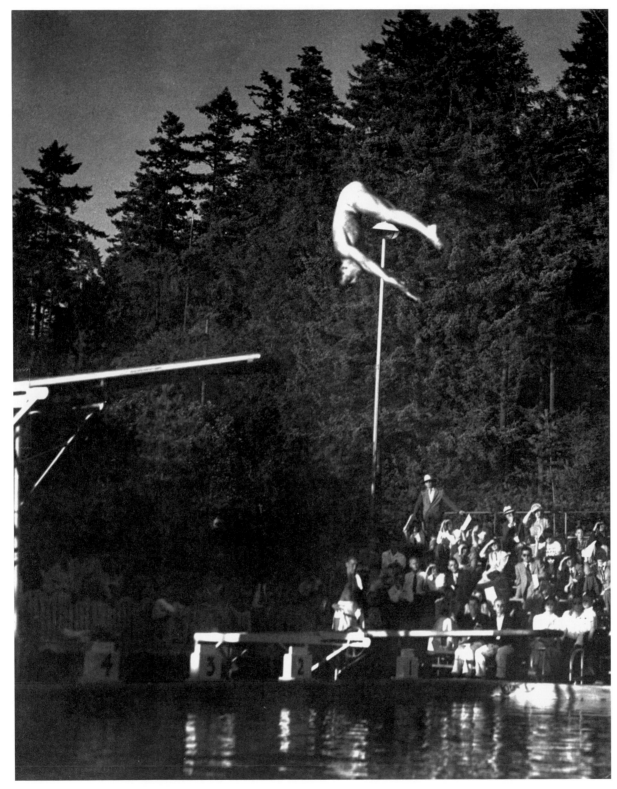

Diver performs at Colman
Pool, Lincoln Park.

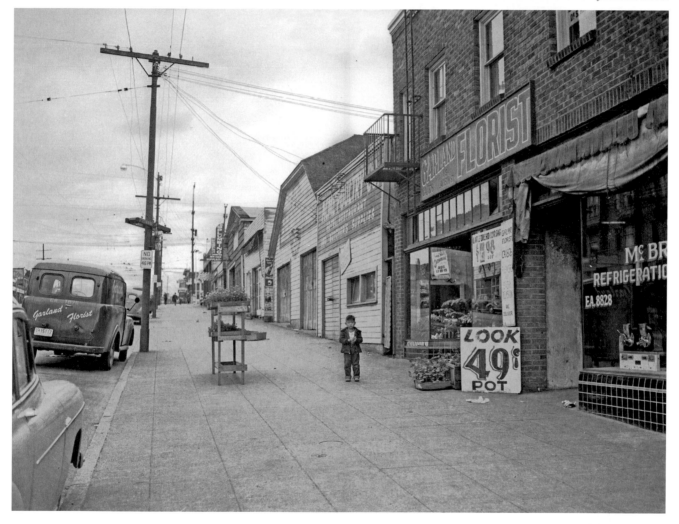

Garland Florist between Tenth and Twelfth on Jackson Street

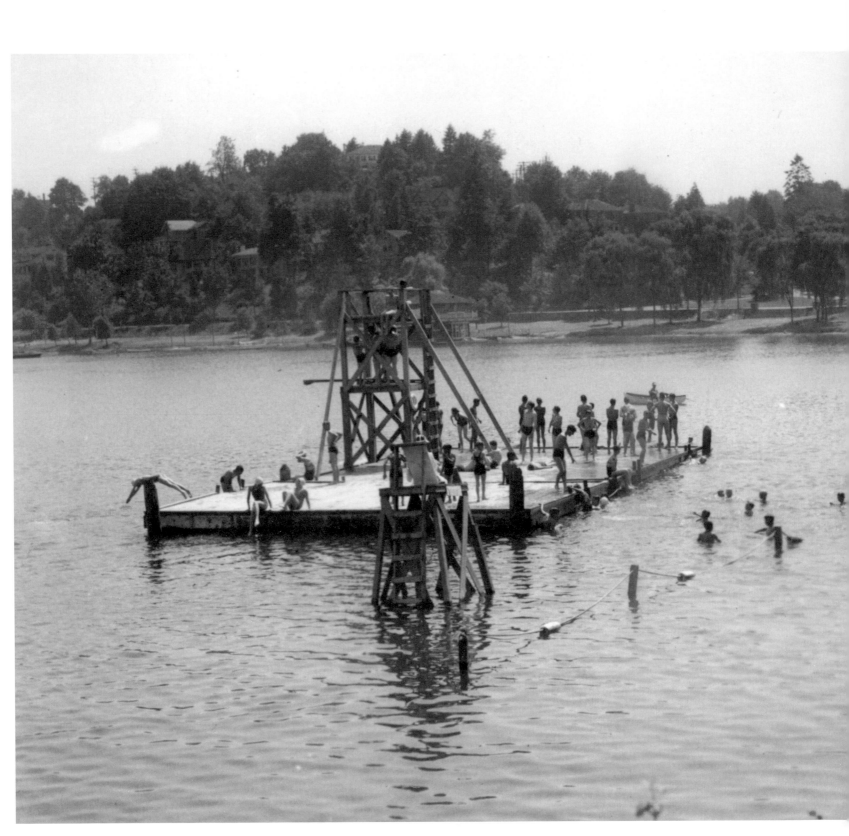

Colman Pool

Following Spread: Engine No. 6,
Seattle City Light Skagit River Project

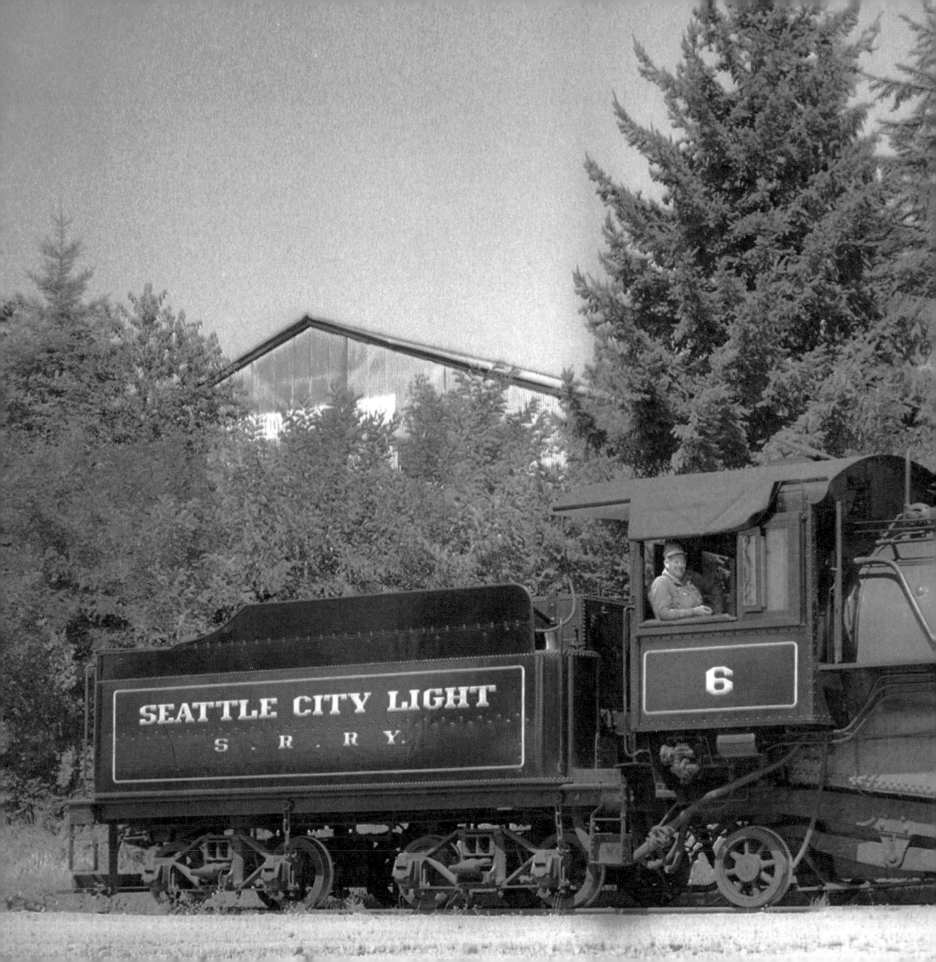

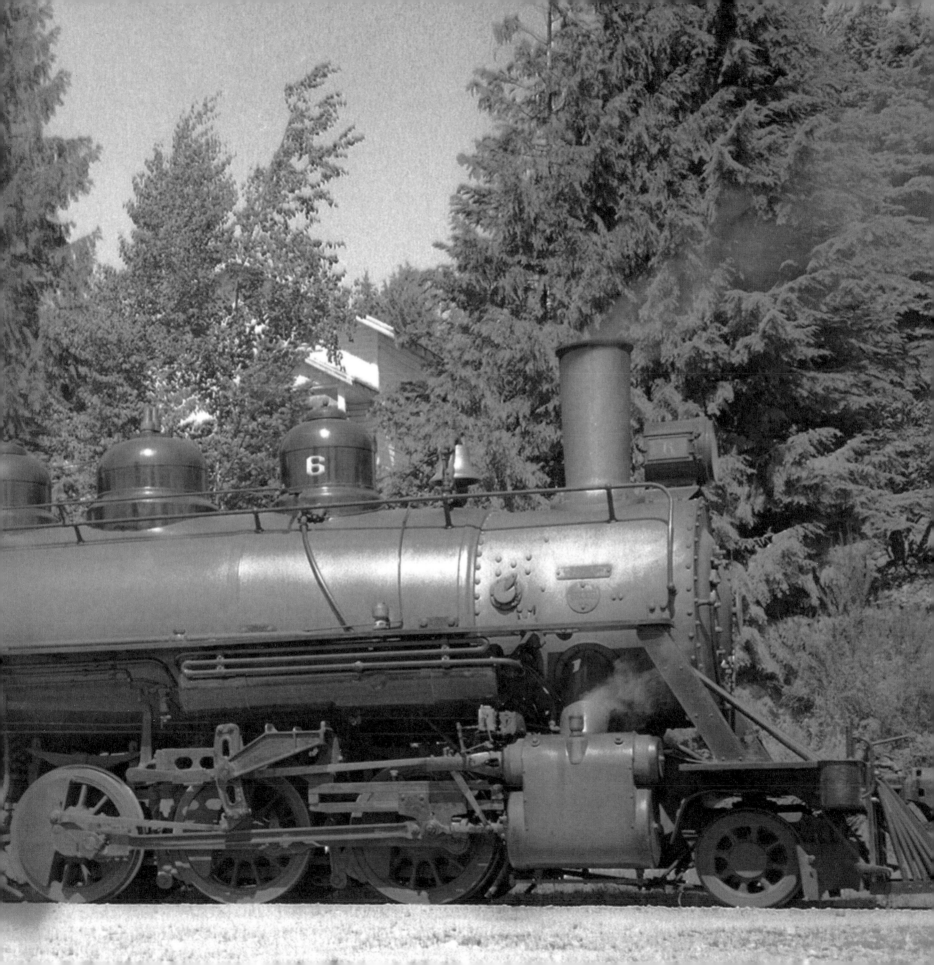

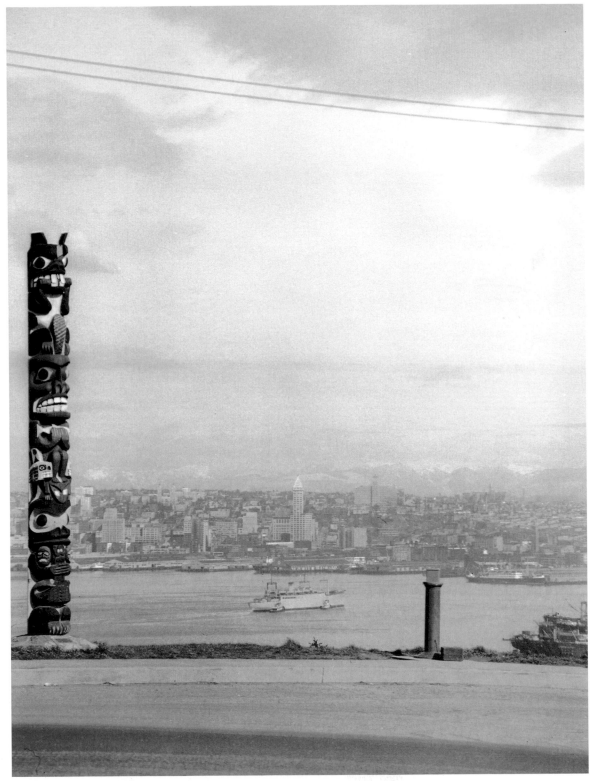

View of Seattle skyline from
Belvedere Place, West Seattle,
featuring Bella Coola totem pole

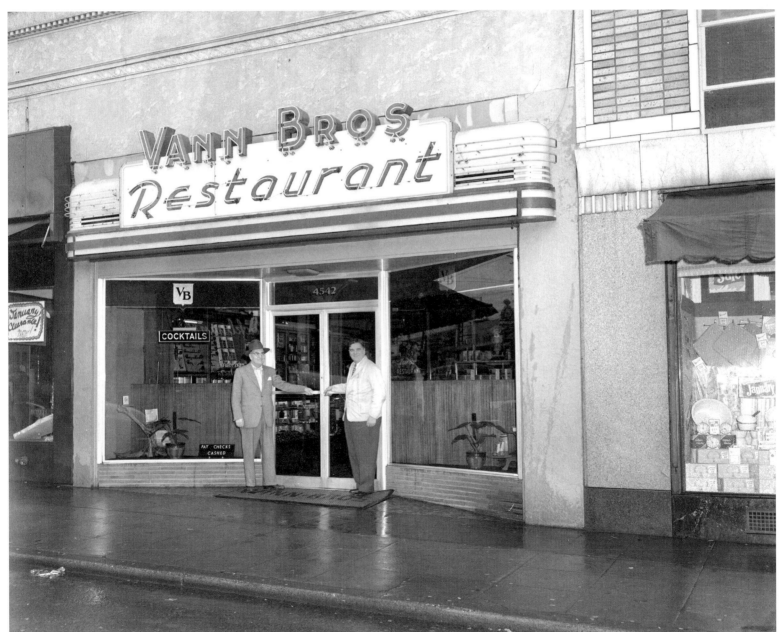

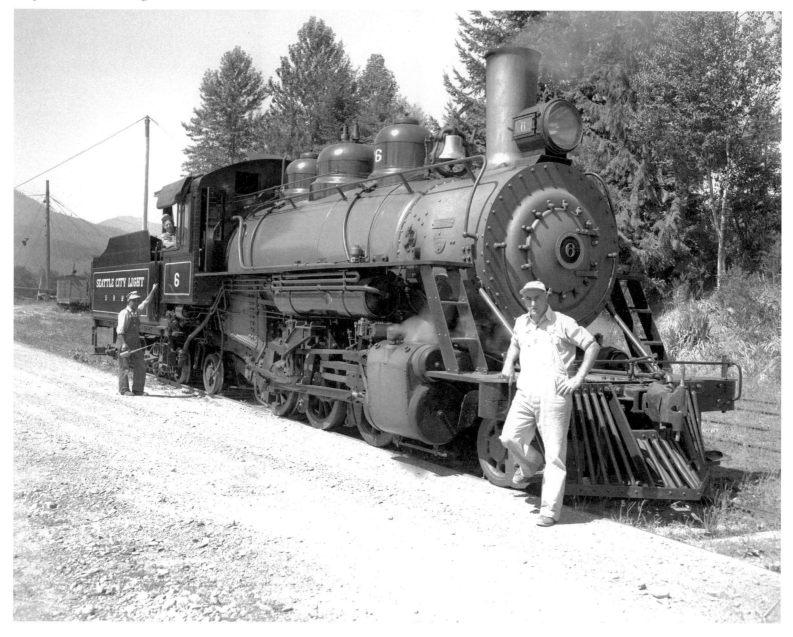

The Northern Lights Dining
Room, 1125 3rd Ave.

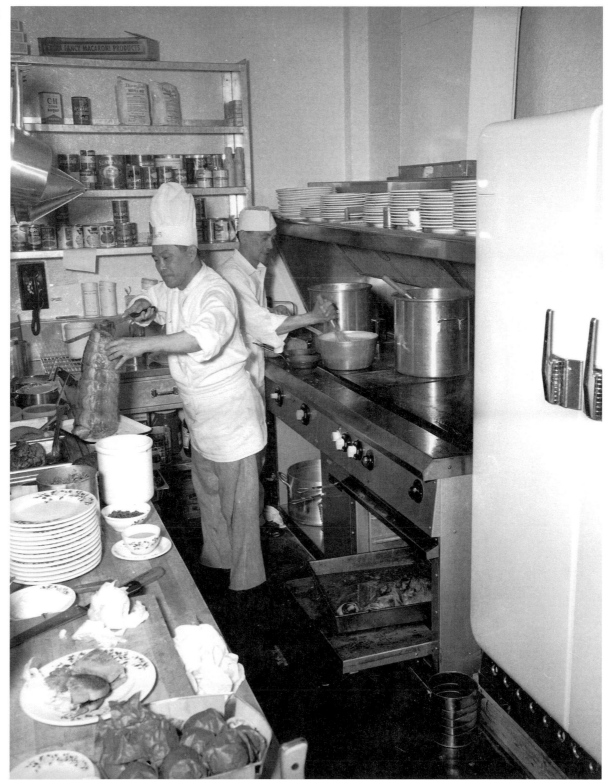

The Northern Lights Dining Room, 1125 3rd Ave.

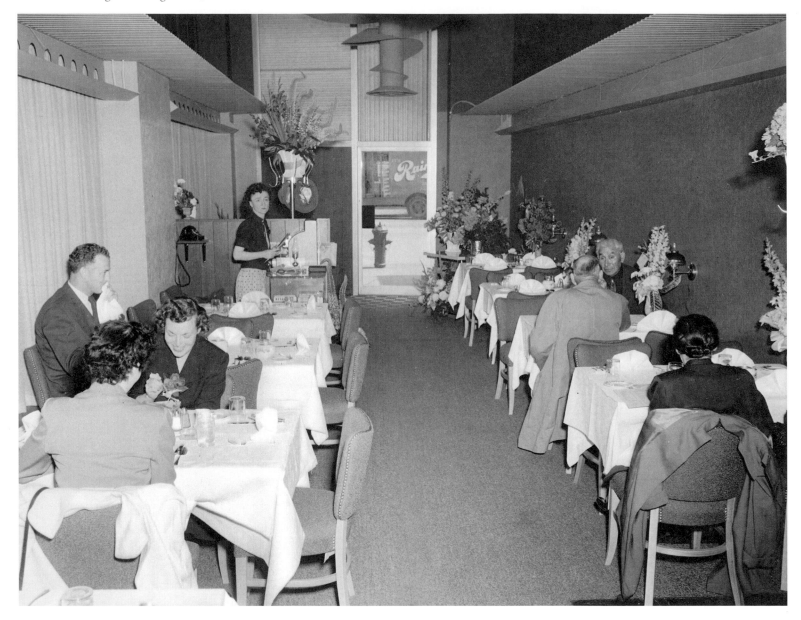

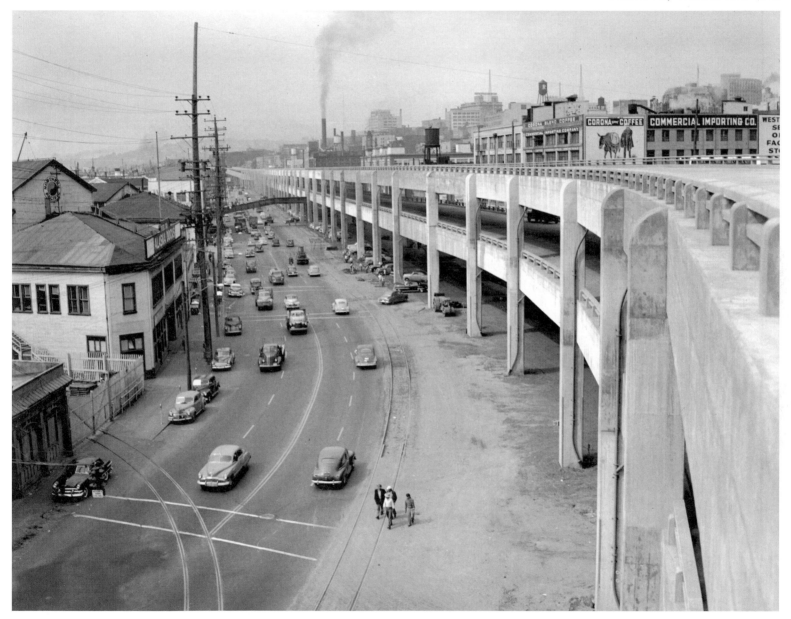

Chuck and Terry's Fish and Chips

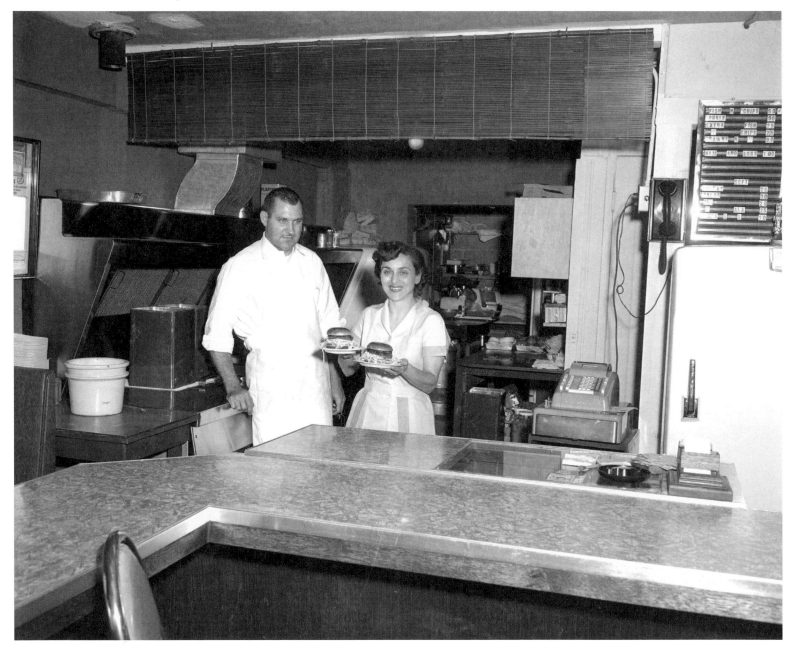

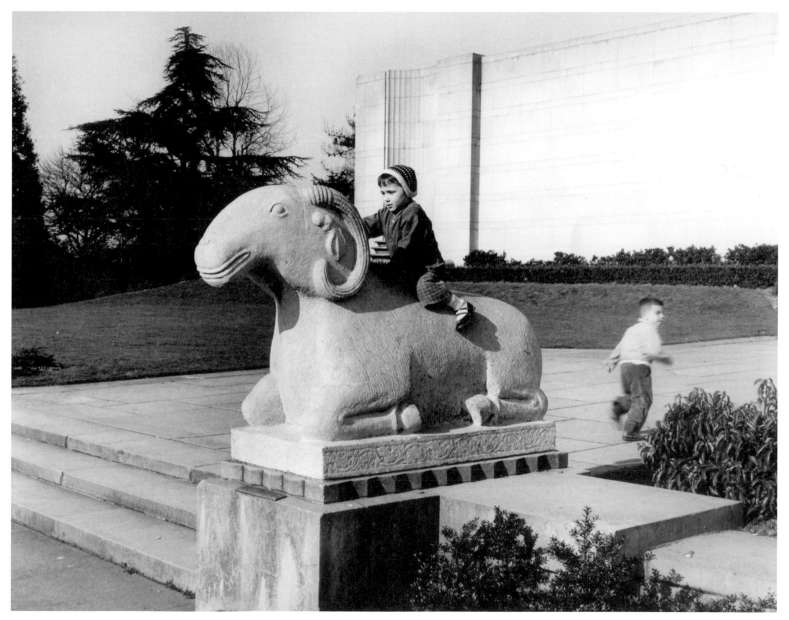

Trackless trolley stop on Pike St. at Fourth Ave. (ca. 1954)

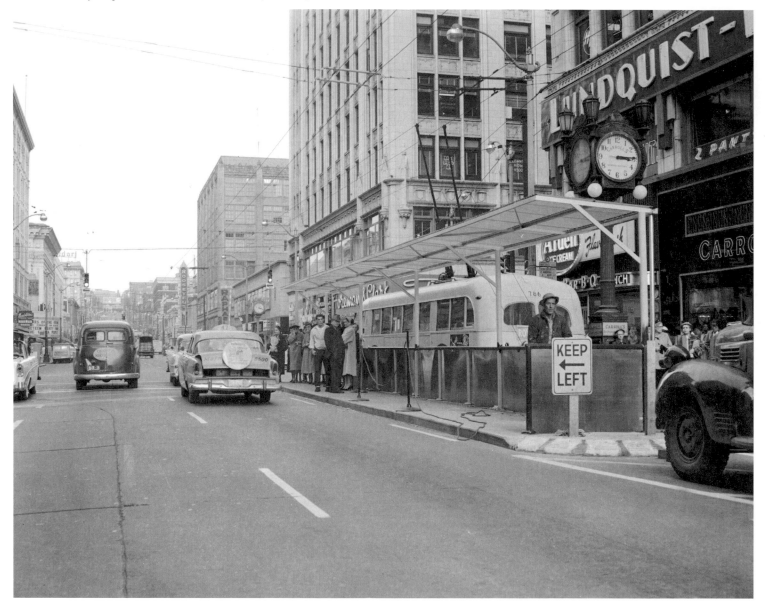

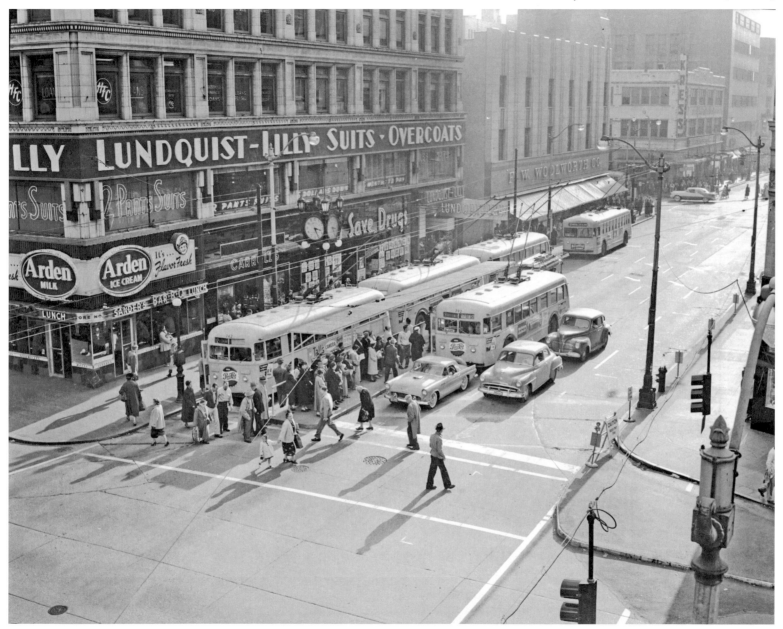

Trackless trolleys on Pike St. at Fourth Ave. (ca. 1954)

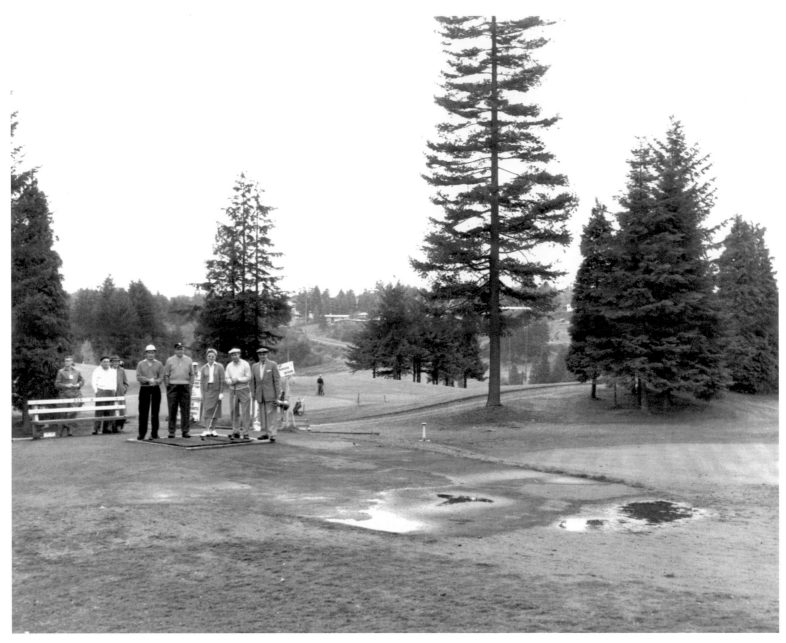

Jackson Park Golf Course

FROM CENTURY 21 TO THE TWENTY-FIRST CENTURY

1960–PRESENT

Work on Interstate 5 and the Evergreen Floating Bridge between Madison Park and the Eastside began in the early 1960s. Meanwhile, Seattle hosted its second world's fair, the Century 21 Exposition, in 1962. The fair left a permanent legacy of public buildings and attractions in today's Seattle Center, including a major sports arena, an opera house (now McCaw Hall), the Pacific Science Center, several theaters, and a new civic totem pole, the Space Needle.

Seattle's population crested at 565,000 in 1965, then began a slow decline as the Baby Boom faded and cheaper housing and open spaces attracted new residents to the suburbs. The population of the rest of King County passed that of Seattle by 1970.

Competition from the suburbs led downtown business interests to advocate "urban renewal" projects that would have flattened Pioneer Square and Pike Place Public Market to make room for parking garages and apartment towers. This sparked an energetic movement for historic preservation, and both were saved along with hundreds of other landmarks. Similarly, neighborhood activists armed with new environmental protection laws scaled back an expansion plan for Interstate 90 and scuttled proposals for two local freeways.

County voters responded to the challenges and opportunities of growth by approving several "Forward Thrust" bond programs in 1968 for new parks, fire stations, and a domed stadium (opened in 1976 and imploded in 2001), but again rejected plans for rail transit. Voters later approved an all-bus system in 1972.

Congressional cancellation of funds for a supersonic transport in 1969 triggered the "Boeing Bust," and the company's payroll plummeted from 100,000 to 40,000 over the next two years. Seattle slipped into another deep recession, which lasted until construction of the trans-Alaska oil pipeline began in 1974. Alaskan "gold" again revived Seattle's economy, but this time it was black.

The downtown began to explode with new high rises such as Columbia Center, which in 1984 briefly recaptured the Smith Tower's crown as the tallest building in the West. Metro Transit opened a bus tunnel beneath downtown in 1990, and voters finally authorized rail transit in 1996. The following year, Seattle voters also approved a new monorail system, but this was later sidelined by inadequate funding.

By the end of the twentieth century, Seattle had gained worldwide cachet for urban chic, thanks to such diverse enterprises as Microsoft, founded by native sons Bill Gates and Paul Allen and based in nearby Redmond, Starbucks coffee, Nordstrom fashions, Amazon.com Web marketing, and Redhook beer and other microbrews. Despite its dependence on international trade, Seattle became ground zero for clashes over globalization when it hosted the World Trade Organization in late 1999.

Despite the WTO riots, Seattle was upbeat. It built new stadiums for the Mariners and Seahawks and voters approved huge bond issues for new libraries and park improvements. On the eve of its 2001 sesquicentennial, Seattle was shaken by "Fat Tuesday" riots in Pioneer Square and a major earthquake on Ash Wednesday. It was shocked again later that year when Boeing shifted its corporate headquarters to Chicago, although greater Seattle remains its main production center. Then the "dot-com bust" pulled the plug on scores of Internet and related software companies.

Seattle rebounded strongly and is now formulating ambitious plans to replace the Alaska Way Viaduct, expand rail transit, rebuild Seattle Center, and create a new neighborhood and bio-tech center on the southern shore of Lake Union to be served by the city's first streetcar in 65 years.

Seattle's founders would be proud of the city that grew from the fragile seed they planted at Alki Beach back on November 13, 1851.

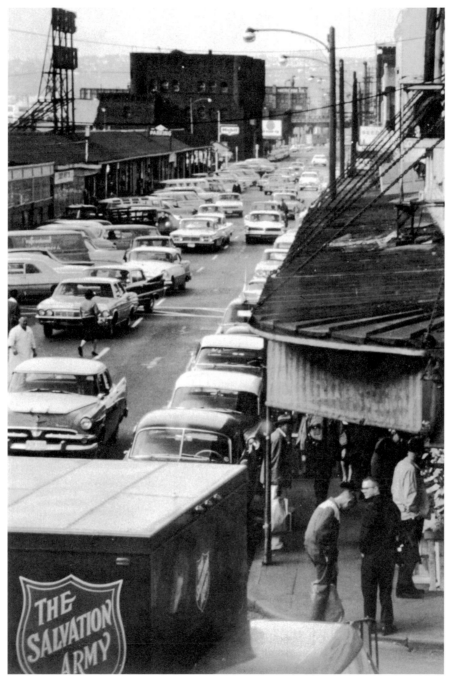

Pike Place, looking
northwest from Economy
Market

One of the several Skagit River hydroelectric projects, the Ross Dam created the waters of Ross Lake.

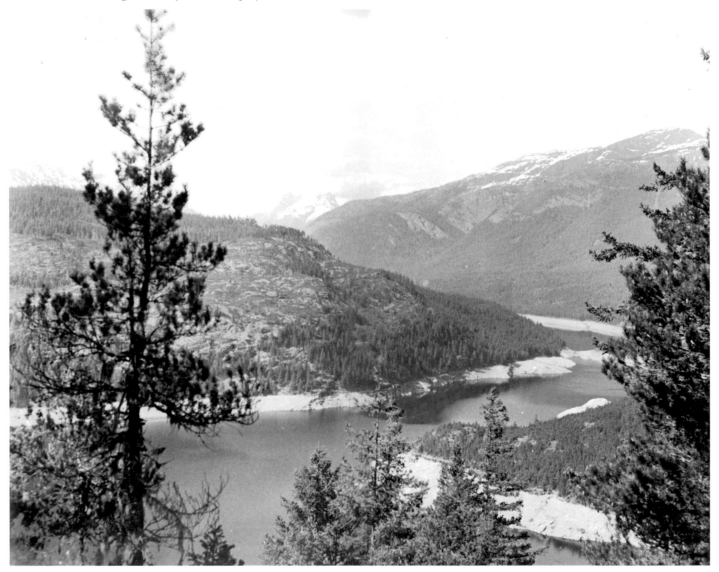

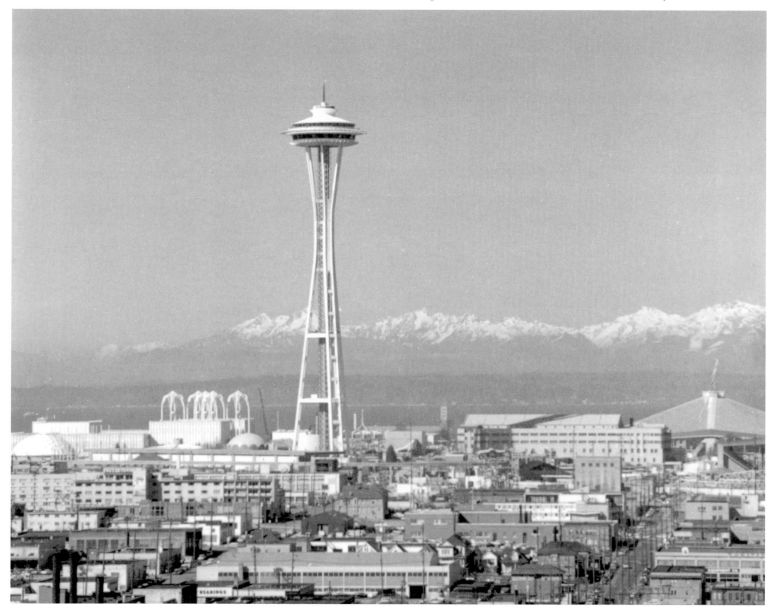

Looking west over downtown Seattle and the Century 21 Exhibition site

Looking out from under the Pergola, First Ave. at Yesler Way (1963)

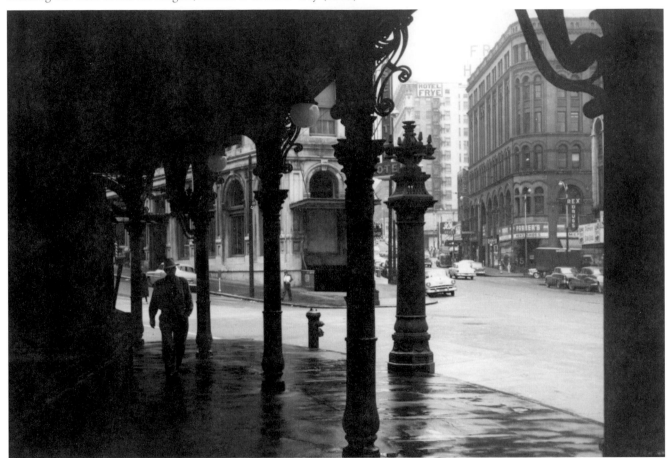

Belvedere Place viewpoint (1965)

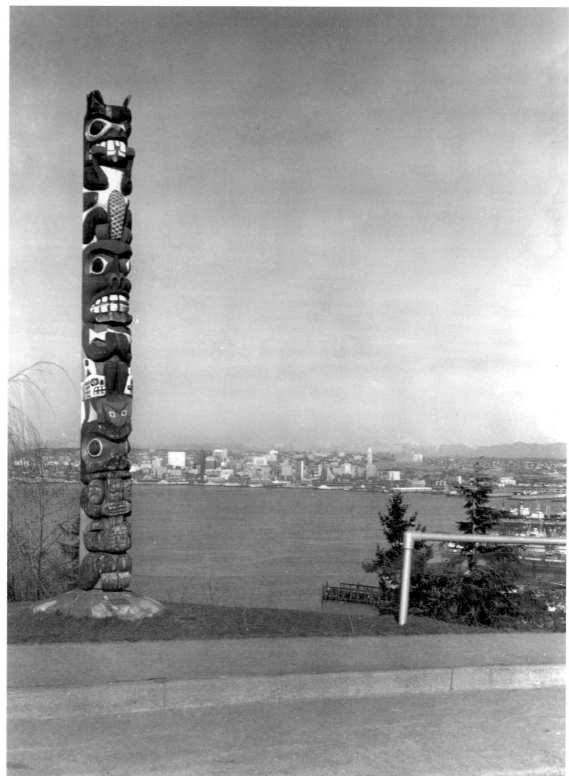

Following Spread: Corner of Pike
Street and First Avenue (1971)

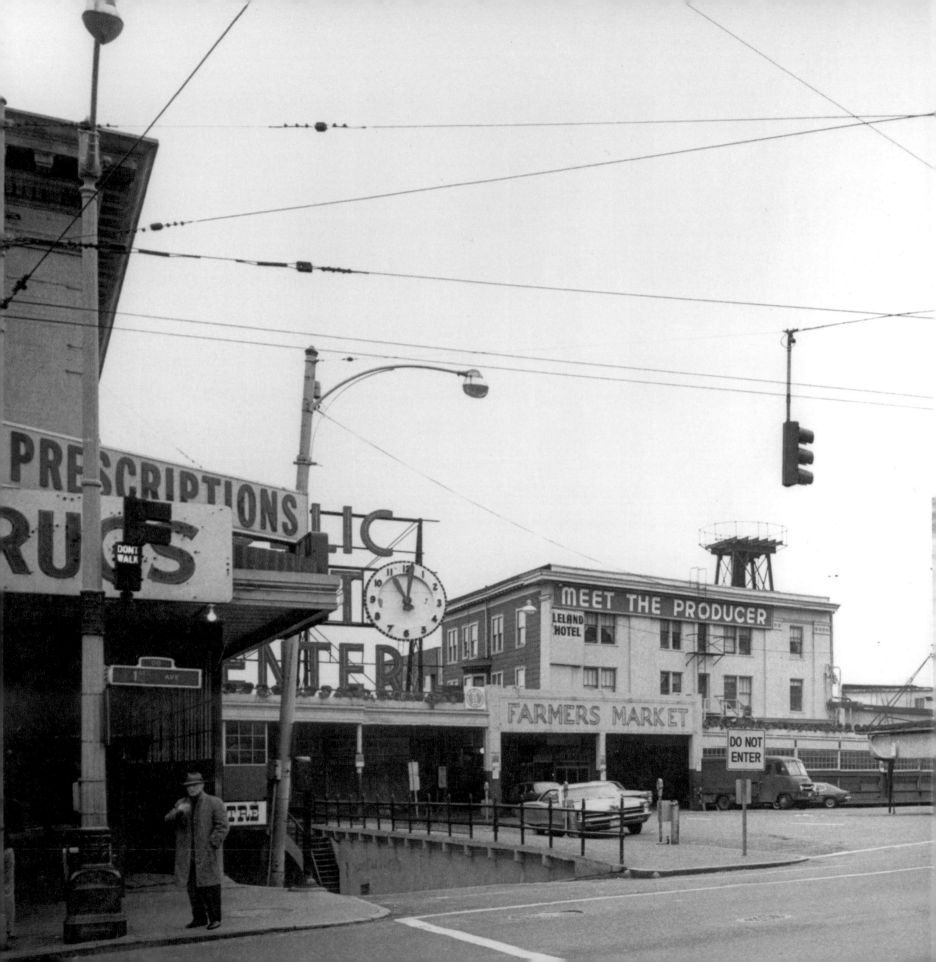

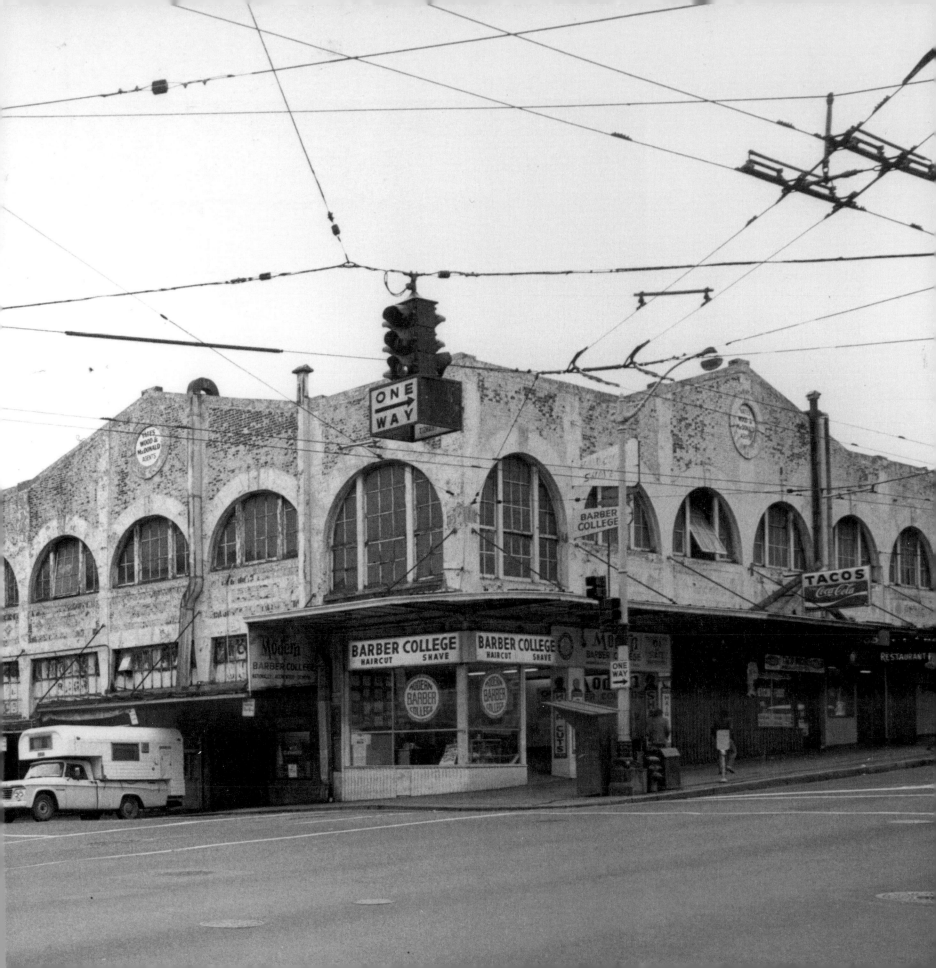

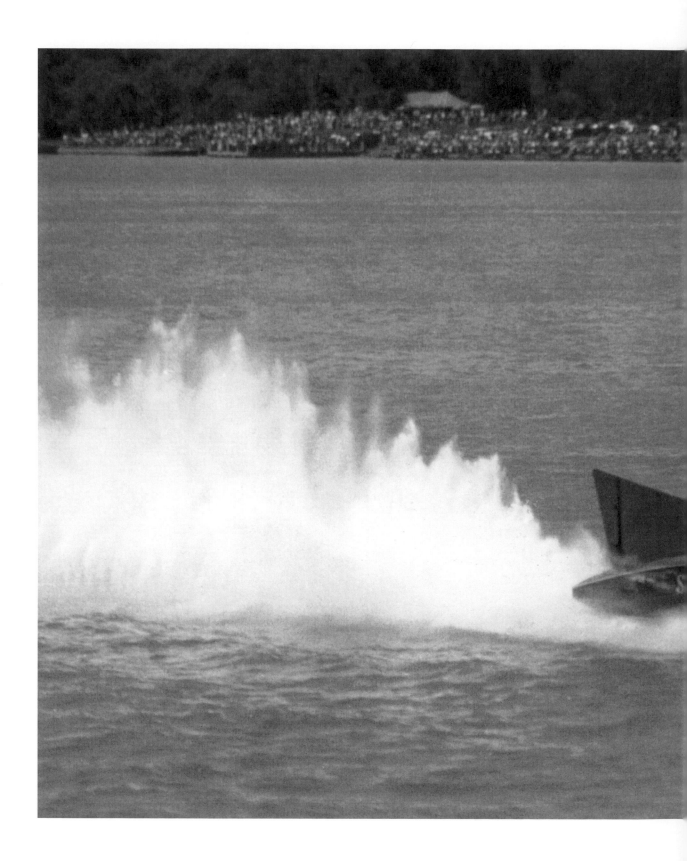

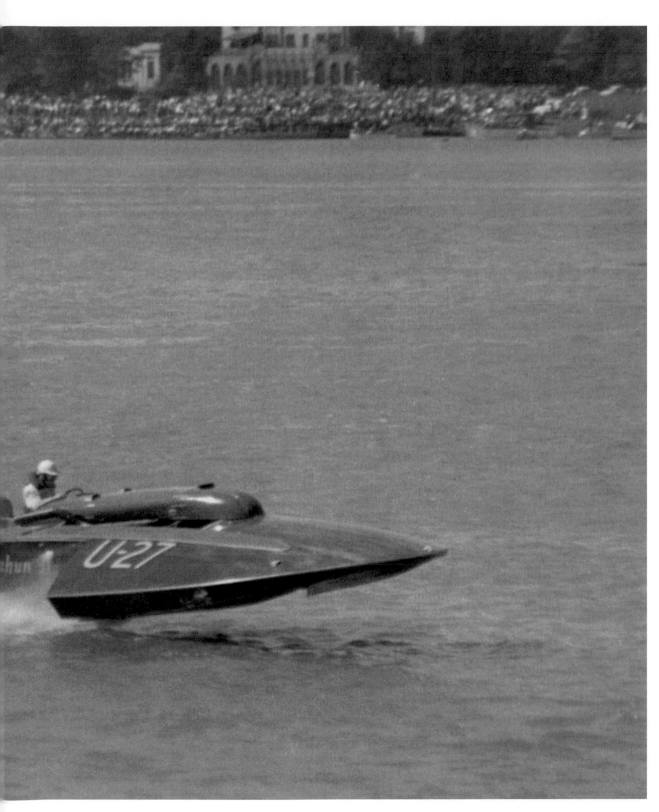

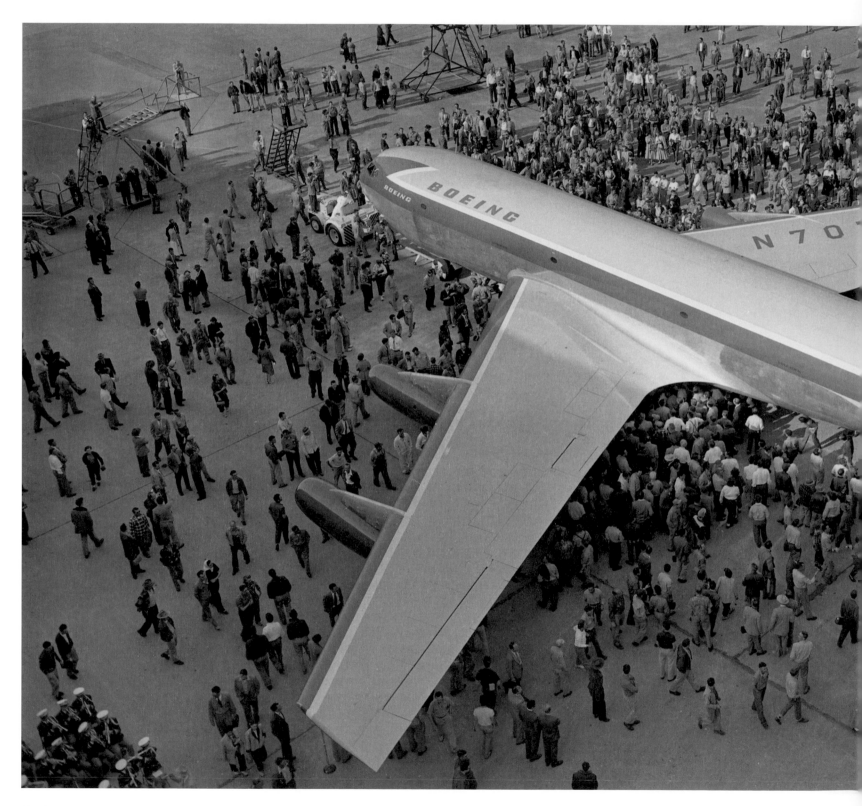

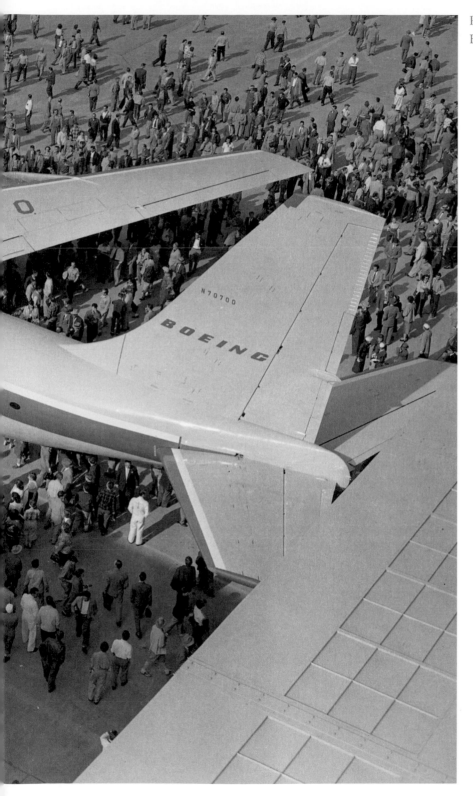

Roll-out of Dash-80 prototype of the Boeing 707 jetliner, Boeing Field (1954)

Following Spread: Monorail and Space Needle (ca. 1994)

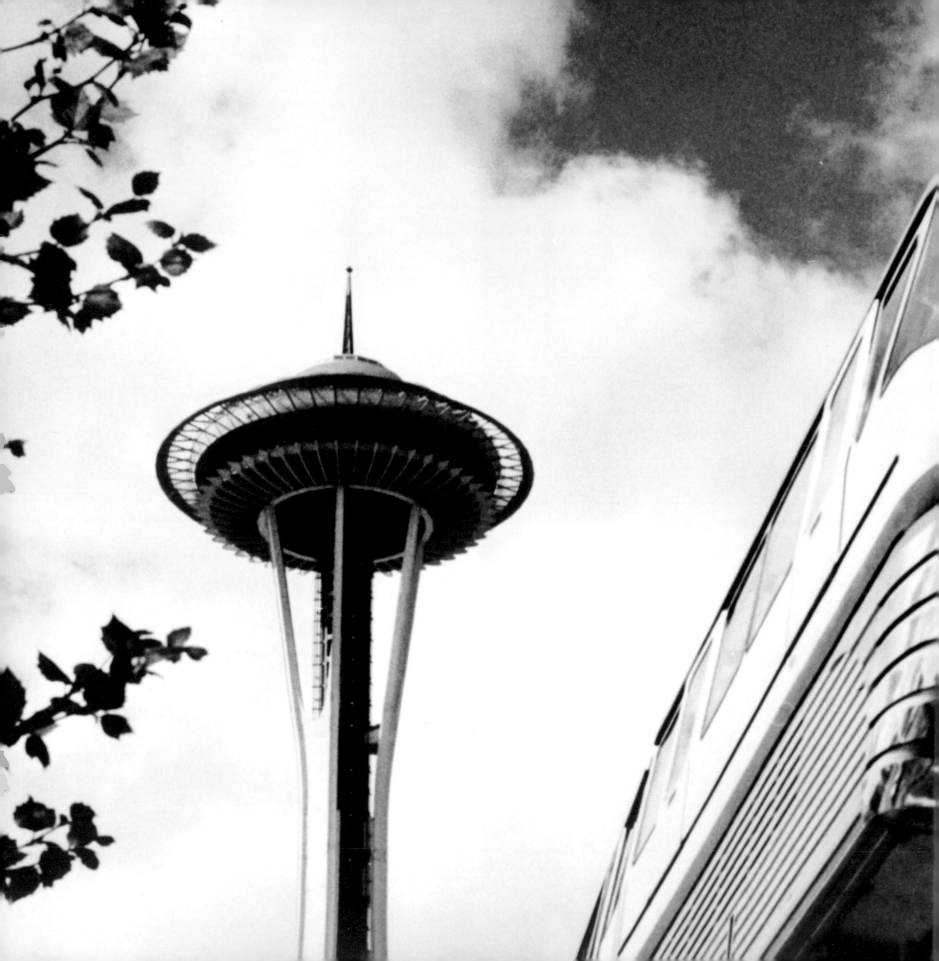

NOTES ON THE PHOTOGRAPHS

These notes, listed by page number, attempt to include all aspects known of the photographs. Each of the photographs is identified by the page number, photograph's title or description, photographer and collection, archive, and call or box number when applicable. Although every attempt was made to collect all available data, in some cases complete data was unavailable due to the age and condition of some of the photographs and records.